NS310 .S .56 L4

KOUEBOKKEVELD SWARTRUG
ROGGEFONTEIN · STOMPIESFON-
TEIN

LADYBRAND BARROW HILL
MOWBRAY · UYSBERG · TRIPOLI-
TANIA · MOOIVLAKTE · MODDER-
POORT · TANDJIESBERG

MACLEAR MOUNT TYNDALE
WIDE VALLEY · HILLSIDE
PROTEA HILLS · CHAMISSO
FERN GROVE

MARANDELLAS MARKWE
VALHALLA

MASERU HA KHOTSO

MATATIELE SWART MODDER-
FONTEIN

MATOPOS CHEETAH ROCK
MAJENJE · SILOZWANE · BOHWE
WHITE RHINO · SPOZWI · AMAD
ZIMBA · MHLANLAN DHLELA

MREWA MREWA CAVE

MTOKO MANEMBA · RUCHERA
CHISEWE

NEWCASTLE ELANDSKLIP

OUDTSHOORN DE HOEK
LOPENDERIVIER

QACHA'S NEK MELIKANE
RANNATLAILE'S · QACHA'S
NEK SHELTER

QUTHING QOMOQOMONG

ROBERT MCILWAINE
NATIONAL PARK
4 SITES

RHODES LONGHOLME
BUTTERMEAD

ROUXVILLE KLIPFONTEIN [4]

RUSAPE DIANA'S VOW · LESAPI
VALLEY

SALISBURY GLEN NORAH

SWAZILAND NSANGWINI

TARKASTAD SWALLEW-
KRANTZ · STIRLING CHASE

UMTALI ODZI

SNOW HILL
· MPANGWENI
IN · BEERSHEBA
WAALHOEK
OGEGEVEN
WILLCOCK'S BRIDGE

ZASTRON LIMBERG

Map labels:
ZAMBEZI RIVER
DOMBASHAWA
MTOKO
SALISBURY
ROBERT MCILWAINE
NATIONAL PARK
MRÉWA
MARANDELLAS
RUSAPE
RHODESIA
UMTALI
FORT VICTORIA
BULAWAYO
MATOPOS
GWANDA
SAVE RIVER
LIMPOPO RIVER
MOCAMBIQUE
VAALWATER
JOHANNESBURG
NSANGWINI
TRANSVAAL
SWAZILAND
VAAL RIVER
WARDEN
NEWCASTLE
HARRISMITH
DUNDEE
BETHLEHEM
BUTHA BUTHE
BERGVILLE
TUGELA RIVER
O.F.S
FOURIESBERG
LADYBRAND
MASERU
ESTCOURT
LESOTHO
UNDERBERG
DURBAN
ZASTRON
QACHA'S NEK
ROUXVILLE
MATATIELE
HERSCHEL
QUTHING
RHODES
Indian Ocean
JAMESTOWN
BARKLY EAST
DORDRECHT
MACLEAR
HOFMEYER
TARKASTAD
NATAL
CATHCART
BEDFORD
EAST LONDON
ORP
PORT ELIZABETH

1. In the Pietermaritzburg Museum.

2. In the Port Elizaberth Museum.

3. In the South African Museum, Cape Town.

4. In the Africana Museum, Johannesburg.

D1379650

ART on the ROCKS
of Southern Africa

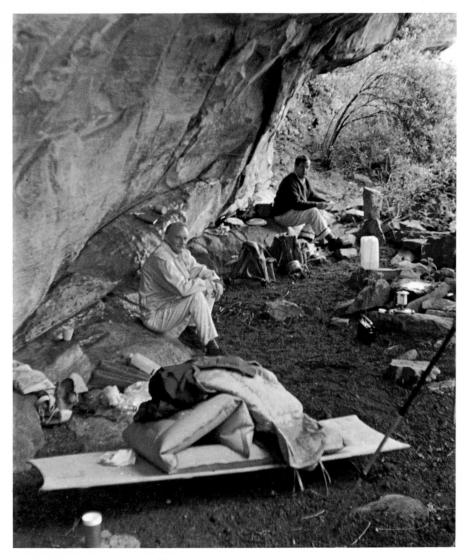

A painted rock shelter used by the authors Bert Woodhouse left, Neil Lee right, as an overnight sleeping place during a photographic expedition. Tandjiesberg, O.F.S.

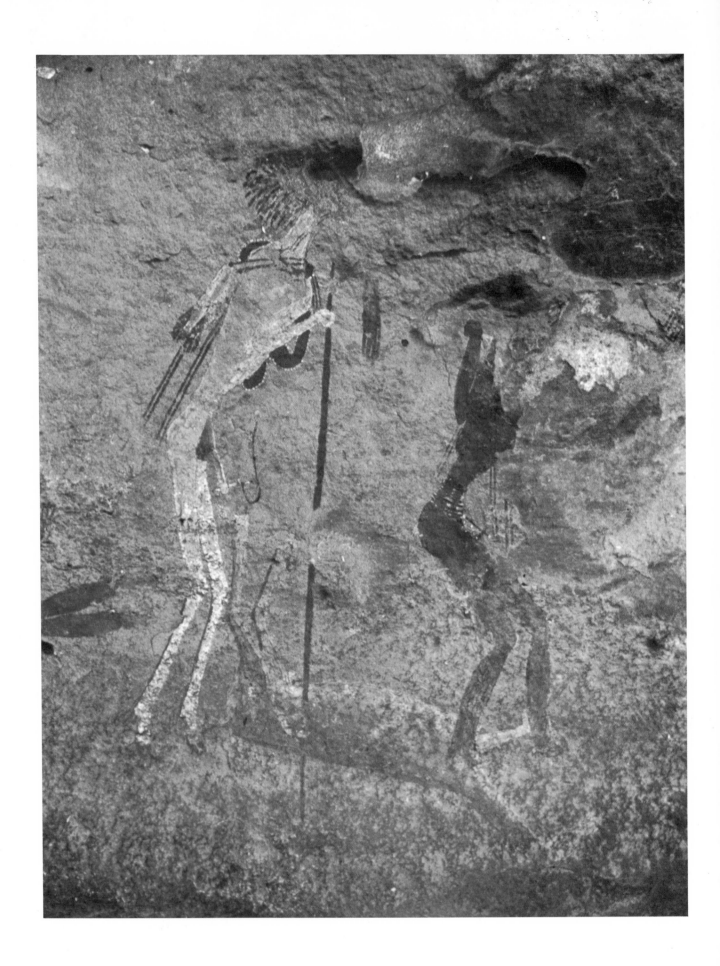

VON CANON LIBRARY
SOUTHERN SEMINARY
BUENA VISTA, VIRGINIA 24416

ART on the ROCKS

of Southern Africa

32654

D. N. LEE
and
H. C. WOODHOUSE

drawings by
Marion Didcott

CHARLES SCRIBNER'S SONS
NEW YORK

COPYRIGHT © 1970 D. N. LEE AND H. C. WOODHOUSE

THIS BOOK PUBLISHED SIMULTANEOUSLY IN THE
UNITED STATES OF AMERICA AND IN CANADA —
COPYRIGHT UNDER THE BERNE CONVENTION.

ALL RIGHTS RESERVED. NO PART OF THIS BOOK
MAY BE REPRODUCED IN ANY FORM WITHOUT THE
PERMISSION OF CHARLES SCRIBNER'S SONS.

PRINTED IN SOUTH AFRICA
LIBRARY OF CONGRESS CATALOG CARD NUMBER 73-18801
ISBN 0 684 13742 9

Foreword by Professor Raymond A. Dart

This book is a sample of the first fruits from co-operation in the same hobby between two extremely busy and highly successful Johannesburg business men. Their joint hobby, as this volume amply and happily reveals, was South African Mural Art; their fruitful collaboration the glorious outcome of a happy meeting ten years ago at a cocktail party. This chance contact was cemented by the friendship of their two families enjoyed whilst spending their next Christmas holiday together in the Natal Drakensberg and developed through subsequent expeditions over the years between. That was the first of many such joint journeys — interfamilial when vacations permitted — to the Eastern Cape Province, Lesotho (formerly Basutoland) and the Orange Free State as holidays and week-ends allowed. These undertakings and the enlargement of these extensive South African photographic frontiers by the journeying of Mr. Lee through South West Africa and the regular tours of Mr. Woodhouse into Rhodesia gradually transformed their hobby into a lively avocation and before long into a steadily widening educational service. Fortunately too, they were gifted with patient and approving spouses

The photography of rock paintings is not easy. Access to the paintings often necessitates hours of walking, and climbing and miles of carrying the heavy photographic apparatus. The better paintings are often awkwardly placed so that the apparatus has to be precariously placed and the photographers correspondingly enforced to assume positions of discomfort amongst the jumbles of fallen rocks or of danger when balanced upon narrow ledges.

They visited hundreds of sites and have thus each accumulated ten thousand odd coloured transparencies during the past decade. Necessarily too they have spent a vast amount of money not only in travelling with their own camping outfits and vehicles, but also in furnishing the necessary photographic equipment and material. Incidentally the reputation of their collections led to frequent demands from close friends and public audiences as well as newspapers to see and have described the treasures their novel technique had discovered and the adventures they encountered. Their responses to these requests have been correspondingly generous.

The systematic recording of our Mural Art was commenced by George W. Stow during last century and continued by Miss Helen Tongue and by Brother Otto of Marianhill Monastery in the teens of this century and by the Frobenius team from Germany in its twenties. Encouraged by Miss M. Wilman's classical work on petroglyphs and by the late Professor C. van Riet Lowe's distributional maps it received the sustained attention of artists of such eminence as Walter Battiss during the thirties and the doyen of French archaeology, the late Abbé Henri Breuil during the second world war period of the forties.

Mr. Alex Willcox was the first to move their study further forward by his careful application of the more modern medium of colour photography in the fifties. Now we have this wonderful volume whose distinctive contribution has been its many close-up photographs in the same medium. This technique, which Lee and Woodhouse have applied with characteristic success, has introduced a new and fertile dimension into the study of all prehistoric art and has thus widened the scope for research into, and appreciation of our own Rock Paintings. As a result of their painstaking work we are really seeing many of the prehistoric masterpieces anew and thus in some vital respects, for the first time; and although a few of their illustrations have been published before, we find much informative detail that had previously escaped notice. They have thus brought new points of view to our prehistoric art and a fresh insight into the studies of their

forerunners. This is truly prehistory and history in pictures. It puts flesh on the bones of our archaeology.

My privilege was meeting these two investigators for the first time and drawing attention to to the scientific importance of their spontaneous collaborative efforts and the technique emerging therefrom when moving a vote of thanks for the lecture they delivered in 1963 when the travelling exhibition of the Bushman paintings copied by the past generations of distinguished artists from Stow to Breuil was sent from Cape Town to be displayed free to the public in the Johannesburg Art Gallery.

The recent establishment of a Rock Art Recording Centre at the South African Museum in Cape Town and the revelations provided by research of this calibre will give added impetus to the study of this long-neglected South African treasure-house of prehistoric art and its interpretation This book, magnificent as it is, represents simultaneously an enrichment of the past and a veritabl fore-taste of the future prehistory that will emerge from the unrecorded paintings still hidde in the hills and valleys of the southern half of Africa.

<div style="text-align:right">Raymond A. Dart.</div>

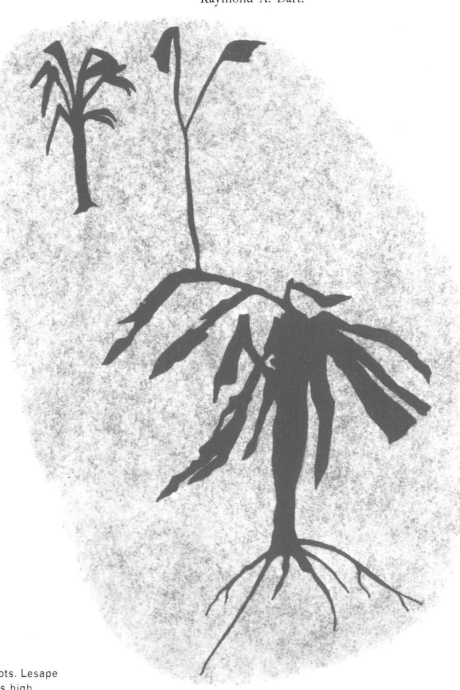

D1.
A tree complete with roots. Lesape Valley, Rusape. 12 inches high.

Remembering

In a book of this type this section is usually headed "Acknowledgements". Even this one commenced that way but, as we checked through our records in search of information, it started such a memory game that "Remembering" seemed a far more appropriate title. It brought back in vivid detail memories of people we have met, the places we have been to and the experiences we have had. Such riches are only given to those who go out in search of them and in this respect our reward has been great.

So many people have helped us in so many ways that it is clearly an impossible task to mention everyone. If there are any who know us and who have helped us in our hobby but are not mentioned here, please accept our true thanks. Heading our list must be the person who started it all, one time ranger at the Giant's Castle Nature Reserve and born naturalist, Robbie Steele. Thinking of "Giants" automatically recalls Bill Barnes and those hair-raising jeep rides which saved us miles upon miles of tramping through the remote areas of the Little Berg. What we believe to be the best method of travel was suggested by the Giddys of Eagle's Craig and Hillside — a donkey with a sack slung on each side carrying all our equipment and food. Not only does this allow one to walk empty handed but also provides room for a bottle of "bungai" apiece. The ingredients of this desirable medicine are equal portions of brandy and Van der Hum and it is prescribed as adequate precaution against the effects of snake, mosquito, flea and other bites, sundry aches and pains and migraines, coughs and prickly heat. It is also positively guaranteed to banish sleeplessness even when lying on the hard ground (but only when administered in an undiluted condition).

Special thanks also go to Pat Carter (née Vinnecombe) whose tracings of rock paintings are a joy to behold and with whom we served our apprenticeship as also to Professors Dart and Tobias whose friendship, enthusiasm and encouragement have been a constant source of inspiration.

We remember the Sephtons of Barkly East, especially Paul Sephton of Pitlochrie whose beautifully drawn and accurate maps only let us down once (how was he to know the farmer had ploughed up the road) and Vera and Joan Simpson, the Shannons and the Putterills of Harrismith, Rev. Martin Payne of Qacha's Nek, Lesotho, Georgie and Hendrik Rautenbach and Mike and Ruth Goldblatt of Clarens and Malcolm and Lorraine Hepburne of Sterkspruit who not only went with us and guided us on many of our trips, but, like the Greylings of Clanville, the Scotts of Tarkastad and the Smits of Slabberts on many occasions took us into their care, gave us a roof over our heads, a warm bed, good wholesome food and above all their friendship and company.

How often too do we have cause to bless the two P's—the country police stations and the pubs, the keepers of which have so many times put us on the right road to some remote area. And the farmers with whom we have drunk gallons of tea and coffee, who have provided us with guides, who have cluttered up their partylines telephoning neighbours seeking details of other sites and who in more ways than we can possibly describe, have proved to be the very salt of the earth. Their philosophy is so beautifully illustrated by the notice on the gate leading to Mr. Strydom's farm in the Clanville district of Dordrecht. It reads, "Please close the gate—come in and lets drink some coffee".

This same philosophy has pervaded our contacts north of the Limpopo. We have received invaluable assistance and advice from such doyens in this field of study as Cran Cooke and Roger Summers in Bulawayo, Mrs. Elizabeth Goodall in Salisbury and Lilian Hodges at Zimbabwe. At the other end of the sub-continent Godfrey Hoehn first introduced us to the joys of sleeping out in the Koue Bokkeveld and Ray Inskeep and his team from Cape Town University allowed us to get the feel (quite literally) of the material excavated from a coastal cave.

A very special thank you must go to our very good friend Marion Didcott who has done all the tracings which form such an essential part of the illustrations in our book. Marion is doubly qualified for this work. As the daughter of the late Professor Goodwin, onetime senior lecturer in ethnology and archaeology at the University of Cape Town, she was brought up in an archaeological environment and being an artist by profession, she can understand and appreciate something of the underlying motivations which inspired the paintings she has illustrated.

Lastly, we cannot forget our long-suffering wives who have accompanied us as unpaid secretaries, cooks and cutters of sandwiches and whose education has been broadened by our occasional comments upon the condition of our equipment, the shelter, the weather, our aching feet and heads and the ancestry of the painters who caused it all. It is absolutely true to say that without their co-operation, understanding and patience this book would never have been written.

D2.
The trophies of a prehistoric hunter
or buck swimming a river?
Flensberg Warden.

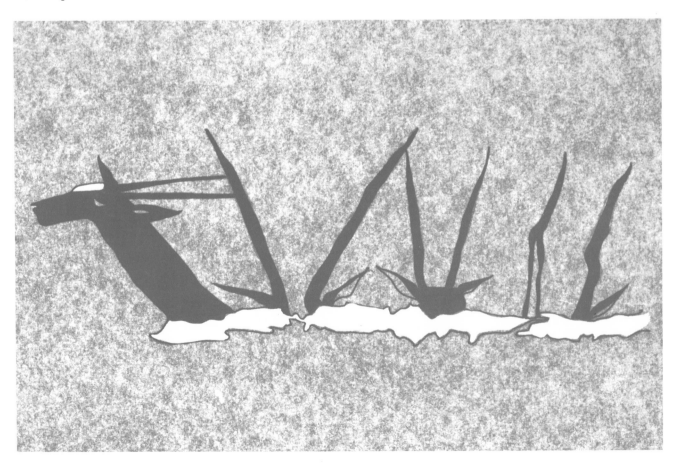

Contents

List of Colour Illustrations

Continued

CHAPTER 1

SOME QUESTIONS —
AND A FEW ANSWERS

The greatest concentration of prehistoric rock paintings in the World is in Africa, South of the Zambesi River—in the territories of Rhodesia, South Africa, Lesotho, Botswana, Swaziland and South West Africa. Although it is not known for certain who painted all of them, they are generally known as Bushman paintings and it is reasonably certain that most were, in fact, painted by Bushmen. Any mention of Bushman paintings in conversation is likely to provoke the following questions:

When were they painted?

What did the artists use for paint?

What did they mix the paint with to make it last so long?

What did they use for brushes?

Why did they paint?

Are you sure it was the Bushmen who painted them?

Where are they?

This is interesting because it is unlikely that similar questions would be asked if the conversation was about the contents of a European or American

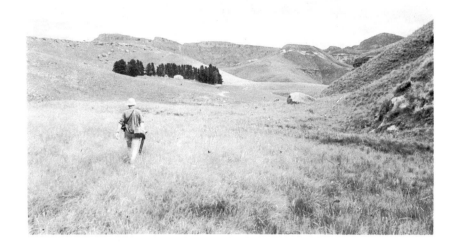

1.

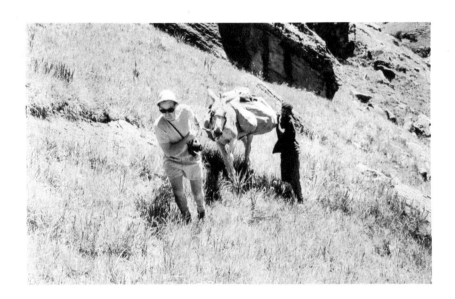

2.

1, 2, 3.
Methods of transport for reaching the paintings vary from simply walking, via the use of a donkey for carrying the photographic equipment and food supplies, to a light aircraft for gaining access to sites in South West Africa. Plane of Derryck Hattingh on the landing strip of Uys tin mine with Brand-berg in the background.

3.

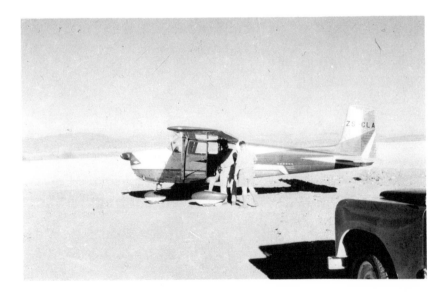

art gallery or an exhibition by modern South African artists. The implication is that the prehistoric painter was a somewhat inferior being to be marvelled at because he developed his technique and because he could not possibly have created "art for art's sake".

Our intention in this book is to try and throw more accent on the subject matter of the paintings, to enjoy them for themselves and to see what they have to communicate about the way of life to which the anonymous artists were witness. Before doing so, however, we will try to dispose of the routine questions as quickly as possible!

When were they painted?

As yet we have no absolute dating method. The technique based on the physical breakdown of carbon (C14) used by archaeologists for dating appropriate material from excavations cannot be used as the paintings contain insufficient carbon. Certain paintings can be dated to the 18th and 19th centuries because of the dress of European women and the use of horses depicted in them. Successive superimposition of paintings gives the impression that the oldest are very much older—particularly as the lower layers do not contain Bantu figures (the Bantu probably spread southwards through Southern Africa about 1,000 years ago). The only flaked off portion of a painting found in a dateable level of an excavation was that in a quite different style at Kasama, Zambia. There, a piece of painted rock which matched a painting on the wall was extracted from a layer dated at approximately 16th century A.D. Pigment has been excavated by Dr. Revil Mason from layers as old as 40,000 years and as Peter Beaumont has demonstrated, mining for pigments was being carried on in Swaziland upwards of 20,000 years ago; but we have no idea whether this material was being used for rock paintings or only for personal adornment. The general consensus is that all the paintings were executed during the Late Stone Age—but even that is a somewhat indeterminate period and might vary considerably in different parts of Southern Africa. It is probably sufficient for the purposes of this book if it is considered as having started about ten thousand years ago.

So the question of dating remains open until an appropriate technique is forthcoming or until paintings are found in a dateable layer of an excavation.

What did they use for paint?

Here we are on firmer ground. The commonest colours are various shades of red, purple and yellow, together with black and white. Much rarer is a bluish grey. The red and yellow are ochres, forms of iron oxide which darkens with heating, the black is charcoal or graphite and the white either kaolin or bird droppings. It is interesting to note that there are three completely different kinds of whites. When wet, one remains the same, one tends to go black and the other disappears completely until it dries again.

What was the paint mixed with?

In her book, *The Mountain Bushmen of Basutoland*, Mrs. How describes the way in which one of the last surviving painters went about mixing his paints. For the red paint he demanded the blood of a freshly-killed eland (for which an ox had to be substituted) and for the white he used the juice of a succulent plant. Experiments conducted by Townley Johnson and his team of investigators at Cape Town have suggested that egg (as used by the Italian tempera painters) would have been an ideal fixative which would have been easy to obtain.

4.

This quartzite stone was found in 1911 resting on the hip bone of a skeleton buried in a coastal cave near Coldstream in the southern Cape Province. It is usually referred to as the Coldstream Burial Stone and is the most important example of art mobilier found in South Africa. The figures have similar characteristics to many of the paintings found on the walls of the shelters such as white faces with red lines painted on them and "hook-heads". The central figure appears to be carrying the equipment of a painter. It consists of a long feather held in the manner of a quill pen and a stone palette similar to many excavated in the coastal caves of the southern Cape. Central figure 7 inches high.

The wealth of ostrich eggshell beads excavated from rock shelters containing paintings indicates that the people of the Late Stone Age were well acquainted with the eggs of ostriches and, presumably, other birds as well. It is from the rate of breakdown of the amino acids in egg that we may hope to obtain an absolute dating technique.

What did they use for brushes?

Probably a variety of things. Mrs. How's painter used feathers, each attached to the end of a stick and trimmed to a suitable shape. On a painted stone excavated from a burial in a rock shelter on the southern Cape coast near Coldstream is a picture of three figures. The central figure is probably a painter. He carries a large feather in the manner of a quill pen in his right hand and a flat stone palette (of which many examples, some stained with ochre, have been excavated) in his left. The "quill pen" is an appropriate painting instrument—especially good for producing the very fine lines that are a feature of so many paintings.

Hair taken from the tail of an animal such as a wildebeest may also have made a good brush and in an extremity the end of a suitable stick may have been pounded with a stone for the same purpose. Many paintings were obviously made using nothing more complicated than a finger dipped in paint while some delicate little circles must have been produced by using the end of a hollow reed in a similar manner.

Why did they paint?

There must have been many reasons, as an accompaniment to ceremonies such as initiation, to make sympathetic magic to ensure successful hunting or good rains, to decorate the rock shelter which constituted a permanent home, perhaps to denote ownership by a particular group—especially

4.

during a temporary absence, to illustrate folk tales or to record contemporary life. There is every kind of picture: genre, portraits, still life, narrative, imaginative, epic, abstract—even landscape. Such a variety of paintings must have originated from a variety of motives.

Fairly frequently one finds a significant group of paintings in a small and often isolated rock shelter that has all the appearance of a special shrine. This seems to accentuate the possibility of the paintings having been connected with initiation or other ceremonial rites. It is known that many of the aboriginal paintings in Australia originated in this way and that they are renewed from time to time for the same reason. Some Bushman paintings also show signs of having been repainted.

Are you sure it was Bushmen who painted them?
Bushmen were observed painting by the early travellers, they taught Bantu in Lesotho and they are known to have inhabited the rock shelters in which the paintings typically occur. At what point in time the Bushmen arrived in Southern Africa or when the prehistoric inhabitants could fairly have been designated Bushmen or, more correctly, Bosjesmans as the Dutch were the originators of the name, we do not know. The term itself is imprecise. If we accept it to mean shortish, yellowish people with a tendency to large buttocks, an infantile posture and a way of life dependent upon hunting and gathering, with a tenancy of Southern Africa stretching over several thousand years corresponding to the duration of the Wilton, Late Stone Age culture, it seems likely that Bushmen painted most of the paintings. Both Hottentots, a similar but taller, people owning flocks of sheep, goats and cattle, and Bantu, a more negroid people owning flocks and practising agriculture, are depicted in the paintings. The Hottentots may even have painted some of them. According to Mrs. How those Bantu who intermarried with Bush women and fraternised with the Bushmen, particularly in Lesotho, certainly learned to paint and presumably some of their work is extant.

Throughout this book we use the term Bushman paintings as a generally acceptable description subject to the reservations just set out.

5.
Severe weathering is breaking away the overhang of this shelter at Makuini, Lesotho.

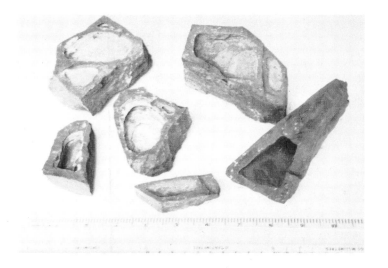

6.
Natural rock formations used as paint pots by a Bushman painter and found in a rock shelter in the Drakensberg. At present in the museum of Kearsney College, Botha's Hill, Natal.

7.

The paintings are to be found throughout Southern Africa wherever there are rock shelters, caves or overhangs that could provide a resting place, temporary for a hunting party, or more permanently for a clan. The greatest concentrations are in the foothills of the Drakensberg and the mountain ranges of the Cape Province but there are thousands of paintings among the granite hills and boulders of Rhodesia and South West Africa. On the open veld where there are no suitable caves there are no paintings but there are engravings, probably, but not certainly, executed by similar people.

7.

A regular supply of water close at hand was an important feature of any rock shelter used by prehistoric men as a permanent home. Eland Cave, Drakensberg.

8.

A valley in the foothills of the Drakensberg showing the weathered line of kranzes along the sides. It is in kranzes such as these that rock shelters are formed by the erosion of wind, rain and temperature change. Giant's Castle, Natal.

9.

North of the Limpopo there are many rock paintings on the sheltered sides of the piles of huge granite boulders, the weathered remains of granite domes, which are such a feature of the landscape. Lake McIlwaine, Salisbury.

10.

A typical shelter containing rock paintings in the granite hills of Matabeleland, Muchezi near Gwanda.

8.

9.

10.

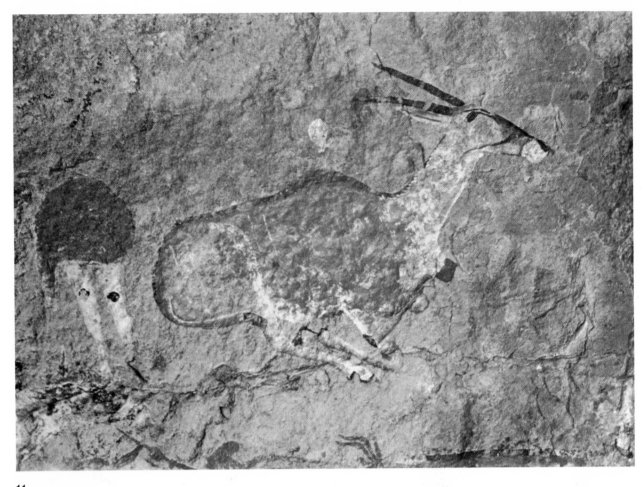

11.

12.

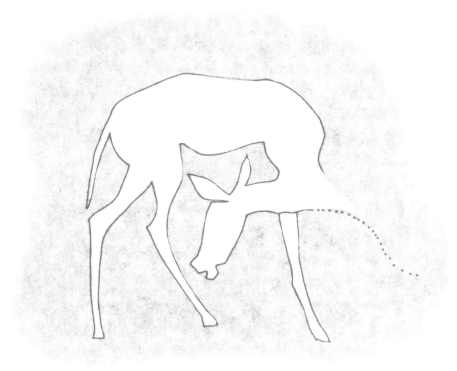

D4.
Although partly eroded away, this simple monochrome provides a perfect example of the technique of foreshortening which is an outstanding characteristic of the rock art of Southern Africa. Delila—Jamestown.

CHAPTER 2

Animals

There is probably no better way in which to appreciate the skills and achievements of Bushman artists than to study their paintings of animals. It is here that each of their techniques can be seen to its best advantage, since it was here they were conceived and, with care and patient practice, gradually brought to full artistic maturity.

Pictures of animals offer a continuous record of the development of South African rock paintings because they provide a means by which we can follow a gradual progression of styles. Starting with simple monochromes, and unshaded polychrome techniques, they advance to the more sophisticated shaded bi-chromes and polychromes, finally ending with the introduction of foreshortening. Prior to this, although some of the most beautiful and technically accurate paintings were in the shaded polychrome style, irrespective of whether the animal was shown standing, lying, grazing or browsing, it was always drawn as if viewed from the side. The ultimate realisation that it could be presented in other ways, and the ability to put this concept into practice, was the final and most dramatic step forward along the pathway of artistic evolution.

11, 12.
Two examples of animals at rest. The eland from Burley in the North-Eastern Cape shows how some artists used a wide range of colours, delicate draughtsmanship and attention to detail to achieve a well proportioned naturalistic representation. Others, like the artist who painted the tiny buck at Upper Kranses in the Natal Drakensberg used only a few colours relying on shading and subtle changes in tone to provide the detail and modelling. This animal merges so well with the colour of the rock face, that it is sometimes difficult to find.
Burley. Barkly East 9 inches.
Upper Kranses, Estcourt. Approx. 2 inches.

The stimulus created by the development of foreshortening encouraged painters of varying abilities to widen their field of expression and at once improve their standard of craftmanship. Simple monochrome and bi-chrome examples were perhaps the first uncertain attempts of a learner to follow the lead of a master to whose skill in the use of several colours, and in shading and modelling, were now added the understanding of foreshortening and perspective. This ultimate standard of artistic brilliance, this simultaneous combination in the naturalistic representation of a form, sets South African rock art in a category above any other.

It is common practice amongst some primitive artists to paint not only what they can see, but also what they know to be there but cannot see. As an extreme example of this there are the Aborigines of Australia who make what are often called "X-ray" paintings since they show not only the skeleton but also the stomach and other internal organs of their subject. Not so the Bushman. With one persistent exception, he seldom portrayed more than he could see at one time.

The exception is domestic cattle where the body, legs and head are always shown in profile, but where the horns are invariably turned and drawn in front elevation. This practice of twisted perspective was by no means exclusive to the Bushman. As far back as 15 to 20,000 B.C. it was a common

13.
Outline drawings are rare in South Africa but they are by no means uncommon in Rhodesia. In this example the artist has super-imposed the bold outline of an elephant over other paintings of human figures and animals. At its back legs are two warthogs one of which is bending forward on its front knees in just the position they adopt when grubbing in the soil for food.
Markwe, Mashonaland. Rhodesia. 51 inches.

13.

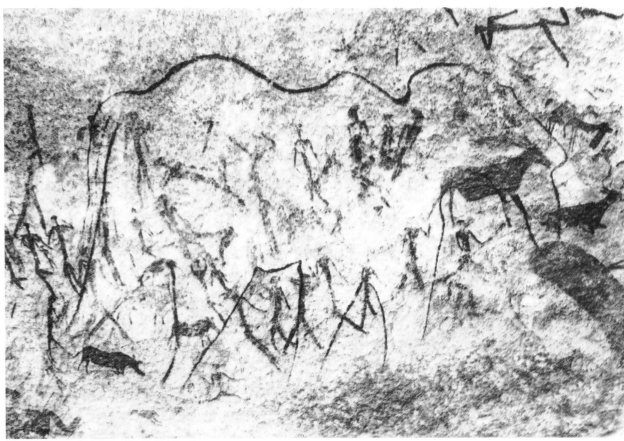

method with the Franco-Cantabrian cave artists; the Egyptian tomb painters first used it during the Third Dynasty (2,500 B.C.) and, as in S.A., it is commonly seen in the paintings in the exposed shelters of North Africa and the Hoggar Mountains of the Central Sahara. To add to the mystery, whereas there are only two recorded examples of foreshortening being used when illustrating cattle, twisted perspective is seldom seen in paintings of any member of the antelope family. The ears and horns are usually shown in precisely the position in which they appear in nature. With the antelope, other conventions were used which repeat themselves through most stages of artistic development. The most common of these was the over-emphasis of the colour difference between the neck and body of the eland. It is easy to understand that this should have been the accepted method with the unshaded bi-chromatic style, but even when the artist had the technical ability and the materials with which to mix the correct colour tones, he still often persisted in following the old stylistic formula of excessive colour contrast. In fact, at times the correct use of colours was completely subjugated in favour of the correct representation of form. The shape of the animal and its meaning in the overall composition was apparently of far greater importance than its colour.

D5.

D5 and D6.
Foreshortened Eland.

D6.

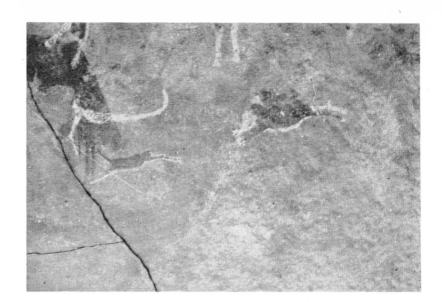

14.
Leopard chasing a buck.
Abbotsann, Dordrecht. Leopard 5
inches.

14, 15.
These two paintings not only
illustrate the Bushman artist's
ability to record movement, but
also his creative genius and his
rare gift of composition. Each of
these pictures was clearly intended
to tell a story—to record a dramatic
event in an otherwise uncompli-
cated existence. And how well
this has been done.

Whilst the introduction of foreshortening and perspective led to properly
composed group scenes, in the majority of paintings where a number of
animals appear, they are arranged in lines, one standing behind another.
At first sight such a presentation seems stiff and formal even though the
draughtsmanship of each individual animal is essentially correct. As those
who have been fortunate enough to visit any of South Africa's game reserves
will know, one of the most fascinating things about studying animals in
their natural surroundings is to sit quietly at a water hole watching whilst
they slowly come down to drink. With at least one of the herd constantly
on the alert for predators, they all drink their fill, then, as if in response
to a signal from their leader, they all move away, usually following one
behind the other as they walk along the game paths into the protecting

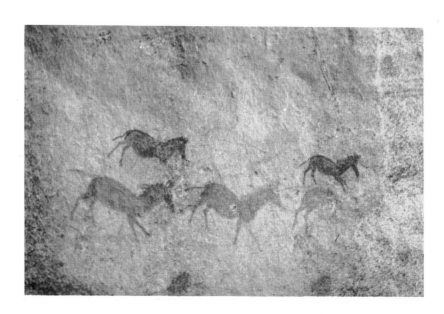

15.
A herd of galloping antelope.
Gomokurira. Average 7 inches.

bush in just the manner illustrated in so many of the paintings. It is then that such scenes spring to life, assuming an air of reality and purpose.

The food producing animals are invariably drawn naturalistically, indicating a close association between the artist and those animals in his environment which were of direct importance to the community as a whole. His competitors, the lions and other meat eating species, were by comparison either badly drawn or stylised to varying degrees. This implies that, although the existence of the carnivores was acknowledged, they had no place in their dietary structure. In fact one can assume that the reverse was more often the case.

The size of the animal paintings varies considerably and, of course, depends upon the animals represented. The majority of eland can be included within the limits of about 6 ins. to 24 ins. in overall length, whilst the smaller animals may vary from 3 ins. to 9 ins. Apart from snakes, which sometimes meander for several feet along the rock face, lifesize portraits were seldom attempted. Usually, as the paintings increased in size, so the proportions became more and more inaccurate. In fact, there seems to be an implied relationship between the artists' own diminutive stature and the size of his paintings.

A systematic analysis of the types of animals in the paintings, immediately indicates such a remarkable bias towards certain species that it soon becomes

D7.
A back view of an eland shown with its head stretched up as it reaches toward an invisible branch.
Aberdeen, Harrismith.

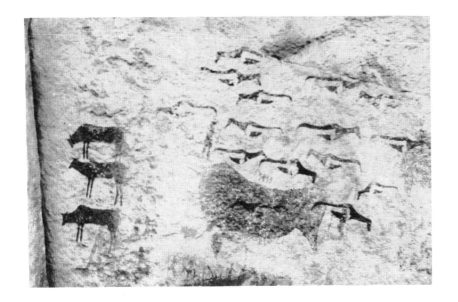

16.
The three animals on the left are typical examples of monochrome, the most elementary technique in rock painting. With the remainder, a second colour may have been used which has since weathered away. The curious patchwork pattern which remains can be followed for miles along the Wilge river valley in which this shelter occurs. Goedgegeven, Warden. approx. 3 inches.

17.
As if to show his independence from the accepted traditions of his contemporaries, this artist has adopted an unusual but effective approach in drawing this animal head. It contrasts strongly with the tiny, more conventional heads (20 in number) which stretch for several feet along the rock face. In neither case is there any sign that the bodies were ever included.
Mount Tyndale. Maclear. 5 inches high.

18.
An animal of doubtful parentage yet drawn with a masterly sense of movement.
Mount Tyndale, Maclear. 11 inches.

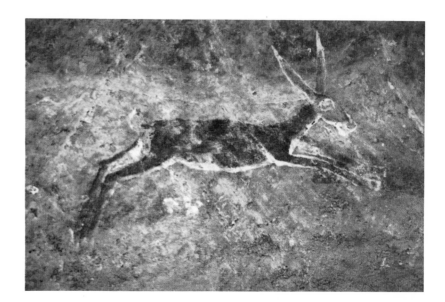

obvious that they can by no means be taken as a true reflection of the former population of the area. As an example of this there is the almost complete absence of kudu and wildebeest in rock paintings south of the Limpopo River even though the animals were widely distributed throughout most of the country. Even the springbok is seldom seen, though it was extremely plentiful in the Transvaal, O.F.S. and Cape Colony. Similarly although the zebra, quagga and giraffe were plentiful in most painting areas of the Cape and O.F.S., they were also seldom represented. Because the eland, the world's largest antelope, is the animal most commonly represented, we may assume that it was the favourite item on the Bushman menu—but is such a guesstimate, necessarily correct? Perhaps it was an easy animal to hunt and kill, and perhaps because of its size it represented the most economical quantity of food for the average sized tribal unit. Or because it is such a prolific breeder, bearing young regularly every year, the paintings of it may have been linked with a fertility cult.

But what taboo could have prevented the frequent representation of the gregarious springbok, which was extremely plentiful in all areas except Natal? Perhaps the narrator of the story "Certain Hunting Observations" provides the answer when he explains that hunters do not eat the flesh of springbok since this would have the magical effect of making slower animals

19.
An indication of the immense size of these stylised elephants is given by Shirley Woodhouse who stands against the shelter wall. At head height and stretching away out of this picture are hundreds of paintings jumbled one over the other in such profusion that in places the texture of the rock is all but lost behind a thick coating of pigment. Ruchera, Mtoko.

19.

27

20.
Judging by today's standards, pigs must surely have provided a succulent feast yet they are seldom seen in the paintings. Perhaps they lacked the personality of the antelope.

Manemba. 11 inches.

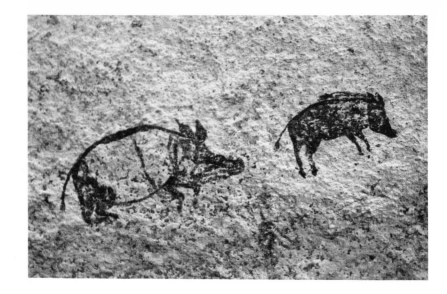

21, 22.
This shaded polychrome illustration of two rhebok mating is another fine example of the high standards achieved by the Bushman artists. Not only did they have a fantastic sense of observation, but they had the uncanny ability of being able to reproduce their impressions clearly and honestly for everyone to see. They were the journalists of their time. These two appear at the upper left of a large group of other rhebok each of which is just as beautifully drawn. The lower picture gives yet another example of artistic brilliance although the technique is different. This artist used the more simple unshaded style, but he had obviously mastered the complexities of foreshortening and perspective. Note the reclining eland drawn entirely from above.

Knuffel's Shelter—Cathedral Peak area.

Eendvogelvlei, Bethlehem.

run fast and make them wander at night and not sleep. "A thing which does not run fast is that which we eat. Therefore the old people do not give us springbok meat; while we feel that the game, if we ate springbok meat, would also do like the springbok; it would not go to a place near at hand, while it felt that we ate springbok which does not sleep, even though it be night".

But what of the smaller animals, the absence of which is so rightly pointed out by Tim Maggs. Fortunately, good housekeeping meant nothing to the shelter dwellers. Once the meat had been chewed away the bone was simply dropped onto the floor, or perhaps thrown over the shoulder, to be eventually covered by ash from fires and other debris. Today those same bones tell us something of their protein diet. Surprisingly the great majority are from small animals, indicating quite clearly that the tortoise, porcupine, dassie and rodent must have provided an essential portion of their food, and yet they are seldom seen in the paintings. It may have been wishful thinking, but surely it was not an attempt to exert the influence of sympathetic magic, which promoted the over-presentation of the eland, hartebeest, rhebok and other small antelope. Judging by the accounts of most 18th and 19th century travellers, the country so teemed with game that sympathetic magic was unnecessary. We can take as an example the account of the hunt organised to honour the visit of Prince Albert, Duke of Edinburgh to Bloemfontein in 1860. During one day, August 24th to be precise, 30,000 animals were rounded up in one colossal drive and senselessly slaughtered.

If we can discount any ideas of auto-suggestion or ritual as having been the purpose for such a proliferation of paintings of animals (and it seems most probable that we can), we are left with the conviction that the motivating force was an inspired expression of art for art's sake which resulted in some singularly beautiful home decorating.

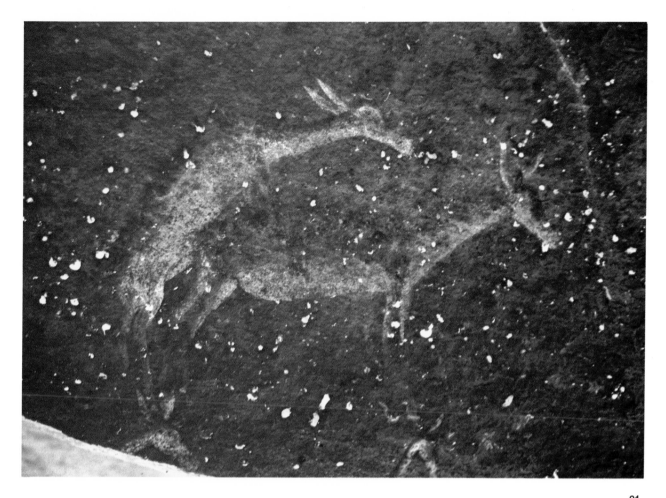

21.

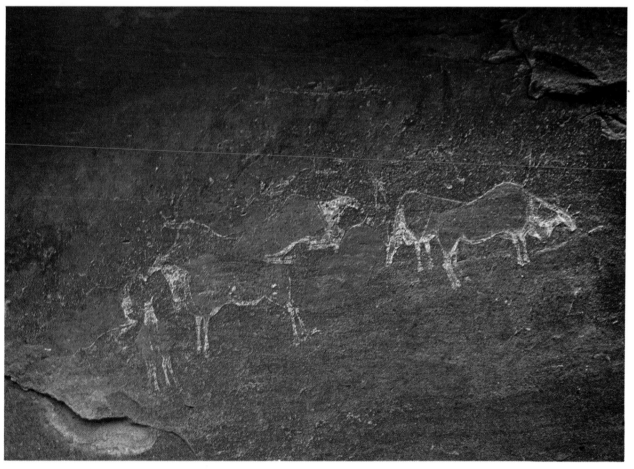

22.

23, 24, 25.

The sense of movement and purpose, and in fact the sheer perfection of so many rock paintings of animals in Southern Africa in itself suggests that they were not drawn for the purpose of exerting sympathetic magic over them, nor to indicate some mysterious ritual. If the artists had been interested in the animals purely as a source of food, then a simple outline drawn to the accompaniment of an intoned prayer to the tribal gods would surely have sufficed. Such ceremonies would hardly have required the immaculate attention to detail seen in these and other paintings. Whether we consider the tottering steps of the new-born buck or the heavy plodding hippo and her baby, these detailed illustrations of animals in movement certainly lend strength to the contention that at least some of the paintings are an expression of art for art's sake.

New-born buck. Eland Cave, Cathedral Peak. 3 ins.

Fleeing buck. Wide Valley, Maclear. 6 inches.

Hippo and baby. Boskrans, Dordrecht. 12 inches.

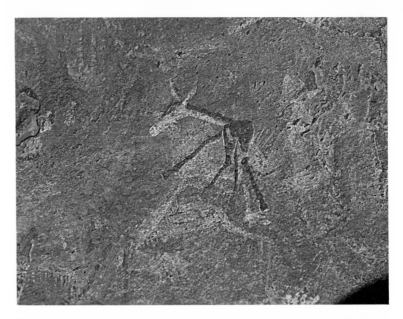

23.

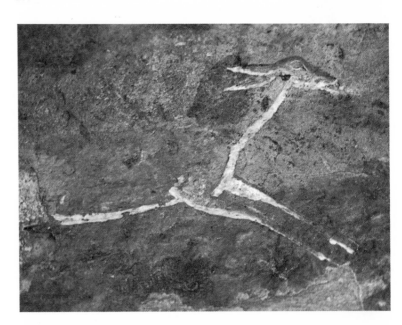

24.
25.

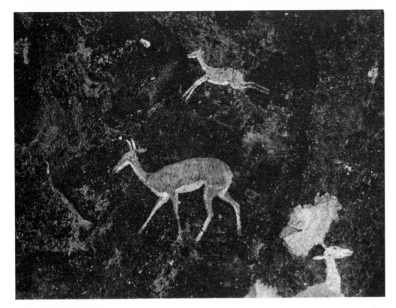

26.

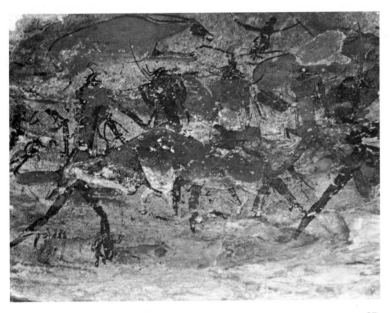

27.
28.

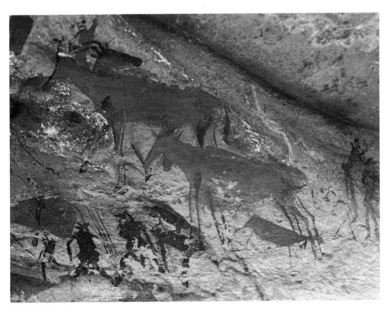

26, 27, 28.
Three examples of perspective. The illusion of depth is generally created by drawing one figure slightly smaller and by placing it slightly above the others. The effect can be seen in 26 where added emphasis has been provided by the contrast of the jet black rock face. In 27 there is the added impression of power and movement as the foreshortened, shaded polychrome eland moves diagonally along the shelter wall. The impression has been accentuated by the tall walking men over which it has been super-imposed.

In the third example the effect has been further heightened by group-ing the animals in pairs and by showing the heads of those on the far side in a slightly darker colour. Again, additional depth has been created by one of the hartebeest in the upper group having its head turned away.

Hillside, Maclear. 5 inches.

Mount Tyndale, Maclear. 23 inches.

Mount Tyndale, Maclear. 12 inches wide.

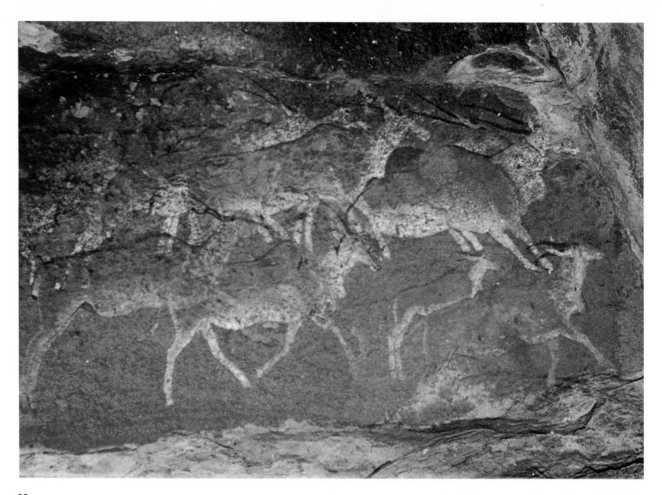

29.

30.

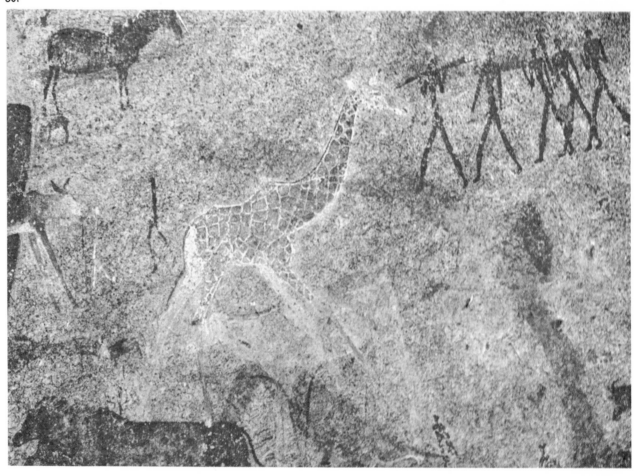

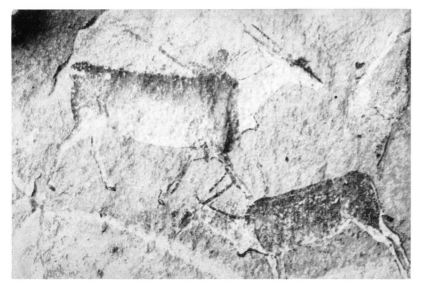

31.

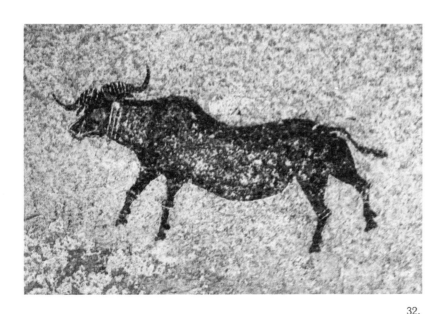

32.

33.

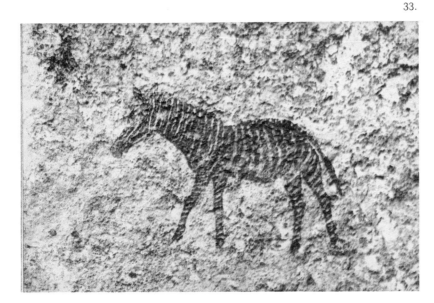

29.
Through a combination of the skills of colour blending and perspective, this group of shaded polychrome eland illustrates the ultimate achievement in the art of composition. So observant was this artist that he has shown one of the eland with a deformed, twisted horn. Barrow Hill, Ladybrand. 34 inches wide.

30.
Paintings of giraffe are comparatively rare south of the Limpopo and the examples that are to be found certainly do not compare with this masterpiece from Majenje (Matopos), Rhodesia. Beautifully proportioned and with skin markings clearly shown, it seems about to move across the rock face in the loping gait so characteristic of this giant amongst the animals. Note the granite rock which is typical of Rhodesian shelters by comparison with the sandstone of South Africa.
Height approx. 32 inches.

31.
A touch of realism has been added to this painting by the eland flipping its tail across its rump as if to remove a troublesome fly.
Burley, Barkly East. 14 inches.

32.
One of a group of six buffalo. Fine white lines clearly indicate the typical heavy-based horns meeting on the mid-brow like carefully parted hair. Note how they have been shown in twisted perspective. There are also signs of an attempt at shading as the outer parts of the body, the shoulders and the rump appear to be in a darker colour tone.
Manemba, Mtoko. 22 inches.

33.
Again from Rhodesia comes this fine example of a zebra, another animal seldom seen in South African rock paintings. The use of a second colour to indicate its striped markings classifies this painting as a bi-chrome.
Ruchera, Mtoko. 9 inches.

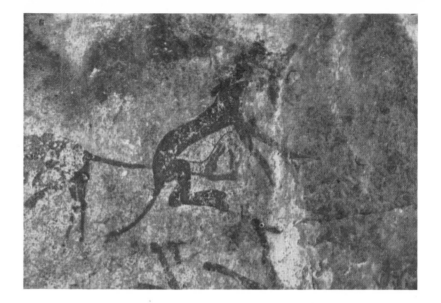

34.
Part of a most unusual frieze of twelve cheetah playing. Each is drawn in a different attitude but unfortunately, as is the case in so many shelters, discoloration and exfoliation of the rock has obliterated much of the detail.
Cheetah Rock, Whitewaters, Matopos. Average size 14 inches.

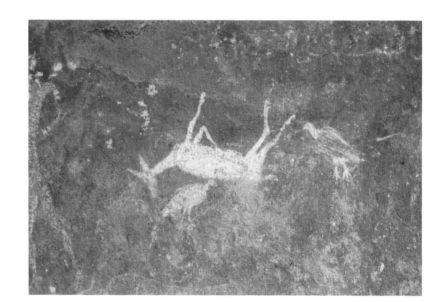

35.
This rather unusual scene from nature shows two vultures standing beside a dead buck. It is an admirable example of the manner in which the story told by so many paintings is heightened by their very simplicity and lack of unnecessary detail.
A dead animal is invariably shown lying on its back with legs and head hanging loose and inert.
Abbotsann, Dordrecht. Buck 3 inches. wide.

36.
By comparison with most other animals, feline were not a popular subject and usually they were crudely drawn and stylised to varying extents. This may have been because they were not a food producing animal.
Makuini 2, Lesotho.

CHAPTER 3

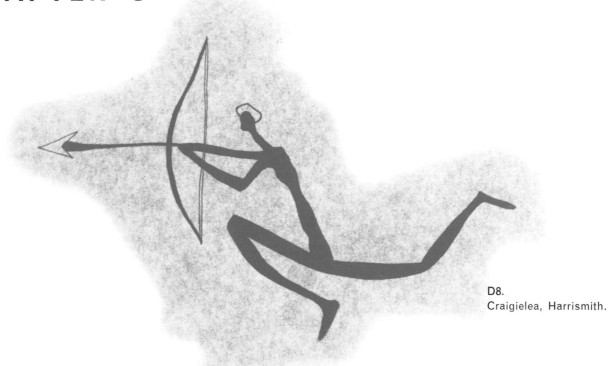

D8.
Craigielea, Harrismith.

Hunting, Fishing and Food-gathering

Where was the next meal to come from? The answer to that question depended upon the combined efforts of all the adult members of any pre-historic community. It is natural therefore that a number of the rock paintings of Southern Africa portray some aspect of hunting or fishing by the men or gathering by the women.

The commonest weapon used for hunting was the bow and arrow. It is frequently and vividly illustrated throughout the whole area covered by the paintings. Some bows are much longer than others in proportion to the men who carry them. It would seem that almost every type of bow appears in the paintings, from the long bow similar to that depicted in Spanish rock paintings to much shorter bows as used by present day Bush-men. Most are a single, slight curve. Some, however, notably at Battle Cave in the Drakensberg and in South West Africa have a triple curve, being bent back at the ends.

While the longer bows probably had a good range, the shorter were

37.
The bow and arrow was used from a variety of positions and attitudes. Helpmekaar, Tugela.

obviously weak and additional facilities were necessary to ensure a successful hunt. One simple technique was the use of beaters to drive the game towards hunters in ambush. In a painting at Makumbe's Shelter near Dombashawa, Salisbury is what may be the result of a beating operation. It is difficult to decide who is the more surprised, the zebra who have been driven into the trap or the bowman who seems to have been caught napping and is fumbling his shot. The artist has done a magnificent job of conveying this surprise; using deliberate distortion to get his effect in a manner worthy of El Greco.

According to Schapera, authority on the Bushmen, a common way of hunting is to run down a small buck on foot, particularly during the rainy season when the progress of the animal is made difficult. Whether this method is illustrated in the paintings is difficult to say, but there are a very large number of wide-striding figures—in fact this convention has become so identified with the rock art of South Africa that one could be forgiven for thinking that it consists of little else. Sometimes two or three such figures are painted carefully side by side—a technical problem which seems to have fascinated the prehistoric artists.

It is impossible to tell from a painting whether arrows were poisoned to increase their effectiveness but in the Silozwane shelter in the Matopos is a fine painting of numerous vignettes from domestic life which includes one of a man who is almost undoubtedly engaged in applying poison to the tips of his arrows. He sits with one foot tucked beneath him, the other leg stretched out to convey a nice sense of balance and with a shallow pot or hollowed stone at hand. The pot or stone was probably the poison receptacle. Two quite separate rows of arrows are carefully placed, one by the side, the other in front of him. He has picked up an arrow and holds it delicately with one hand while with a stick held in the other he applies the poison. An exactly similar procedure has been observed and photo-

D9.
Confrontation. Zebra, probably driven by other hunters, come face to face with a bowman who seems to fumble his shot. The artist has used distortion to communicate an atmosphere of complete surprise. Makumbe's Shelter, Dombashawa, Salisbury. Bowman 5 inches tall.

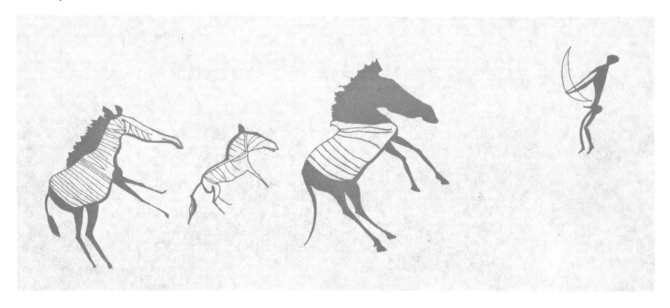

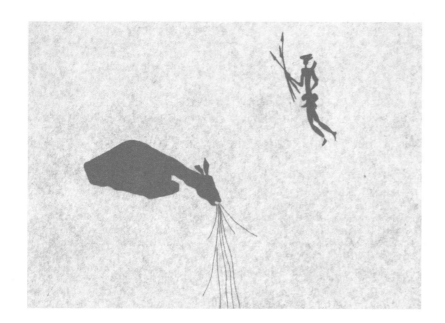

graphed among living Bushmen in the Kalahari by Mrs. Lorna Marshall, author of *The Harmless People*.

Many of the arrows are painted in two colours, the second colour commencing towards the point. The present-day Bushman arrow consists of a main shaft, usually made of a strong reed, and a detachable bone link shaft on to which the arrowhead is joined. The purpose is twofold; to enable poisoned arrowheads to be reversed for safety when not in use, and to ensure that an animal attempting to brush off the arrow against a tree only succeeds in dislodging the shaft, not the point. It would seem that the paintings in two colours indicate the two sections of such arrows. The actual arrowheads are not always shown—but some are large and painted in a different colour, particularly white which was a fugitive colour and has not lasted as well as the red. It seems likely, therefore, that a large number of paintings of arrowheads have faded away. If these large arrowheads were a literal representation they seem to conflict with the material culture of small stone flakes, (microliths) frequently found near painting sites and generally assumed to represent the material culture of the artists. They are more like the iron arrowheads used by Bantu—which would, of course, have been observed with interest by artists of a different culture.

The various attitudes from which the hunters shot were a favourite theme for the artists. Standing, crouching, kneeling, lying down flat and shooting upwards—all are shown, with an infinite number of small variations—no two are ever exactly alike.

In order to get within range of their quarry the hunters frequently disguised themselves in animal skins and particularly the heads of buck. The early traveller, Burchell made reference to a springbok "be-creeping" cap used by Bushmen, and in about 1875 Stow recorded a painting of a hunter disguised in an ostrich skin in the Herschel district. Fortunately

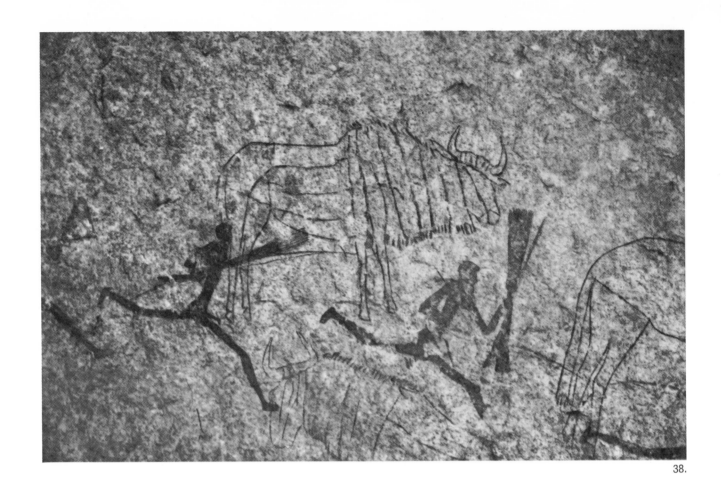

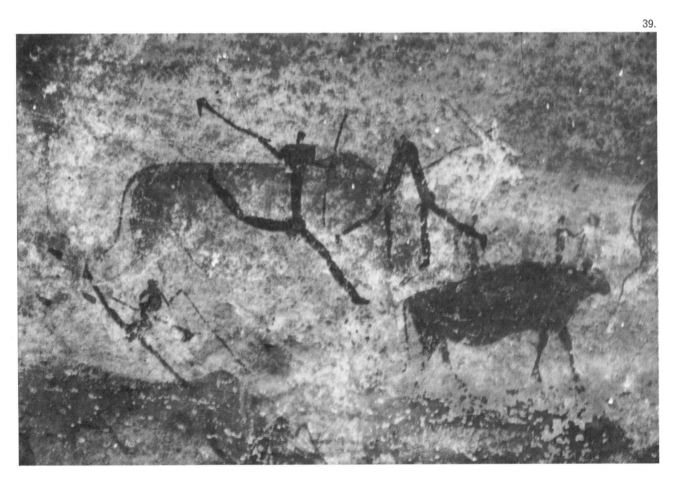

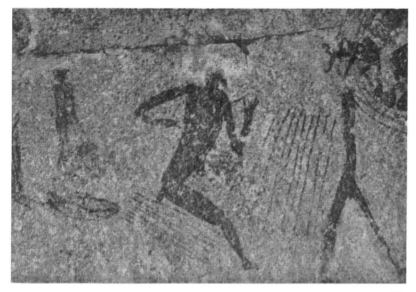

40.

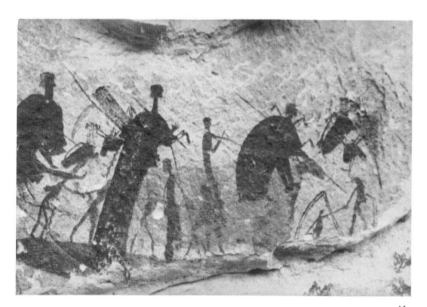

41.

42.

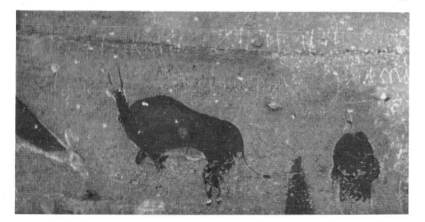

38.
Men carrying unusually long bows
superimposed on a fine line draw-
ing of a wildebeest. Bows of this
type are more typical of Bantu than
Bushmen.
White Rhino Shelter, Matopos.
Each wildebeest about 6 inches
wide.

39.
Two wide-striding figures typical
of many rock paintings throughout
Southern Africa. The hooked
sticks in their hands may have been
used for hooking small animals
such as rock rabbits from holes
under rocks or they may represent
battle-axes.
Main figure about 7 inches wide.
Flauwkraal, Dordrecht.

40.
The careful application of poison
to arrows. The unpoisoned arrows
and bowl of poison are to the left.
The poisoned arrows, laid out to
dry, are to the right.
Silozwane, Matopos. 15 inches
high.

41.
The equipment of a group of
hunters, including quiver, arrows,
whisks and an animal-head mask
with horns.
Mountain View, Harrismith. Tall
figure 5 inches high.

42.
A disguised hunter approaches an
eland.
Snow Hill, Underberg. Figure 11
inches wide.

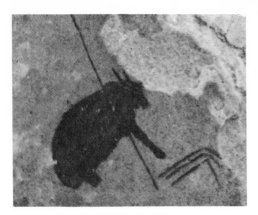

43.
A hunter wearing an animal head-mask.
Mountain View, Harrismith.

he made a copy of the painting—which has become very well-known, but the original has never been re-discovered. There are a large number of other paintings illustrating the use of disguise. In some illustrations the hunter has pushed his animal-head mask onto the back of his neck to get a breath of fresh air.

An effective, but wasteful, hunting method was employed from time to time by hunting people all over the world—the method of driving a frightened herd over the edge of a cliff. In the Smithsonian Institute in Washington there is a tableau of Red Indians doing this to bison and there is a magnificent rock painting of a similar scene with eland as the victims at Pelendaba in the Herschel district. The contorted attitudes of the animals have provided an opportunity for the artist to demonstrate his virtuosity.

From one of his interviews with Bushmen brought to work at Cape Town during the last century Dr. Bleek described a very sophisticated driving method used in the hunting of springbok. Sticks with tufts of red feathers at the top were planted in the ground in a curved line—something like the shape of a question mark. The bowmen lay in wait (with the owner of the sticks first in line) at the end of the curve. The animals were driven towards the bottom of the question mark where a woman frightened them by throwing sand in the air. This caused them to run inside the line of feathered sticks—towards the men in ambush.

In another interview the preparation of the sticks is described in detail—the feathers were coloured with red ochre and impregnated with the smoke of a foul smelling substance.

Although these sticks cannot be positively identified in any of the paintings there are a number of possibilities, notably at Mount Tyndale near Maclear. The only problem is that the feathered sticks are there painted black—which seems a little strange if they were really red—as red is the commonest colour in the paintings. As Bleek's informant mentioned that the feathers were the body feathers of an ostrich, however, black would be appropriate if these particular ones had not been subjected to the red ochre treatment.

It seems likely that animals involved in this sort of drive would end up

44.
To make up for the short range of their bows the hunters disguised themselves in animal skins, wore animal head masks and imitated the movements of the animals as they approached the grazing herds.
Burley, Barkly East.

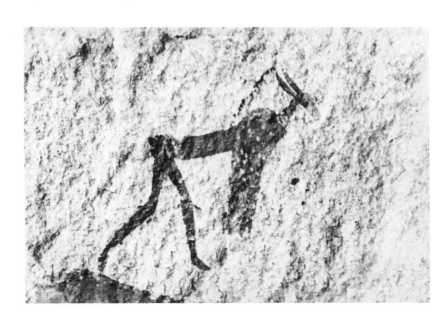

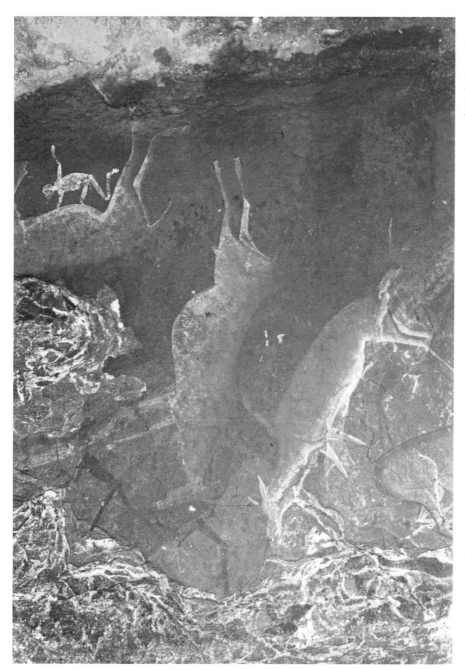

45.
The death plunge when a frightened
herd of eland was stampeded over
the edge of a krantz.
Pelendaba, Herschel.

46.
The excitement and elation of a
successful hunt is captured in
this masterpiece at Langkloof, Harri-
smith. Approximately 5 feet wide.

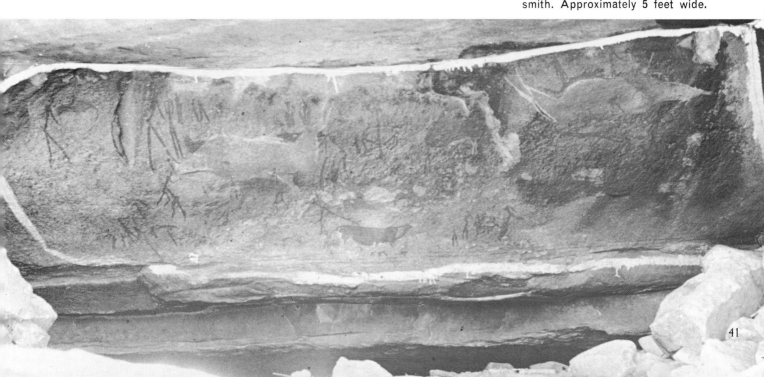

47

The concentration necessary for spear-fishing is caught in the twine-toed attitude of the first figure. The second yanks a fish over his head on to the bank where a quiver lies. Uysberg, Ladybrand. Figures approximately 7 inches high.

48.

Among the equipment of this hunter is a stick with a bunch of feathers on the end. Such sticks were placed in a line in the ground to direct animals being driven into an ambush.
Mount Tyndale, Maclear. 7 inches tall.

49.

A successful fisherman with a line of four fish is greeted by an elaborately masked figure who turns a somersault in the air. The fisherman wears an animal-head mask and the somersaulting figure has a long tail. Approximately 9 inches high. Leeuwkraal, Dordrecht.

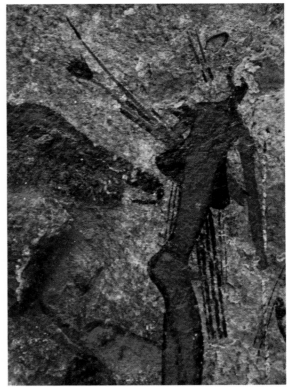

48.

47.

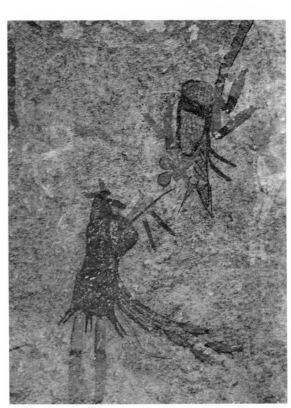

49.

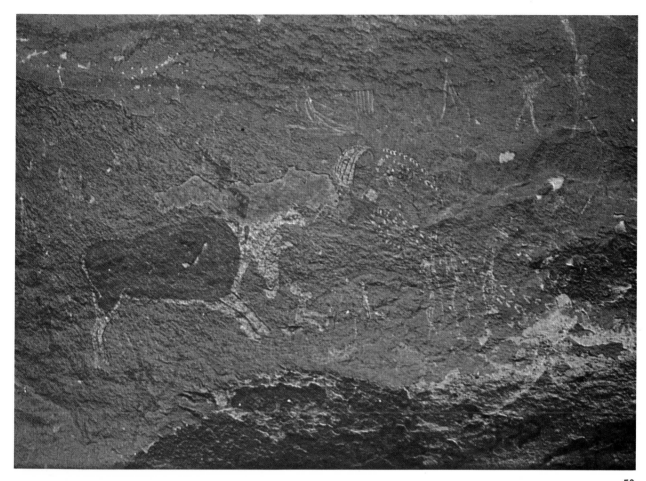

50.

51.

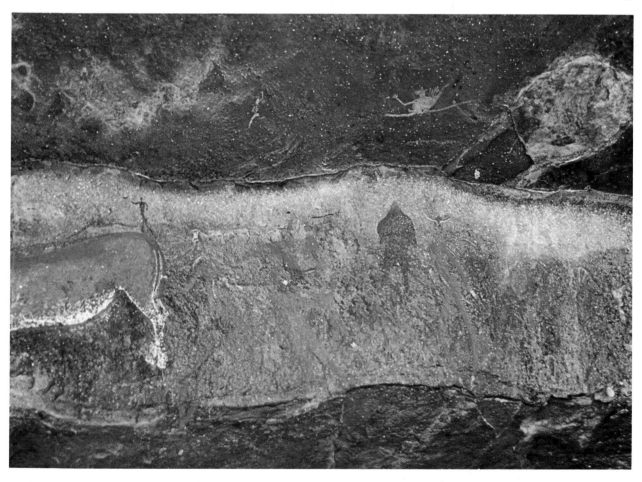

50.

When eland were plentiful and hunting disguises had achieved great sophistication, hunting became almost ceremonial—something like primitive bull-fighting. In this painting three men wearing elaborate masks approach an almost stupefied eland. The central figure trails streamers, probably of feathers, as part of his regalia. Eland Cave, Umhlwasine, Bergville.

51.

The eland is a complacent animal that regards man with some tolerance. Here one has permitted its tail to be grasped by a "prehistoric matador" while the significance of the feat is emphasised by a second "performer" bowing to a third. The nonchalance and sophistication of the scene is emphasised by the crossed legs of the "matador". Tiny hairs painted on the right hand figure seem to indicate that he is wearing a tightly-fitting skin suit. Game Pass, Kamberg. 13 inches tall.

52.

The hunters hunted. Not always was the hunt easy. There were times when roles were reversed, as in this painting. The animals have the general appearance of lions but they have tusks. Coerland, Clarens.

53.

The theme of the hunter chased by lions recurs at a number of sites. This is the largest version—and one of the largest individual animal painting in Southern Africa; 5 feet across. Rannatlaile's, Qacha's Nek.

54.

Big animals were probably cut up where they were killed. A hunter stands astride an eland and starts to skin it while another bends forward to steady the forelegs. Klipkraal, Clanville, Dordrecht. 7 inches long.

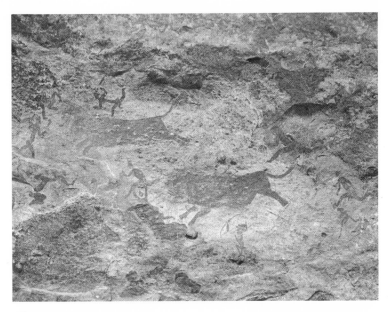

52.

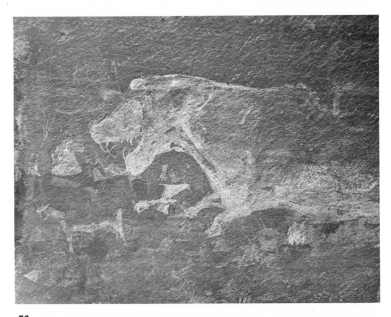

53.
54.

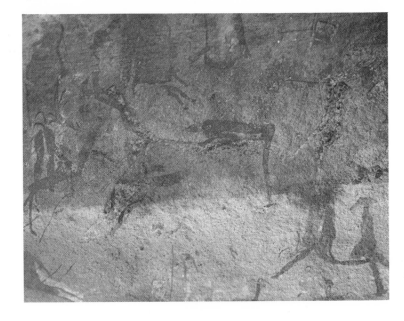

in a seething, milling mass. Just such a scene, with hunters wearing their "be-creeping caps" approaching it is painted near the Witzieshoek Bantu Reserve on the farm Mountain View. From a confusion of paint protrude most delicately drawn buck heads. Their fate is not in much doubt but strangely enough some of the masked hunters are unarmed. Possibly they functioned purely as beaters and it was left to an elite to make the kill.

Another hunting method is illustrated in a painting from Karee Kloof near Hofmeyr which is now in the Port Elizabeth Museum. It shows a row of stakes or piles of stones with gaps between them. They are presumably arranged along a river bank so as to force the animals to walk between them when coming down to the river to drink. Pits could then be dug and concealed with brushwood, grass and earth to make traps, or the hunters could lie in ambush concentrating on particular routes.

Even more ingenious are the fall traps in the paintings at Gomokurira near Salisbury, Rhodesia. Large rocks are suspended on the end of thongs to be released on to the victim by a trip mechanism. One painting shows the rock about to descend on the back of an unfortunate buck.

One of the largest paintings in Southern Africa, also near Salisbury, appears to represent a buck with its legs trapped between rocks. But this may not be the correct explanation. The painting may have a mythological association and may represent the "rain bull" resting on the mountains. Owing to the proximity of a crouching human figure, however, the trap explanation seems more probably correct.

Hunting with javelins, spears or assegais is nothing like so common in the paintings as hunting with bows and arrows. There are only a few examples known to us. On the farm Mooivlakte, Ladybrand district, is a painting of several upside-down eland. Protruding from the back of one is a weapon resembling an arrow but much more substantial. Writing in

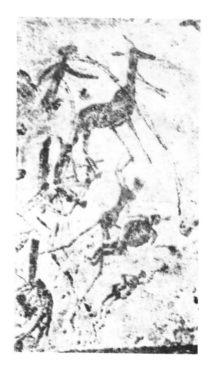

55.
The use of the bolas? A young kudu jerks back in surprise as a weighted thong wraps round its neck. Behind, with arm outstretched in the act of having thrown the bolas is the hunter. The fighting figures below are probably not connected with the incident above.
Mrewa, Mashonaland. Kudu 5 ins. high.

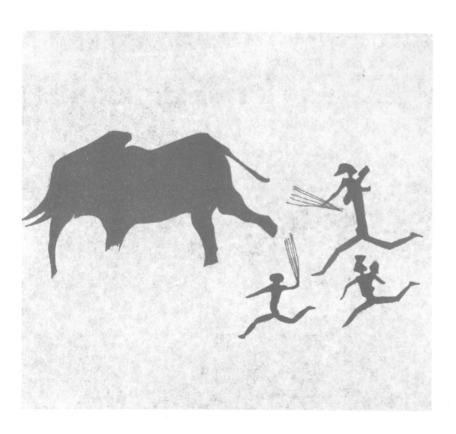

D11.
Elephant hunting with bows and arrows!
Valhalla, Mashonaland. Elephant 18 inches wide.

45

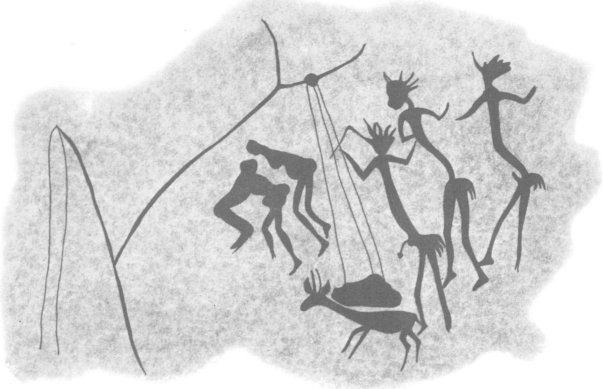

D12.
A fall trap consisting of a large rock suspended from a branch and linked to a trip rope. Below it walks an unsuspecting steenbok. Gomokurira, Salisbury.

56.
Bohwe, Matopos.

the early 17th century Sir Thomas Herbert, on a visit to the Cape, described the inhabitants, the Hottentots, as having as their only weapon "a javelin headed with iron, and directed by some feathers, which they take off and on at pleasure". This seems to correspond roughly with the weapon used at Mooivlakte.

A weapon not usually associated with Africa but rather with South American gauchos is the bolas. Nevertheless, archaeologists, notably Desmond Clark, have long suspected its use in Southern Africa because of numerous finds in excavations of round stone balls in groups of two or three. Professor Leakey of Olduvai fame is illustrated in the *National Geographic Magazine* of February 1965 holding a reconstruction of a prehistoric bolas. At Mrewa in Mashonaland is a magnificent large rock shelter containing numerous paintings including one that almost undoubtedly illustrates the use of the bolas for bringing down a buck. The animal has been brought to a sudden startled halt by the impact of a weighted thong around its neck and behind it stands a man with arm outstretched in an attitude perfectly in keeping with having just released the bolas. There appears to be another weighted thong in his left hand but the painting is slightly incomplete as a result of flaking rock.

Dogs are traditionally the companions of man in hunting. A painting clearly demonstrating this relationship in Southern Africa has yet to be

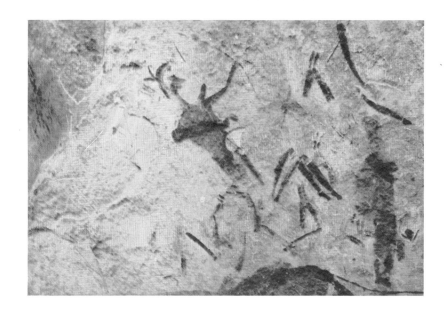

The bow and arrow was used from a variety of positions and attitudes.

57.
Fulton's Rock, Giant's Castle.

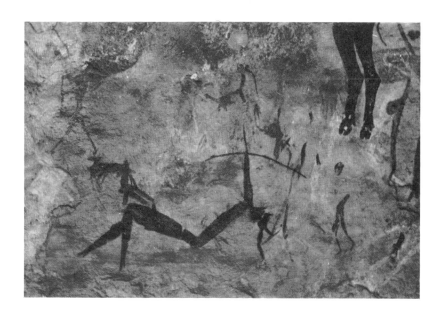

58.
Mowbray, Ladybrand.

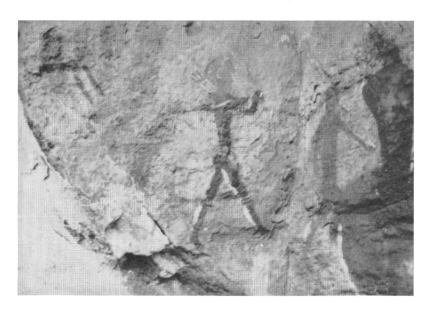

The different colours of the arrow in certain paintings indicate its division into a main shaft and a link shaft in the manner of the arrow used by the present-day Bushmen. If the animal succeeds in brushing off the main shaft the link shaft and poisoned arrowhead are left behind embedded in its flesh.

59.
Cascades, Drakensberg.

60.

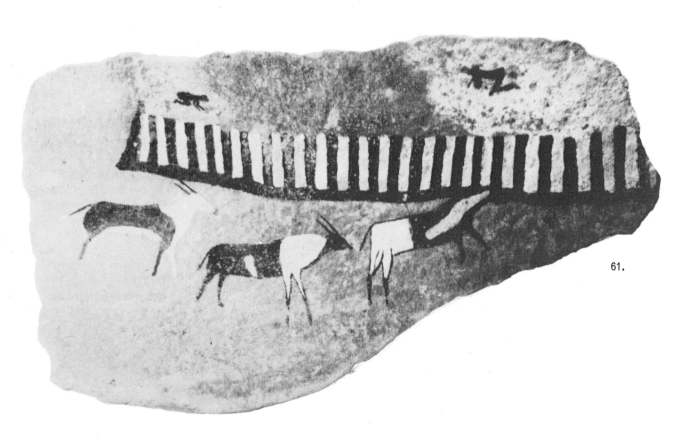

61.

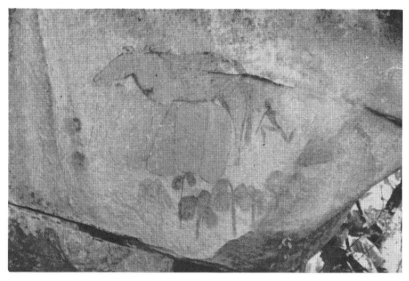

62.

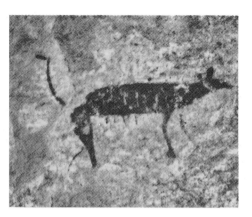

63.

60.
Hunters approach a milling crowd of eland, probably stampeded into a dead-end by beaters. From a crouching position one hunter rises to fling an assegai.
Mountain View, Harrismith.
Hunters 4 to 5 inches.

61.
The slow, suspicious approach of buck to piles of stones built across their path to drinking water. Hunters crouch in ambush. Karee Kloof, Hofmeyr, now in Port Elizabeth Museum. Buck approximately 7 ins. wide.

62.
Sophisticated trap, natural accident or mythology? The legs of a buck are caught between shapes which strongly resemble the granite boulders of Rhodesia. The human figures approaching with caution seem to indicate a deliberate trap but the scene may also be explained as a "rain animal" resting like a cloud on the rocks.
Lake McIlwaine, Salisbury. The painting is unusually large, more than 4 feet across.

63.
Man's companionship with hunting dogs stretches far back into prehistory. This one is portrayed at Reenen's Hoep, Harrismith. 4 ins. long.

D13.
A dead eland with a barbed or feathered javelin protruding from its back. Paintings of upside-down eland are frequently and competently executed.
Mooivlakte, Ladybrand. Eland 6 inches from nose to tail.

D13.

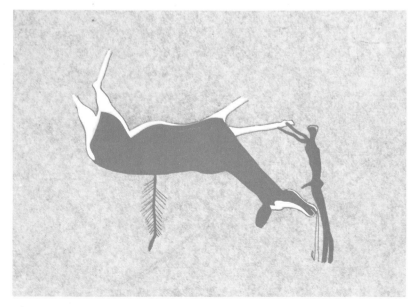

found but there are a number which come close to doing so. There are a number of paintings of dogs in the Harrismith district. An animal among the crowded paintings at Diana's Vow, Rusape, Rhodesia looks like a typical lean hunting dog of the type used by the ancient Egyptians for hunting gazelles—but it is equipped with a pair of slender curving tusks sprouting from its nose which may mean that its significance is mythical—unless the tusks were added by its owner, or the painter.

Whatever the method employed, a successful hunt eventually posed the problem of carrying the dead animal back to the women and children. A small buck could be carried whole but the larger animals needed dismembering. Both processes are illustrated in the paintings. In times of hunger the successful hunter would be sure of a great welcome on his return to the family group. The spontaneous joy of a grateful wife is well illustrated in a tiny painting at Reenen's Hoep, Harrismith.

But in more plentiful times hunting must have been more a pleasure than an arduous duty. That an element of sport or ceremonial had gradually crept in is demonstrated by other paintings where eland are depicted in a bemused state and the men approaching them are dressed in elaborate masks and other regalia. The eland is an animal unusually indifferent to human-beings so that it is not hard to believe that hunting where it was numerous could quickly have risen above the routine necessary for subsistence and have acquired the ceremonial significance of a bull-fight. The apogee of this performance is demonstrated in a painting on the farm

D14.
A tragic end to an encounter with a lioness. The dismembered arm of a fallen hunter has been graphically recorded by the prehistoric artist. Bohwe, Matopos.

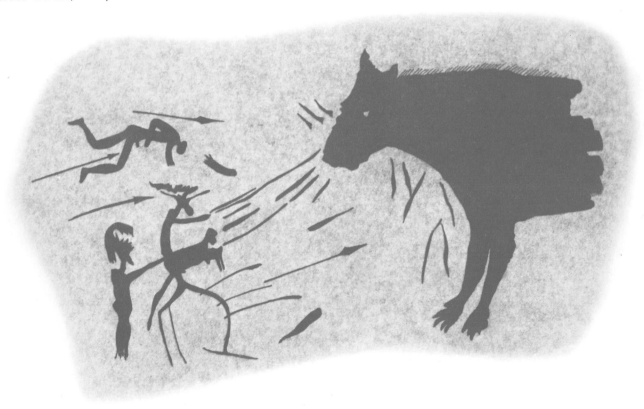

64, 65.
Fisherman's story? Two men are needed to carry the result of their fishing in the Caledon River. There is no denying the dolphin-like appearance and proportions of the creature they carry. Dolphins have been known to swim far up African rivers but the Caledon is approximately 1,700 miles from the mouth of the Orange. There are other paintings of these creatures a few miles away at Caledon's Poort (below) but there they are not associated with human figures so their proportions are not established and it has been suggested that they are fish of the genus mormyrus. Uysberg, Ladybrand. Approximately 6 inches high.

Game Pass in the Natal Drakensberg where one man nonchalantly grasps the tail of an eland while another makes a deep bow to a third, as much as to say "Observe the prowess of my friend, the distinguished matador!"

Not always, however, were things so easy for the prehistoric hunters. Their problems are illustrated with great verve in various paintings of encounters with lions. There is a particularly good example on the farm Coerland in the Eastern Orange Free State. The theme is repeated in Lesotho where the painting of the lion (?) is the immense (for Southern Africa) size of five feet from nose to rump—the tail has disappeared under a calcified rock face. There must have been many occasions when hunters were killed. One is illustrated at Bohwe in the Matopos where the lion has torn an arm off one of the hunters whose body lies prone in front of the animal which is kept at bay by the weapons of his comrades.

Rock paintings involving the maintenance of a food supply are not confined to hunting. There are many fishing scenes. The commonest method of fishing shown in the paintings is using a spear. The spears shown are all very long and thin. Some are used from land but others are used from boats or floats. Historical sources throw little light on the use of such sophisticated techniques but the paintings are clear and the boats most resemble bark canoes similar to that recovered from Vendaland in the Northern Transvaal and moved to the National Museum in Bloemfontein in 1935. In one or two cases a line with a blob on the end protrudes from the boat. It is not clear whether this represents the use of a stone as an anchor or whether it is a form of outrigger or keel.

At Leeuwkraal a hunter wearing a skin cloak and animalhead mask has obviously been fishing despite his mask which seems more appropriate to hunting. Lines to which four fish are attached trail to one side of him.

Some paintings of fish include a line and gorge or primitive fish hook.

An alternative fishing method is illustrated with great economy of line in a small shelter on a farm in the Koue Bokkeveld, North-western Cape. The vertical curve of red ochre appears to represent a dam or weir which has trapped two fish—about to be collected by two approaching figures. No physical traces of weirs have been found in the vicinity but many tidal

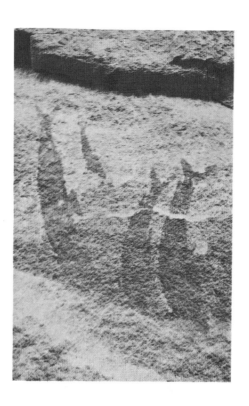

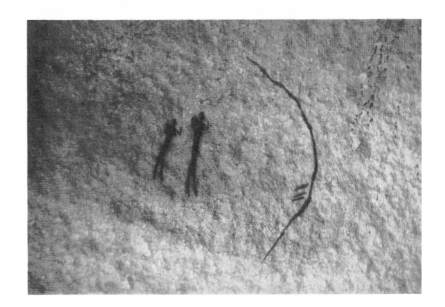

66.
Depicted with a fine economy of line. Two fishermen approach the fish trapped behind a weir. Sandy Spruit, Swartrug, Koue Bokkeveld. 6 inches long.

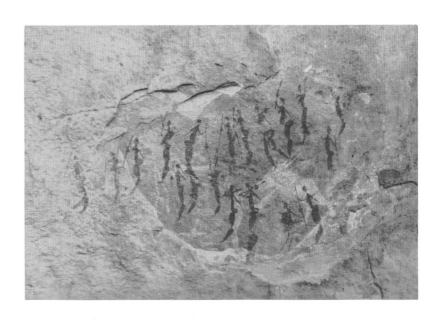

67.
Women with weighted digging sticks starting on the daily search for roots, fruit and insects. The round bored stones with which the sticks were weighted may be seen in most South African museums. Tripolitania, Ladybrand. Each 3 inches high.

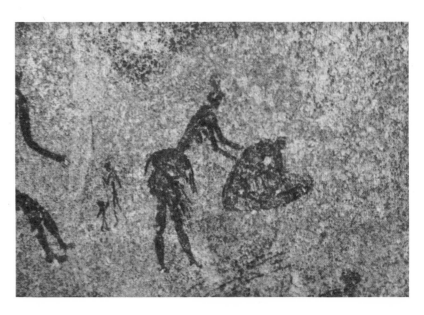

68.
Massage after the efforts of the day. The distinctive head-dress of the woman is to be found in several Rhodesian rock paintings. Silozwane, Matopos. 18 inches tall.

fish traps are known on the South Cape coast.

Two specially successful fishermen at Uysberg near the Caledon River are staggering under the burden of a dolphin (?) as large as themselves. To show that this is not an isolated phenomenon so far from the sea there is a group of similar creatures painted in a small shelter at Caledon's Poort, about fifty miles away.

While the men were hunting or fishing it is apparent from the paintings that the women were out gathering the seeds, nuts, fruits, roots and insects that completed the family diet. For this they needed bags and digging sticks. Both are frequently illustrated. Bags were frequently quite decorative, with a fringe of strips or tails of fur and ostrich eggshell beads sewn to them. Normally the paintings cannot reveal what the bags contain— but there is an exception tucked away on a remote farm in the Maclear district where two tiny buck peep over the edge of a bag. It is to be hoped that they were intended as pets for the children and not destined for the pot. That the artist painted them with such a sympathetic touch seems to indicate that they were due to become friends of the family.

Digging sticks were weighted in the middle with the round bored stones that abound in the museums of Southern Africa. They varied in length as much as did the bows of the men. Usually women carrying such sticks are painted in groups and it seems highly likely that digging for roots was a very sociable business. There are only a few known paintings of roots, the best of which is at Mrewa, Rhodesia. It corresponds almost exactly to a plate in *Bushman Folklore* by Bleek and Lloyd published in 1911, which illustrates the most popular root food of the Cape Bushmen.

When the hunting, fishing and collecting activity was over for the day there were probably some aching backs. A return to Silozwane reveals a picture of a woman massaging the back of, presumably, her husband— a fitting conclusion to the exertions of the day, when the next meal had been assured.

D15.
The successful hunter with three buck to his credit makes a gesture of pride as he is greeted by his wife. Reenen's Hoep, Harrismith, 5 ins. tall.

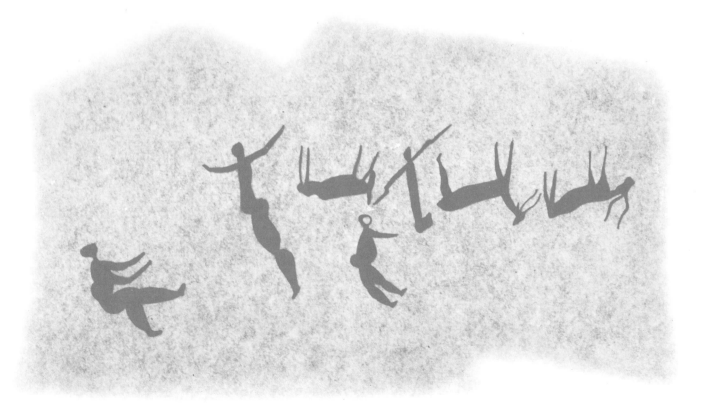

69.
Root collected for food. Mrewa, Mashonaland.

70.
A collection of digging sticks. A method of wedging the spherical stone weights on to the centre of the sticks is clearly indicated. Mount Tyndale, Maclear. 6 inches long.

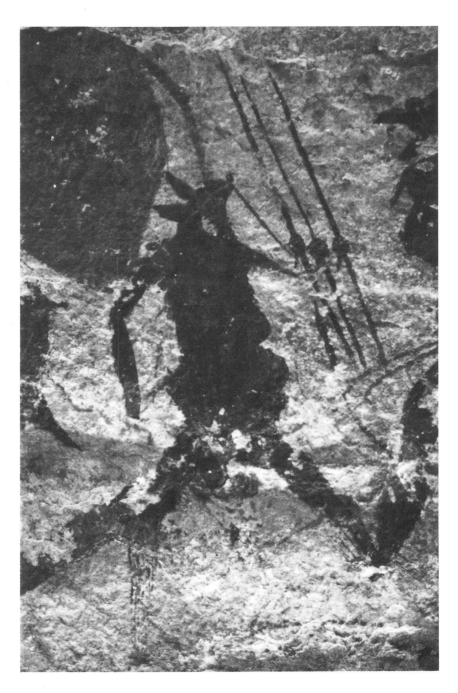

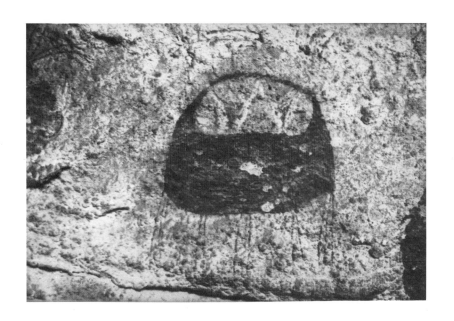

71.
In the bag! Two orphaned buck to be taken home as pets for the children — or to help fill the pot. Protea Hills, Maclear. 4 inches wide.

72.
Among the equipment of this group of figures is a bolas.
Near Mhlanlandhlela, Matopos.

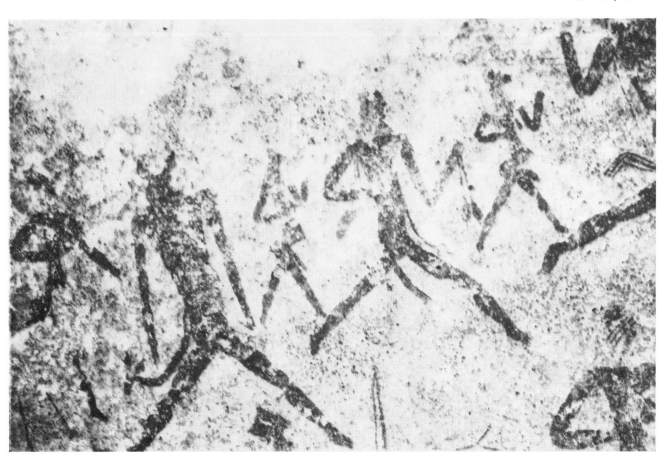

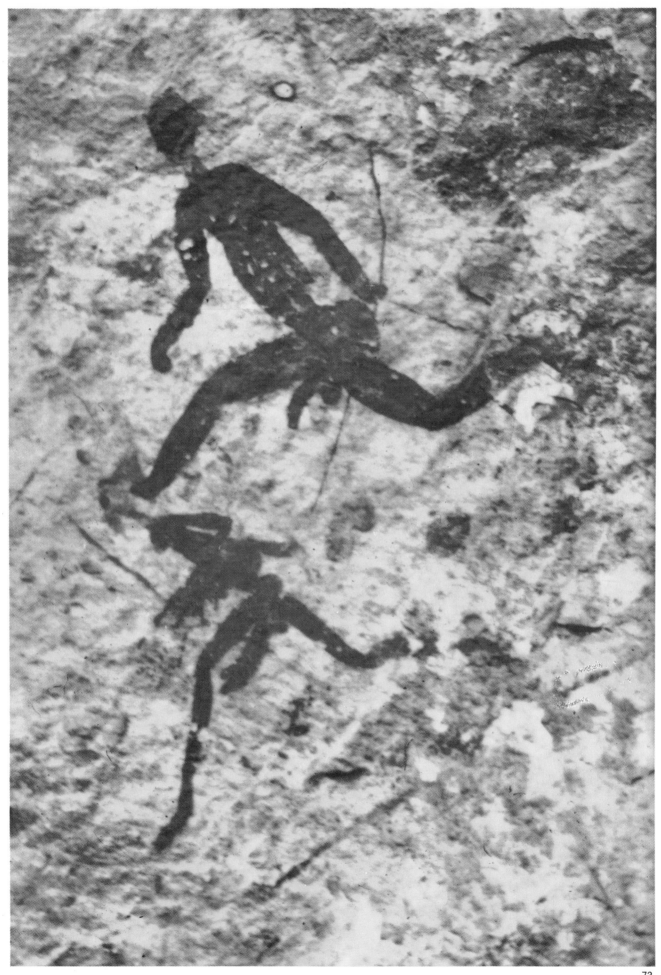

73.

CHAPTER 4

People

D16.
Two women, each with a baby strapped to her back so leaving her hands free to carry a weighted digging stick used to dig for edible roots.
Eland Cave, Cathedral Peak area.

South Africa's past has been described as the greatest silence in history and indeed this could well have been true were it not for the paintings which remain on the walls of so many rock shelters. Without them we could have only a sketchy and inaccurate account of the existence of a race of people who were at one time the country's principal inhabitants. Our only direct knowledge of them would have come from the writings of early explorers and hunters whose opinions and descriptions of the Bushmen tell of little but their loathing and contempt for them. In 1836, during the early stages of his famous hunting expedition, Captain Sir William Cornwallis Harris tells us of his first encounter with the Bushmen.

"We had now fairly quitted civilisation, and were entering upon a sterile inhospitable region, sparingly inhabited by Bushmen—the remnant of the Hottentot hordes, and the wild aborigines of the country—who, gradually receding before the encroachments of the European colonists, have long since sought refuge in the pathless desert. Unblessed amongst the nations of the earth, the hand of these wandering outcasts is against every man, and every man's hand is against them. Existing precariously

73.
This close up of two running men from the lion hunt at Coerland (52. Page 44) shows how much detail is included in many rock paintings of people. The lower figure indicates that circumcision was practised amongst some tribes. His companion is shown with an arrow notched to his bow ready for instant action.
Coerland, Fouriesberg. 4 inches high.

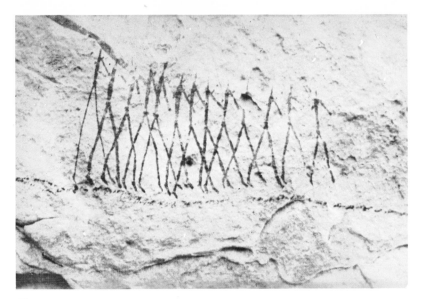

74.

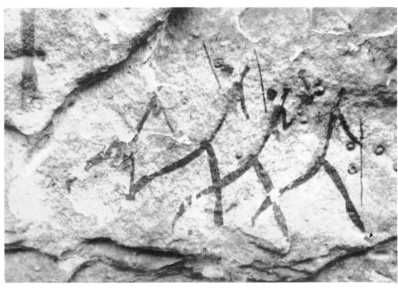

75.

76.

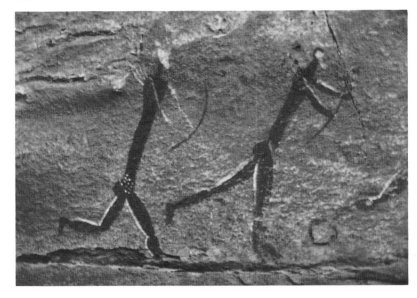

74, 75, 76.
Most people's impression of Bushman paintings is that they are essentially a collection of stick-like figures with blobs for heads. Although this certainly describes the simple figures in 74 the design formed by the criss-cross pattern of the legs is most striking. Whilst this technique is not uncommon it is presented with varying degrees of sophistication as can be seen from 75 and 76.

Arrarat 1. Harrismith.

Arrarat 1. Harrismith.

Eland Cave. Umhlwasine Valley, Natal Drakensberg.

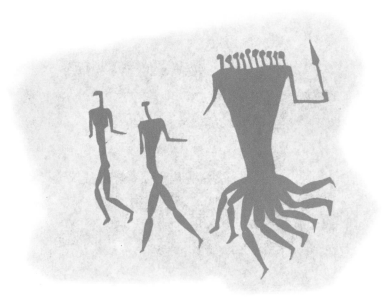

D17.
A number of people drawn as if
sharing one common body.
Swallewkranz, Tarkastad. 5 ins.

77.
A man chopping down a tree with
an axe.
Mavara, Rhodesia. 9 inches.

from day to day—heedless of futurity, and forgetful of the past—without
either laws, arts or religion—only a faint glimmering ray of instinct
guides their benighted paths. Depending for subsistence upon the pro-
duce of the chase, or the spontaneous gifts of nature, they share the
wilderness with beasts of prey, and are but one grade higher in the scale
of existence".

Like most of his fellow explorers, Sir William had confused the Bushman/
Hottentot relationship, and his comments and observations followed the
accepted patterns. Fortunately there were others such as the Swedish
naturalist, Andrew Sparrman, who toured the Cape interior from March
1775 to April 1776. His book is regarded as being the most trustworthy
account of the Cape Colony and the people living there to have been
published before the beginning of the 19th century. However, the real
champion of the Bushman was undoubtedly George W. Stow, a geologist
who, during his extensive travels through the Cape Province and Orange
Free State, made copies of hundreds of rock paintings. In his book, *The
Natave Races of South Africa*, he set out to describe for the first time their
way of life, customs and superstitions.

Stow was one of the first to realise that the rock paintings are a record
of their way of life— a series of pages from the history book of South Africa.
So well do they highlight scenes from everyday life, that it soon became
apparent to Stow that, contrary to the beliefs of Cornwallis Harris and
other explorers, the Bushmen's existence was in fact regulated by customs,
laws and religion. It followed from this that they led a far more sophisti-
cated existence than had been realised.

So vivid is the apparent realism of many of the figures and scenes they
portray that at one time a virtual competition seemed to exist between

D18.
A group of women showing marked steatopygia.
Eland Cave. Cathedral Peak Area.

78.
Undoubtedly the local dandy with his painted face, body decorations and bracelets. Like many other men, he wears a white stick indicating infibulation.
Stirling Chase, Tarkastad. 5 inches.

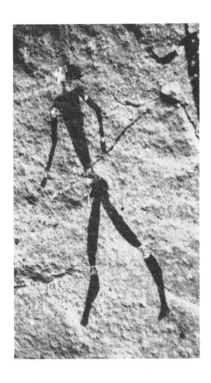

some researchers to see who could outdo who with the improbability of their identifications. So far-flung were the imagined countries of origin of some of the people represented, that there must have been a thriving tourist industry even in those days! Excellent comment is made by Willcox on the misguided interpretation of foreigners in South African rock paintings. Frivolous comparisons where no comparisons can possibly exist do nothing to add to our meagre fund of knowledge. They merely emphasise the enormity of the opportunity long since cast away, for an extensive study of a people whose rudimentary culture on the one hand conflicted so violently with their outstanding artistic abilities on the other. Today the customs and environmental conditions of the living Bushmen of the Kalahari desert are so different from those of the ancestral Bushmen that they give us no key with which to unlock the mysteries of the past.

It must have required a great deal of courage to hunt during the Early Stone Age when wild beasts had to be killed with little more than sticks and stones. Without a successful hunt, or without finding an animal which had died from natural causes, the tribe was destined to perish from starvation within a few weeks. What better conditions than these could have existed in which to encourage the development of steatopygia. When meat became available the members of the tribe would gorge themselves near to bursting. They would then rely upon their own reserves of fat until the next meal became available. Exaggeration of the buttocks, which is characteristic of steatopygia, is easily recognisable in such figurines as the woman from Willendorf, Austria, and the low relief of the woman

79.

80.

81.

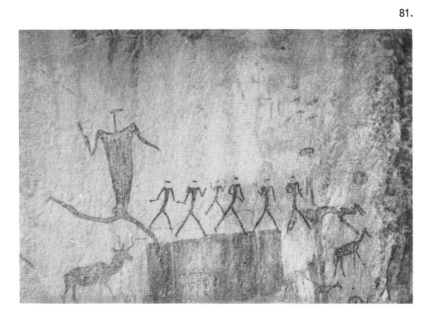

79, 80, 81.
A common way of indicating that a figure is running was to draw the legs in the most incredible horizontal position, like a champion hurdler. Then, if the artist wanted to indicate more than one person, in order to create an illusion of depth, he sometimes drew them slightly off-set from each other.
The example from Rhodesia is rather more crudely drawn, but still creates the same impression. It is doubtful whether the kudu is in anyway connected with this scene. It was probably painted by another artist at a different time.
Reenen's Hoep, Harrismith. 4 ins.
Makuini, Lesotho. 9 inches.
Ndanda School, Rhodesia.

61

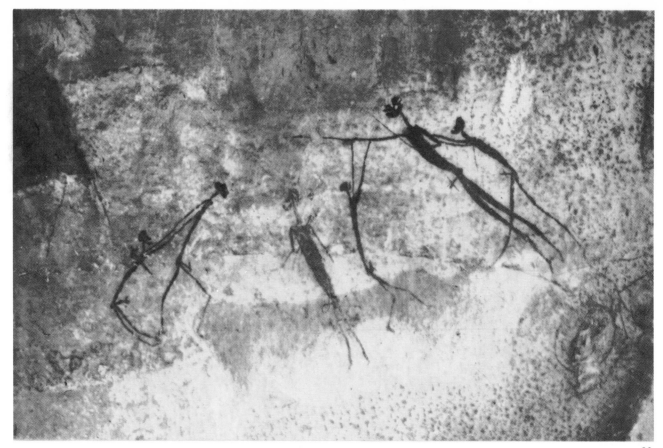

82.

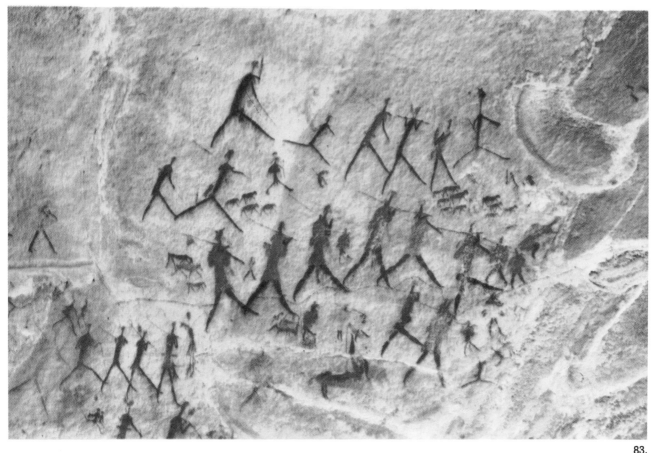

83.

84.

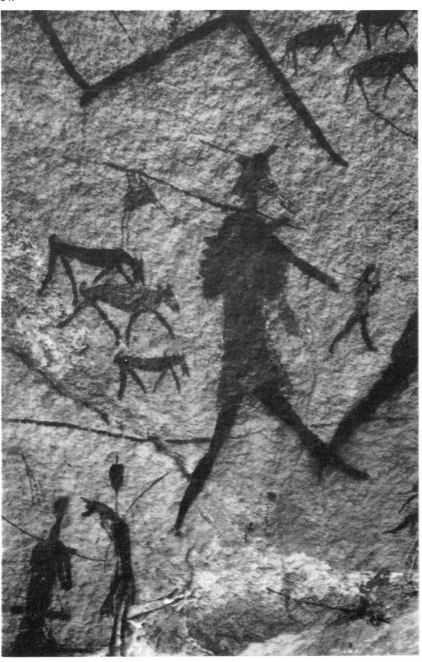

82.
Here are the same simple stick-like figures as in 74 but this time they are grouped together to form a more meaningful composition. In fact one of high drama as people try to separate two arguing men who seem intent upon settling their differences by more active means. Here too are other examples of infibulation. Note also how the figures have been superimposed over a shaded eland, now very faded.
Grootvlei, Harrismith. 14 inches wide.

83.
There is quite a variety of styles in this scene. Some of the people are drawn in a simple stick-like form whilst others, particularly those in the centre, are shown much more realistically. As if to show off his versatility, the artist has tried to lend depth to his composition by drawing some figures smaller than others. He has certainly tried to be descriptive as many of the people are shown with long sticks over their shoulders. There are carrying bags, and dogs and a long wavy line has been drawn at the feet of the central group. This may be a contour or game path along which they are walking.
Delila 4, Jamestown. Main figures average 8 inches high.

84.
A close-up of one figure from 83. This man is a veritable Dick Whittington as he strides along with his pack hanging from a stick carried over his shoulder and with his dogs following behind. Of interest is the fact that the same colour has been used throughout. Detail and contrast have been obtained by simply varying the tone.
Delila 4. Jamestown. 9 inches high.

85.

By its very simplicity this figure contrasts violently with some of the others seen in this chapter, but what it lacks in detail it makes up in humour. As he bends over about to flay the soft underbelly of the dead eland, this man drools at the mouth and his toes curl up at the very thought of the fine feast to come. Right next to him is another man (86). The significance of the long tailed frock coat and the spectacles is not known! A glance at the portions of the eland in these two pictures indicates how skilfully the artists merged one colour into another to achieve both shading and modelling.

Pelendaba Location, Herschel. 4 inches and 5 inches.

87.

It is not possible to determine the sex of either of these figures. Both have skirts and are either wearing baboon-like masks or have been drawn with stylised faces. Of particular interest are the decorations worn about the knees of the front figure since in South Africa these are more commonly associated with paintings of Bantu. This may indicate that the people illustrated here are not Bushmen.

Chisewe, Rhodesia. 12 inches high.

85.

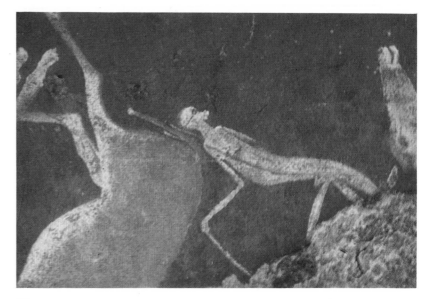

86.

87.

holding a bison horn from Laussel, France. However, controversy still exists as to whether this is in fact a testimony to the anthropological characteristics of the women at that time or a representation of a fertility cult.

Similar examples are quite common in the rock paintings of Southern Africa, but here the exaggerated buttocks are accepted as being literal since steatopygia is found amongst several African tribes. It is most marked in both the Hottentot and Bush people. The localised accumulation of fat over the thighs and buttocks acts as a food reserve in much the same way as the camel's hump or the sheep's fat tail. It was also considered by her less fortunate sisters as a sign of beauty. As a further fringe benefit it would also have served as a useful and readily available built-in cushion!

How envious would have been the bustle-wearing ladies of the Edwardian era. To prove that custom dies hard, some African women still wear a roll of cloth or hair under the skirt of their traditional costume so that a large protusion is formed at the back.

In his book *"Travels and adventures in Southern Africa"* Thompson gives us a graphic word picture of steatopygia:—

"The projection of the posterior in one subject measured 5½ ins. from the line touching the spine. This protruberance consisted entirely of fat and when the woman walked it exhibited the most ridiculous appearance imaginable, every step being accompanied with a quivering and tremulous motion as if two masses of jelly had been attached behind her."

Again, like her Gravettian forebears of Europe who lived between 20,000 and 25,000 B.C., the women in our parietal art are often shown with excessively pendulous breasts, drooping like sacks to about waist level. As with many present day African women, this could have been caused by prolonged natural feeding of children to the age of two years and more.

Where men are concerned, the male organ is invariable shown in a semierect condition. This equally curious phenomenon is characteristic of Bushmen and is a condition where the penis rests on the scrotum so preventing it from being pendulous as is the case with other African tribes. Even so, it is often further exaggerated in the paintings and is in many cases illustrated as if pierced with a piece of stick, a hooked plug of some sort, or a porcupine quill.

Examples of the practice will be found in many of the illustrations in this book but none will provide a reason for it. We can only assume that it was intended as a form of adornment in the same manner as some tribes pierce the fleshy part of the nose, lips or ears. In such cases the piercing is started at an early age and the hole is gradually made bigger by inserting larger and larger plugs. A glimmer of a clue may come from excavations

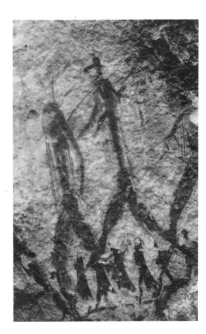

88.

89.

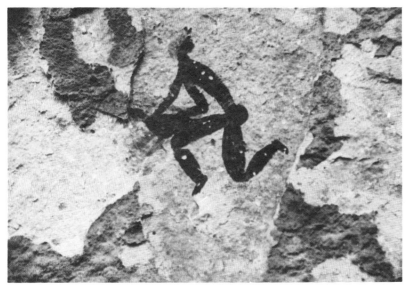

88.
Two of a group of men each carrying bows and quivers full of arrows. They have highly conventionalized heads and long strings hang from their shoulders.
Procession Shelter, Cathedral Peak

89.
At first sight this man seems to be wearing a lace bonnet with a bow in the front. He certainly strikes an elegant pose as he kneels on one knee and looks back over his shoulder. There are signs of body decoration about the waist and upper arms.
Botha's Shelter, Cathedral Peak.

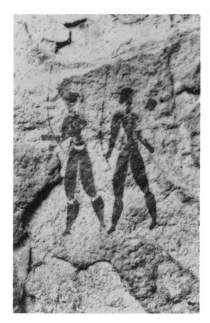

90.

on Robberg near Plettenberg Bay carried out by Ray Inskeep of the University of Cape Town. A skeleton of an eleven year old child of Bushmanoid type was discovered and was subsequently dated by the University of Louvain to approximately 700 BC. Between the thighbones of the skeleton a slender bone "skewer" was discovered.

If its purpose was to prevent copulation in compliance with some tribal taboo, then this system of mutilation could be called infibulation. This is generally used as the descriptive term, despite the fact that the practice is virtually unknown amongst men in Africa-though it has been followed amongst the women of some tribes. The reason for the mutilation is completely unknown and there is no record of it ever having been seen by early explorers. In fact, were it not for the widespread pictorial evidence from the Cape right through to Mashonaland, we would have no knowledge of the practice at all. This gives rise to a counter argument as to whether it could have been a conventionalised illustration of a fertility cult along the same lines as one of the explanations put forward to explain the exaggerated sexual features of the human statuettes of the Gravettian cultures.

It was in the presentation of people that the Bushman artist excelled in the technique of composition. He loved showing them doing things—dancing, running, walking. Each figure had a part to play and something to contribute to the overall activity. Strangely enough, he was not over fond of painting stories of fighting or hunting. There are of course a few such scenes, most of which are well known, but these are the exceptions rather than the rule. We are at a loss to try and explain why such group activities were so seldom illustrated by comparison with others such as dancing.

90.
Two men with bows. Note the headdress and mask of the one on the left.
Fullerton 2, Harrismith.

91.
This is probably one of the finest examples of rock paintings of human figures ever found. Although the faces are stylised everything else has been shown in the same detail and with the same degree of accuracy as is usually associated with the finest paintings of animals, as for instance the eland head on the left. Considering the texture of the rock one can only wonder at the quality of the paint, the texture of the brushes and the infinite patience required to achieve the fine lines and delicate shading of this study. (See also 101.)
Mount Tyndale, Maclear.

91.

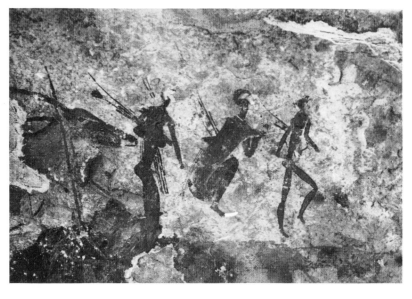

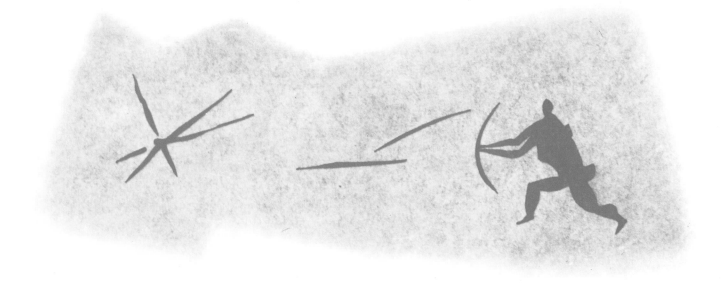

D19. Target Practice

Except in a few cases—and most of these are to be found in Rhodesia—the actors alone are made to tell the story as scenery was seldom included. It was considered to be superfluous and was therefore ignored indicating that, unlike the Rhodesian artists (as shown in Chapter 10) the South African painters never realised that scenery could be used to provide a background against which the figures could be viewed. The illusion of depth was either obtained by overlapping, or as at Delila, it was created by some figures being drawn smaller than others. It will be noted then, that paintings involving human beings, were invariably stripped of any detail which was not meaningful to the story. For example, we know of

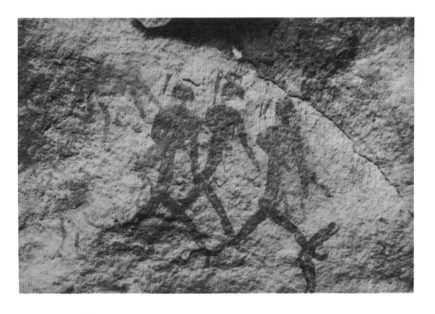

92.
Three striding figures each of whom is either wearing a shaggy fur cap with dangling streamers or is sadly in need of a hair cut! The central figure has a tiny animal fixed to the top of his head-dress as a decoration. Here again are examples of infibulation. They have been drawn over a troop of baboons Langkloof 2, Bethlehem. 5 inches high.

67

95.

This is a closer view of some figures in a previous illustration (83) included here for the reason that a detailed study of individuals in a mass of figures is usually very rewarding. Each of these women wears a mini-kaross and two of them carry babies on their backs. One wears a pony-tail headdress identical to that of her child. Delila 4, Jamestown.

93.

Drawn with extraordinary poise, this man struts along proudly displaying the bands of bead decorations around his waist, wrist, knee and ankles. The other marks on the rock are the remains of larger paintings.
Mount Tyndale, Maclear. 2 inches.

94.

Unfortunately the legs of this man have disappeared due to gradual crumbling of the rock face but what is left is a remarkable record of his choice of clothing and head-dress. Note also the way in which his face has been painted white and how a small smudge has been wiped away from under his nose creating the appearance of a moustache.
Wide Valley, Maclear. 4 inches.

no paintings where any figure, whether human or animal, casts a shadow. It is often considered that the reason for this simplification of the human figures was an all-out effort to purposely distort or stylise in order to avoid the influences of sympathetic magic. Whether this was so is debatable and in fact, we maintain this was not the case. Admittedly there were certain accepted conventions whereby the face and head was shown as a blob or as a large-snouted mask but there are also many cases where the features are remarkably naturalistic (See chapter 6).

Typical of the extreme cases of simplification are the sticklike marching figures from Ararat, whose over-lapping legs form a geometric pattern along the rock face. Another example is the two running men from the Cave of Eland, also in the Harrismith area. Shown slightly offset one from the other and with legs in an impossibly horizontal position, this vignette is full of movement and purpose. The same theme repeats itself at Makuini in Lesotho, but in this case, although the addition of far more detail makes the group more sophisticated, the feeling of humour is lost.

It was by no means uncommon for an artist to use the work of another as a base for his own expression, as for example at Pelendaba Location, where a man is shown bending forward over the upturned belly of a dead eland. His toes are gripped and he drools at the mouth as if in ecstacies of anticipation of the feast to come. It seems unlikely that the person who drew this simple white monochrome figure had the necessary skill to achieve the fine shading of the belly and back legs of the eland and yet the sense of humour and the depth of meaning in the cartoon is quite outstanding.

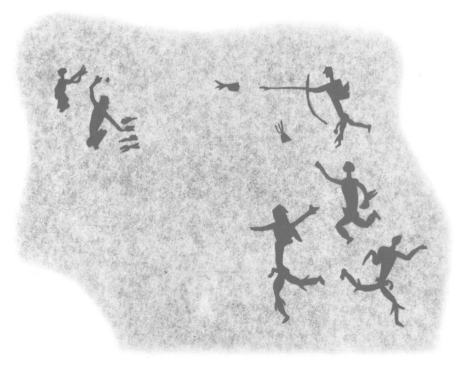

D20. Clay-pigeon shooting in the Late Stone Age.
Epiphany Mission.

93.

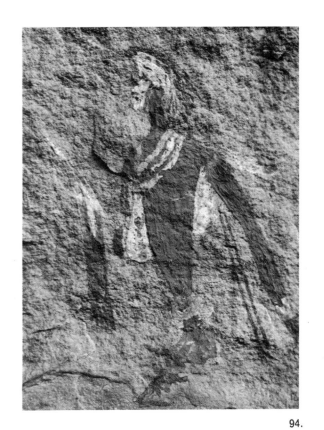

94.

95.

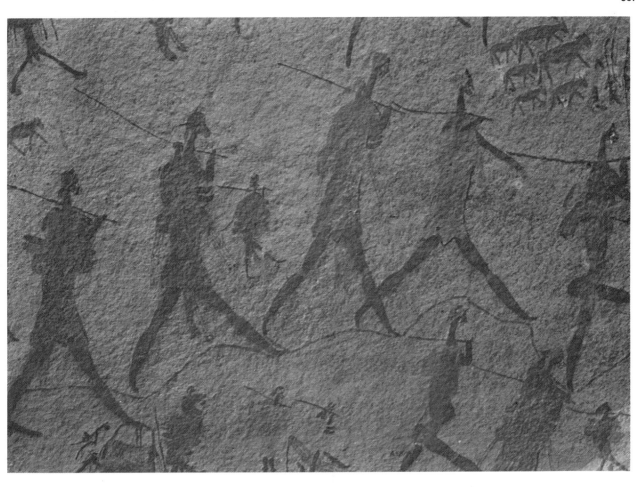

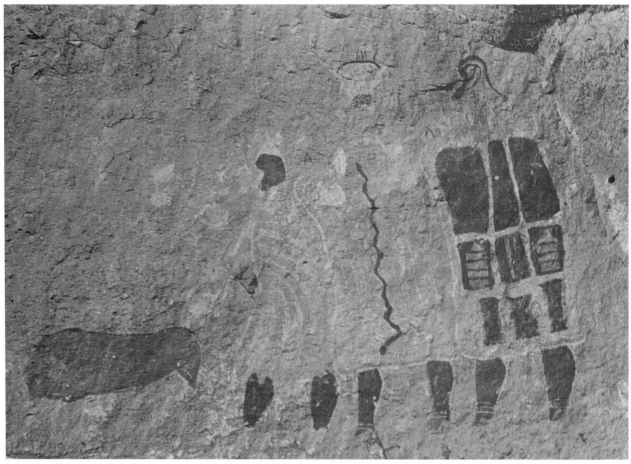

96,

96, 97.

This group is an outstanding example of the full length voluminous kaross which would probably have been worn during the cold winter months. The close-up detail taken of the right hand figure shows how skins have been sewn on top of one another to create a pattern. Thin streamers can also be seen hanging from the bottom of the kaross. Upper Ncibidwane, Natal Drakensberg.

98.

The central figure in this group has a long feather held against his forehead by a thin band. He also wears a long kaross gathered tightly around him and he is either wearing ankle length boots or his legs are painted red. To his left is a man sporting what appears to be long Wellington boots. Whatever they may be they are patterned with a chevron design in fine white and red lines.
Klipkraal 2, Dordrecht. Approx. 9 inches high.

99.

A warmly dressed person whose cloak is almost ankle length, and who is wearing long strings of beads. The anklets may be inflated animal bladders or pouches made from animal skin then filled with seeds so that they rattle when walking and especially when dancing.
Rannatlaile's 1, Lesotho. 5 inches high.

100.

Although each of these four men carries a bow they are so highly ornamented that it seems more likely they are on their way to a ceremony rather than a hunt. The veil of the first man and the elaborate adornments of the others are probably made from hundreds of carefully prepared ostrich shell beads threaded onto animal sinew.
Kranses, Estcourt, Natal Drakensberg.

97.

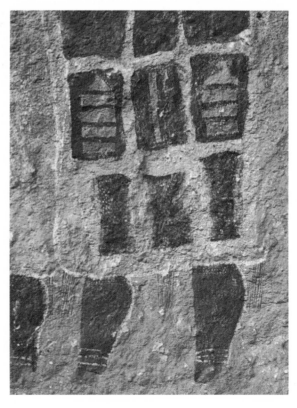

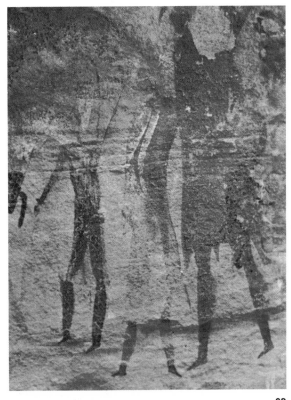

98.

99.

100.

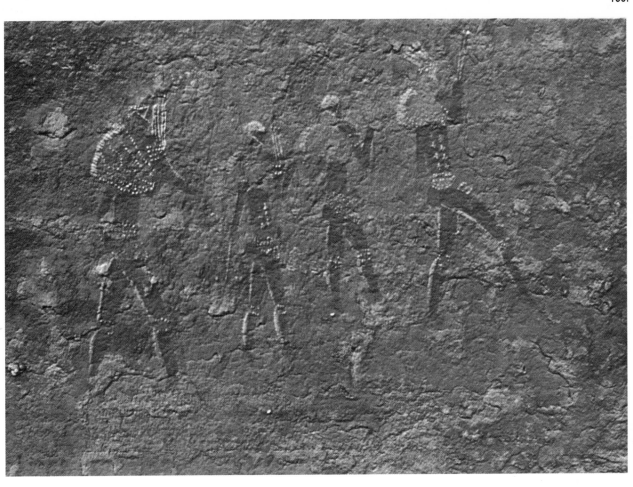

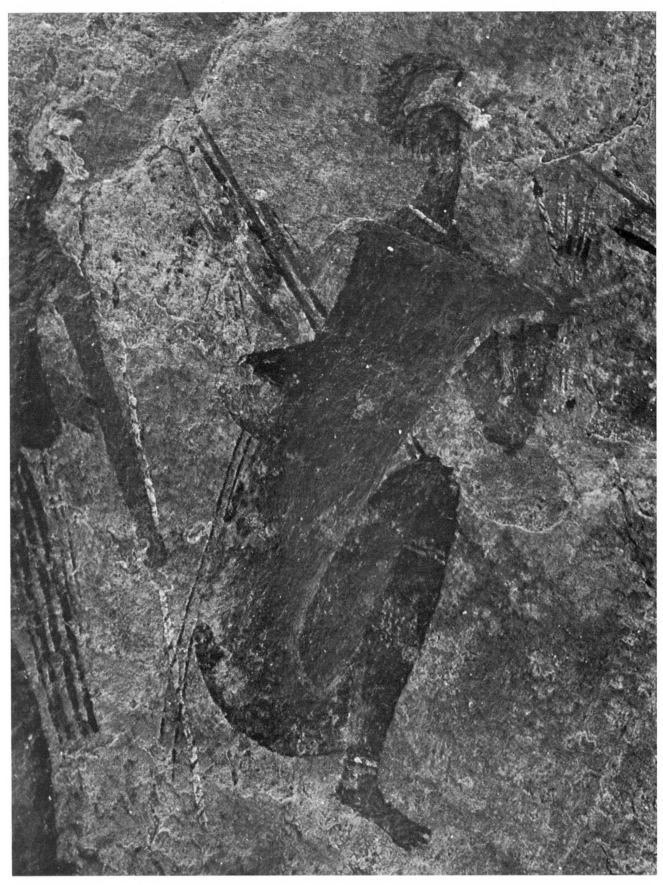

101.

CHAPTER 5

Clothing

102.
A well-dressed man wearing an immaculately cut skin cloak, the front of which is partially open to allow freedom of movement. He also has a head band, necklace and wide bead ornaments around his knees.
Ikanti Mountain. Himeville.

As a means of ironic or satirical commentary about the life he leads, man has for thousands of years practiced "graffiti", the art of anonymous wall writing. Where this has been backed up by more authorised writings, archaeologists and historians have been able to deduce a clear picture of the way of life of many ancient civilisations such as Egypt, Greece and Crete. Although they had no alphabet, no knowledge of pictographs and certainly no knowledge of the written word, the ancestral Bushmen were such enthusiastic graffitists that their wall paintings provide a means by which students can piece together some of the scattered remains of a gigantic jig-saw puzzle, the picture on which illustrates many characteristics of their culture. We know for instance that the Bush people wore beads and small decorations because they are occasionally found in the dust and debris of the living floor of their shelters. But this does not tell us how they were worn, or who wore them—the man, woman or both. What of their clothing, any remains of which rotted away long years ago? Although throughout most of the year the South African climate is warm

101.
Although this is a repetition in detail of the central figure in illustration 91, it provides a perfect example of the heights to which rock art rose as a means of illustrating some of the characteristics of the indigenous people of the country. If this had been a photograph it could hardly have described in more faithful detail the type of kaross and decorations worn by this man and the hunting equipment he carries. The overall effect is dramatised even further by the artist's immaculate control of colour and shading.
Mount Tyndale, Maclear.

103.
These highly stylised figures show the favourite places for wearing decorations — knees, waist, wrists, upper arms and neck. The shading of the legs is unusual in that the colours are reversed, unless of course, it is intended to convey that parts of the body were deliberately covered in white pigment.
Ndedema Junction, Cathedral Peak.

and pleasant, some form of cover is often required. What shape did it take? Was it worn long or short? Was it plain or decorated? Once again we must study our stone encyclopedia.

Judging from the fact that we find naked and clothed figures in the same group, and that the clothed ones are by no means uniformly dressed, we can conclude that different individuals had different ideas on fashion. Undoubtedly the means for catering for this fashion-consciousness was quite highly developed since there was a need for garments both as purely functional items and as a means of decoration for dances and ceremonies or as a disguise during the hunt. As most costumes were made from animal skins, they must have known how to make them soft and supple. The first stage in the process was to peg out the skin and then carefully scrape it with a stone implement specially prepared for the purpose. After this, the texture was loosened either by tanning with the juice of plants or by constant rubbing and stretching. Late Stone Age tailors must have also known how to join small skins together with sinews or long thin strips of leather. Such thongs may have been made additionally pliable by repeated chewing. The technique of sewing was certainly known to them as there are paintings showing small skins appliqued on to long karosses as a means of decoration and bone awls used for piercing skins have been found in occupation deposits.

Long karosses would have been worn during the cold weather and undoubtedly served the dual purpose of a warm cloak by day and an equally warm cover by night. There are numerous examples of men in groups of two or more sitting as if in earnest conversation with their cloaks drawn tightly around them. Some are plain, others are decorated to varying extents and some give the impression that the fur is to the inside. Between the full length garment and the short shoulder cloak there was a style to suit the available skin. Karosses were worn to the knee, thigh or simply to waist level; they were worn as a wrap-around or could be opened and thrown casually over the shoulder as the weather demanded; they could consist of a plain piece of skin or could be decorated with long dangling filaments. A popular piece of men's clothing consisted of a small apron,

D21.
This man comes from the same group as 103. His whole body is covered by an elaborate striped decoration. He is either infibulated or he wears a tasselled penis sheath.

75

104.

Clothing illustrated in rock paintings cannot always be described as being functional in design.
Rydal Mount, Harrismith. 6 inches.

105.

The two karossed figures seated facing each other are unusual for South African rock paintings in that the artist has relied entirely upon an outline. This abstract method of expression is in contrast with the other three human figures in this same illustration and conflicts violently with the minute detail of the naturalistic style of 101. The head in the bottom left takes stylisation to its ultimate conclusion.
Klipkraal, Dordrecht.

106.

These long karosses were obviously designed for cold conditions. Most interesting is the fact that each of the persons carries a bag on his left arm. The conventionalised heads have all but disappeared, probably because they were done in white which is the least durable colour. Long streamers hang from the bottom of the kaross and bag of the left hand figure.
Kraal Rock, Natal Drakensberg. 6 inches high.

D22.

It seems that if no rock face was available the Bushmen painted upon themselves. This man's body was first covered with a white pigment and then the small design was either painted on or was created by removing the pigment so that the natural colour of the skin showed through.
Junction Farm, Cathcart.

107.

The fact that the animal head masks worn by these two men have all but faded away is of no consequence on this occasion. The focal point is their clothing. Drawn entirely from the back we get a vivid impression of the shape of their two-piece costume, each section of which is fringed around the edge.
Tsoelike River, Lesotho.

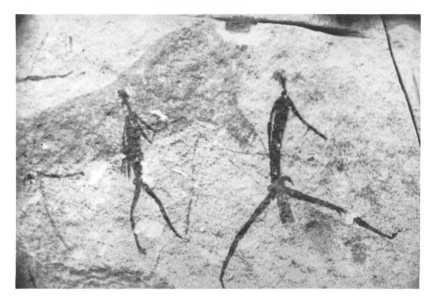

104.

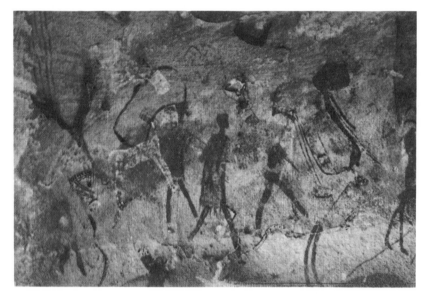

105.

106.

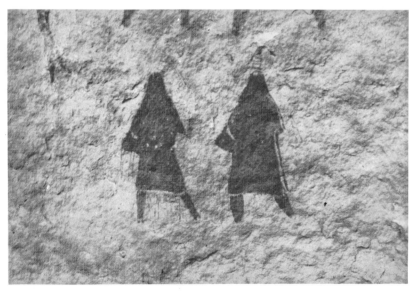

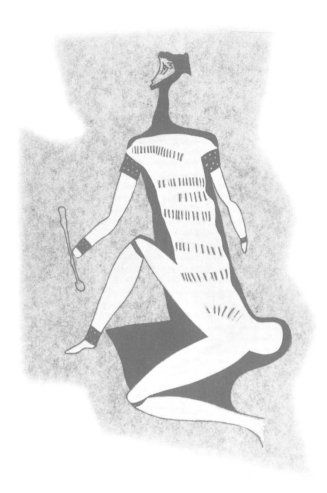

D22.

or loin cloth, the edges of which were tucked under a belt tied around the waist. The advantage of this lay mainly in the fact that there was nothing to get in the way when running in the hunt. As a covering it was inadequate, to say the least.

By comparison with the men who are represented in all manner of attitudes, performing all manner of deeds, women are seldom shown unless going about their accustomed task of gathering edible roots and tubers with their digging sticks balanced across their shoulders or standing around a group of dancers singing and clapping to provide the rhythmic beat. Even then their dress shows little versatility and usually consists of little more than either a fore and hind kaross, tied about the waist in the manner of short aprons or a skirt of length varying from thigh to calf level. This infrequent occurrence of the female coupled with a lack of detail of her dress and decoration, conflicts so strongly with the word pictures of early travellers that this may be an example of the convention that men were the masters and the women their lowly minions—even after accepting the fact that many of the activities illustrated are those from which women would be naturally excluded.

The use of beads as a means of currency is centuries old. In the 14th Century they were used by Portuguese traders as payment for gold and ivory and for the puchase of food. Their use as a means of decoration was, and still is, widespread throughout Southern Africa. Although early travellers described in detail the decorations used by the women, if the paintings are anything to go by the most lavishly decorated were the men. They are often shown with strings of bead necklaces, bracelets, anklets or waist bands and sometimes with other strings entwined in their hair and hanging over the face as a veil. Excavations of burial sites support the

107.

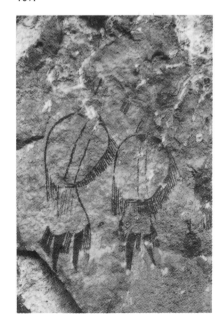

pictorial evidence that other ornaments were used as well, such as animal teeth and pendants of stones, shell, bone and ivory. When manufactured from ostrich shell, beads were a positive work of art and making them up in long strings must have been a painstaking operation. Chipped into irregular shaped pieces, then drilled with a central hole, they were strung onto a sinew or string made of twisted hair and finally brought to an almost perfect circular shape of about ½ in. in diameter by being dragged backwards and forwards along a groove in a sandstone block. Illustrations of these beads are relative common, suggesting a wide distribution of the ostrich, yet the bird itself was seldom painted. This is made all the more curious by the fact that ostrich feathers are frequently shown as headdresses.

There is plenty of evidence of their love of body painting as a means of personal adornment to the extent that one is almost forced to the conclusion that when no rock face was conveniently available, they painted on themselves instead. There are many examples of men with their bodies decorated by coloured lines sometimes drawn straight and at others drawn

108.

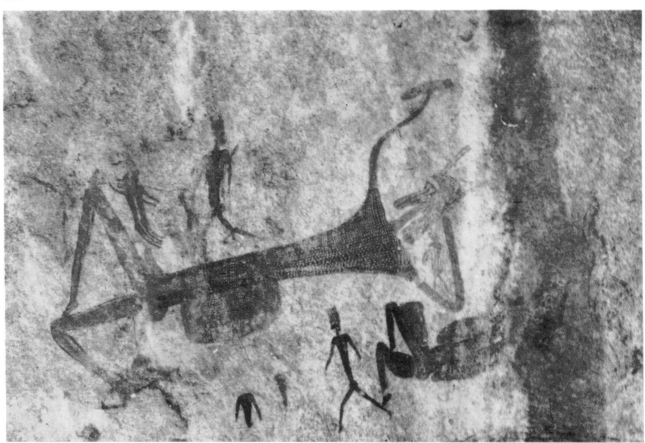

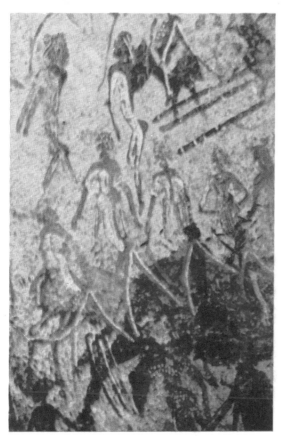

109.

108, 109, 110.
Scenes from the famous Diana's Vow paintings—Rusape, Rhodesia. This is usually described as a burial ceremony, the "king" having been wrapped in bandages ready for interment. To us this explanation seems a little unlikely as the pattern of dotted lines is more representative of a tight-fitting costume. Further, to judge by the relaxed attitude of the "body" which has one hand propping up its head, and the other holding an object remarkably like a drinking vessel, it is far more reminiscent of someone enjoying a glorious beer drink. The calabashes (illus. 110) may well hold a reserve supply. In the close-up shots on page 79 (illus. 109) some of the attendant figures have painted bodies, elaborate head-dresses and decorations woven into their hair. Most of them wear penis sheaths decorated with beads. The "king" himself has a more dressy affair with a long dangling tassel.

110.

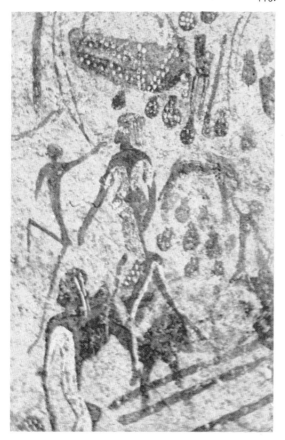

111.

There is nothing unusual about this cloak except perhaps the long strings hanging down between the man's legs. What makes it a remarkable painting is the head-dress, the white face, the ankle and waist decorations and of course the wonderfully described squatting posture and the detail of the hands and fingers. (See also illus. 170).
Wide Valley, Maclear. 3 inches.

112.

Most of the figures in this scene have been obliterated by calcification of the rock surface. Just enough detail is left to give us an impression of the fanciful costumes which were worn during this ceremony.
War Trail, Barkly East.

113.

At first sight this person appears to be wearing a natty one-piece ensemble made up of a long kaross and a tight-fitting hood. In fact the hood is a separate skin, the back portion of which shows the hind quarters of a small animal Of interest too is the white front of the kaross and the tasselled bag But particularly so is the positioning of the eye and mouth and the suggestion of a facial profile—intriguingly European in appearance
Mount Tyndale, Maclear. 6 inches

111.

112.

113.

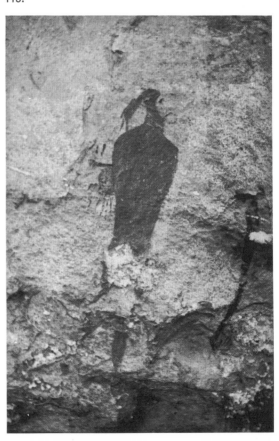

Examples of seated human figures wearing karosses.

114.
Kranses, Estcourt, Natal Drakensberg.

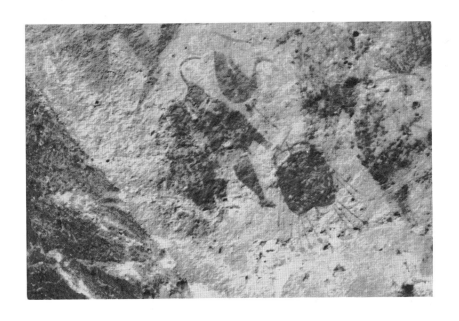

115.
Main Cave, Giant's Castle.

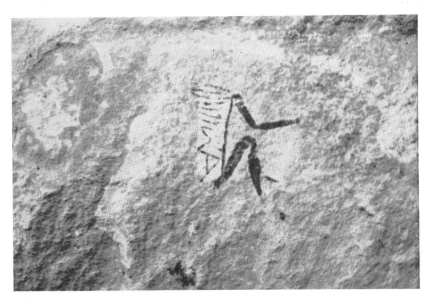

116.
Flauwkraal, Dordrecht.

117.

By contrast with other examples this illustration of a kaross is absurdly simple, but nontheless expressive.
Makuini 2, Lesotho. 13 inches.

118.

A group of people with highly conventionalised heads, some of whom wear what can best be described as fur-lined cloaks, Halestone, Barkly East. Average height 5 inches.

119.

Judging by the contraption he carries in his hands, this man could easily be taken for the local water diviner.
Arrarat, Harrismith. 8 inches.

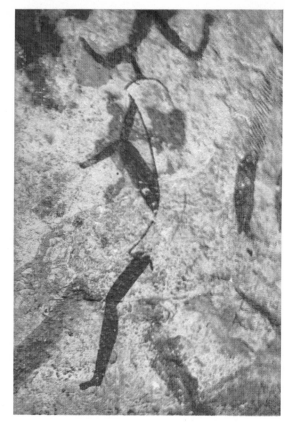

117.

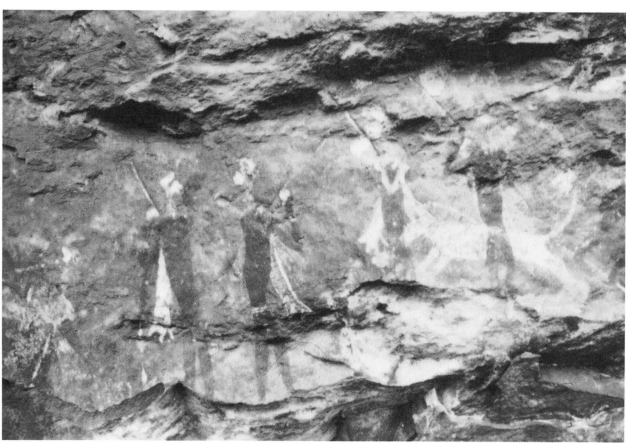

118.

ziz-zag in a chevron-like pattern. There are plenty of examples also of men with their faces and parts of their bodies coloured white leaving the hands, feet or parts of the legs uncoloured. Illustrations of this type probably record initiation or other ceremonies.

There are several accounts of Hottentots rubbing animal fat over their bodies to protect themselves from the sun and weather and it would be surprising if the Bushmen did not follow the same practice. In a shelter at Olieboomspoort in the Northern Transvaal parts of the rock face are so thickly covered with red pigment that it is quite impossible to distinguish the texture of the stone. It occurs at just that height which suggests that it could have been caused by painted bodies rubbing against the wall. Never great ones for washing, the constant application of grease and fat must have resulted in an evilsmelling cosmetic cream or, as the 18th Century traveller Andrew Sparrman put it, "The skin of a Hottentot ungreased seems to exhibit some defect in dress, like shoes in want of blacking".

D23.
Cloaked Figure.
Rietfontein Location, Herschel.

119.

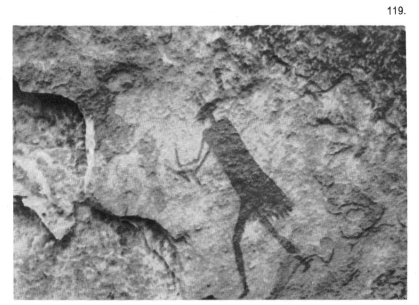

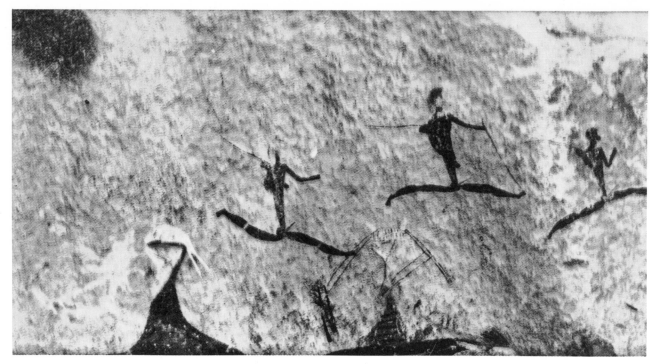

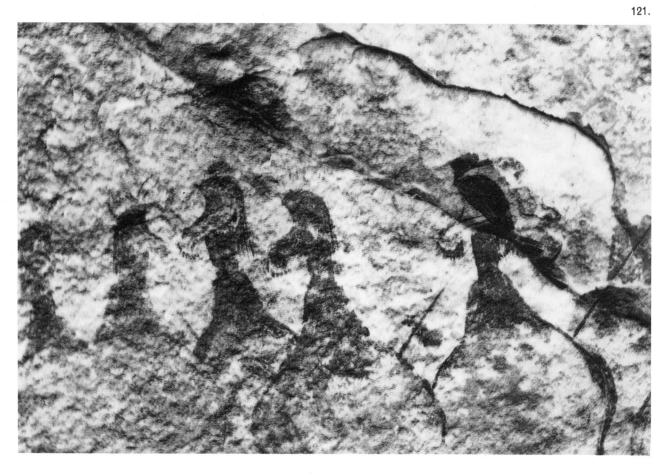

CHAPTER 6

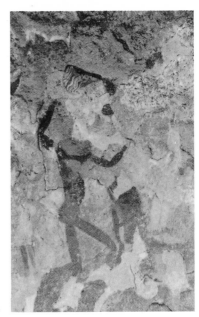

122.

Heads and Head-dresses

Previous writings on the rock paintings of Southern Africa may well have conveyed the impression that all the human heads and faces were painted in a stylised or conventionalized form with little attempt to portray the individual person. This is not altogether true. A study of close-up photographs of the heads of hundreds of figures leaves no doubt of the individual character of a large number of the paintings and of the variety of physical types, probably Bushmen, Hottentots and Bantu depicted in them.

One of the problems still to be solved, however, is to determine just what is represented by the many white faces painted in the form of an upside-down triangle which, when seen from the side, appears to be somewhat concave. Whether these represent a very flat-nosed people who had painted their faces white, whether they are a complete conventionalisation or whether they may represent masks, possibly made of hide and whitened, cannot be certain at present. The latter theory receives some support from

Heads and head-dresses vary in size from approximately half-an-inch to two inches from neck to crown of head.

120.
Running Bushmen pass the heads of two larger figures with typical white, triangular faces. The left hand one wears a Chamisso-type cap with two tails.
Game Pass, Kamberg.

121.
The prognathous, baboon-like faces of a group of figures wearing karosses.
Cleopatra, Estcourt.

122.
One of a group of mysteriously masked figures.
Sijora, Herschel.

123.
Three fearsome prognathous faces
Champagne Castle area, Drakensberg.

124.
Two heads from Ncibidwane, Giant's Castle, one full face, the other in profile.

125.
A group of three seated figures with jaws so long as to appear baboon-like.
Grootvlei, Harrismith.

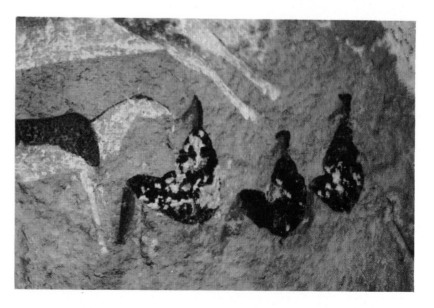

126.
An ornamented "hook-head" with white face. Ha Khotso, Lesotho. The blobs of white may represent shells, beads or daubs of specularite.

the known use of such masks among the tribes of East Africa as recorded by Joy Adamson in many paintings reproduced in her book *The Peoples of Kenya*.

The shiny metallic ore, specularite, has been mined for thousands of years and is in common use in many parts of Africa as a cosmetic, particularly for rubbing in the hair. In many of the rock paintings, the hair is shown in a lighter colour which is probably a reflection of this custom. This introduction of a second colour was one of the simplest steps away from a completely monochrome painting and, once made, it led to many interesting variations. At Nelson's Kop near Harrismith a broad white stripe was painted across the top of a man's head, round the back of it and then on to the chin and down the neck. This may have represented a head-dress like a Balaclava helmet, a hair style or, more likely, actual paint on the person portrayed.

Once they had satisfied their hunger, prehistoric people would have had plenty of time to experiment with their personal appearance and to devise new methods of personal adornment. So, at Huntly Glen, the round head of a black figure has a few touches of white added to the top to represent beads or bladders worn ornamentally in the hair and there are similar paintings at other sites.

At Le Bonheur, Harrismith, a man painted in red has black hair or a black head-dress which falls in a thick fold in his neck. An additional interesting feature is a large tassel hanging on a slender thread from the crown, probably an individual hair style.

Paintings in Mrs. Adamson's book clearly indicate how cosmetic paint is frequently applied to the cheeks, chin and neck leaving an unpainted panel containing the eyes, nose and mouth. This creates the Balaclava helmet effect already mentioned which seems to have resulted in the development of a definite, and widespread, technique among the rock paintings. This consists of drawing a head made up of a red or black hook like the top of a question mark filled in with white or a pinky-cream colour for the face. Examples are to be found near Clanwilliam in the Western Cape, throughout Lesotho and in many parts of the Eastern Cape. The figures painted on the Coldstream Burial Stone show a similar technique. In some cases the white face has disappeared leaving only a so-called hook-head but there are sufficient examples still left to make it virtually certain that all hook-heads previously included a white or other light coloured face.

Quite apart from the hook-headed figures, white is one of the commonest colours used for painting portraits on the rocks. It is the colour used to record a particularly ferocious trio in a rock shelter in the Champagne Castle area of the Drakensberg. The faces are decidedly prognathous and probably Bantu, but despite their family resemblance each is very much an individual who has accentuated his individuality by the care that he has given to the painting of his own face—which the artist has faithfully reproduced.

Faces with elongated jaws are common among the rock paintings.

127.

The figure on the left has a face reminiscent of a character from a painting by Toulouse-Lautrec. The figure on the right wears a distinctive cap with two tails—the Chamisso-type and a feathered head-band. St. Fort, Clarens.

128.

In the centre of a hunting scene. A concave white face ornamented with red stripes
Swart Modderfontein, Matatiele.

129.

Protea Hills, Maclear.

130.

An unusual full-face portrait with a Napoleon-like air.
Qacha's Nek.

131.

With a cap to suit Davy Crockett. Wide Valley.

132.

Portrait of an elaborately dressed figure holding a stick across the back of his shoulders in a manner still common among Bantu.
Mount Tyndale, Maclear.

133.

The white spots in the hair may well represent the cosmetic use of specularite—a shiny type of iron ore which has been mined in Southern Africa for thousands of years. The outsize ear-rings were probably copper.
Huntly Glen, Bedford.

134.

Protea Hills, Maclear.

135.

Bladders worn as a crown-like head-dress.
Protea Hills, Maclear.
67, 35, 22.
Mount Tyndale, Maclear.

136.

Part of a portrait gallery in a tiny shelter at Qacha's Nek.

D24.

The prototype of the "Chamisso head-dress". A cap probably made of the skin of a small animal such as a hare or jackal with the tail removed.

Although usually white, they occasionally occur in other colours. In some cases the jaws are so long that they resemble baboons. This raises the question of whether they were wearing baboon masks or, again, whether it was a case of the Bushman artist doing what amounted to a caricature of early Bantu arrivals in the country.

A specially interesting representation of the long-jawed figures is painted on a large rock in the Forestry Reserve. Giant's Castle area, Estcourt. The people of the main group are painted mainly in black and wear karosses but facing them is a single figure probably wearing a tight-fitting skin suit and having a "crown" of slender, slightly curved lines which probably represent porcupine quills.

There are a number of paintings which include these quills. A particularly

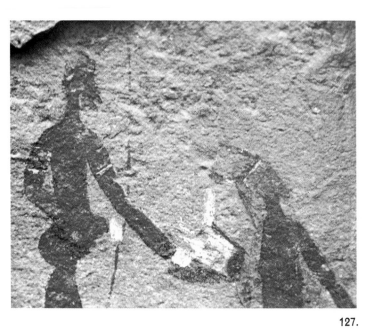

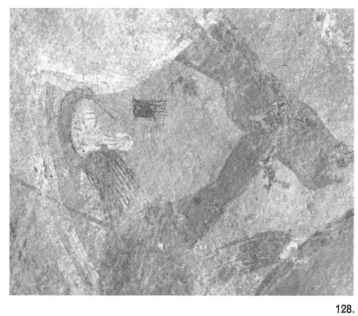

127.

128.

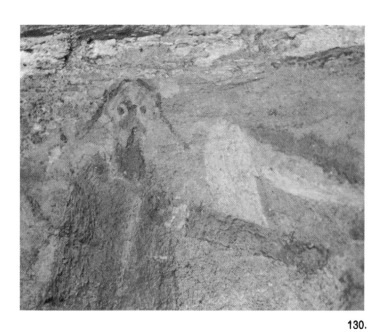

129.

130.

131.

132.

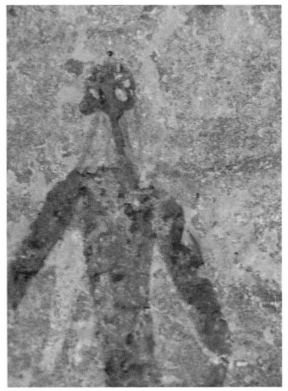

133.

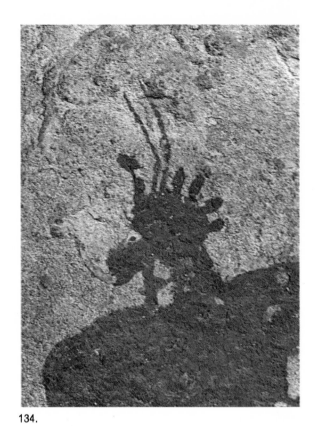

134.

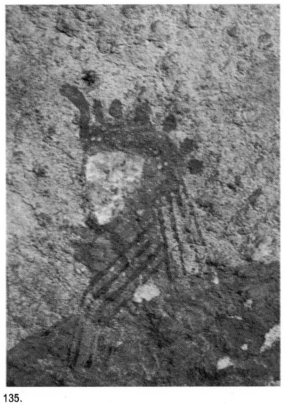

135.

136.

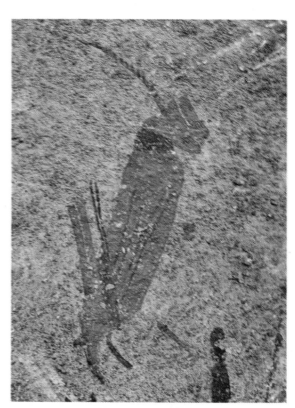

137.

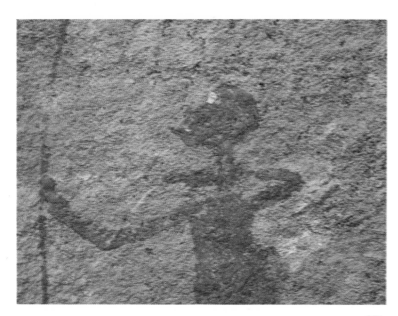

140.

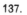

138.
139.

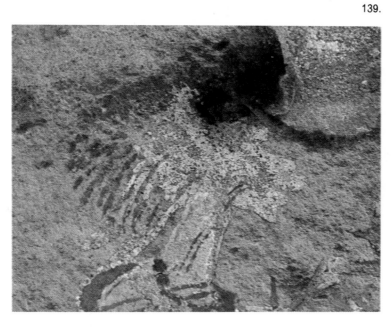

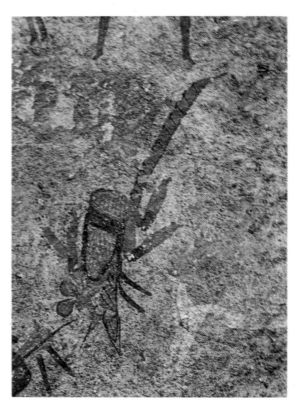

141.

142.

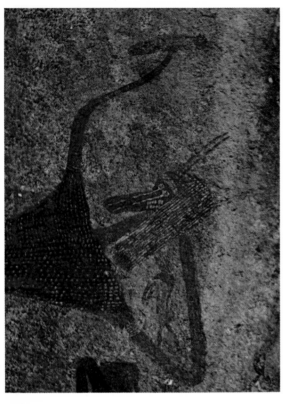

143.

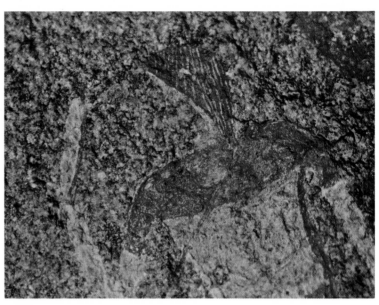

143.
A famous portrait from Rhodesia.
Impey's Cave, Fort Victoria.

142.
The baboon-like mask worn by the principal figure reclining in a feasting scene at Diana's Vow, Rusape.

144.
Portrait of a prehistoric painter. The central figure on the burial stone excavated from a shelter at Coldstream between Plettenberg Bay and Humansdorp.

145.
Elaborately attired and wearing porcupine quills. Two detailed portraits with decidedly Bantu characteristics.
Sunday Falls, Bergville.

144.

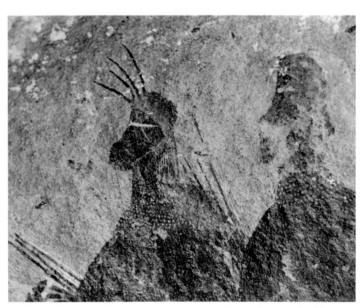

145.

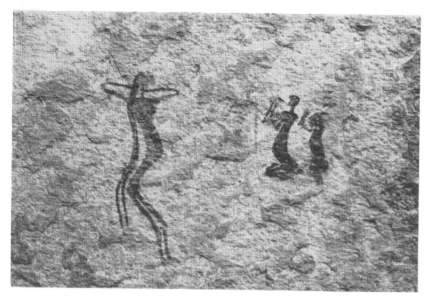

146.

fine example, painted in such detail as to leave little doubt that it is an actual portrait, or pair of portraits because two figures are depicted, is at Sunday Falls in the Bergville district of the Drakensberg. This pair appear to be a man and a woman. They have a distinctly Bantu appearance and she has the high hairstyle still worn by Zulu women as one of the signs of married status. Both have heavily beaded collars or many rows of necklaces and the man has a little beard and white stripes above his eyebrows.

There is a considerable similarity between this man and a portrait at Modderpoort on the border between Lesotho and the Orange Free State where both the prognathous appearance and the porcupine quills recur. There are two additions, however. The first is a cluster of drops apparently falling from the nose of the figure and the other is a very bulky head-dress. Bulky head-dresses are still worn by Xhosa women, as are ornaments suspended from the nose. Zulus and Xhosas are, of course, closely related people.

Although noses are seldom prominent in the paintings, there are one or two exceptions. A portrait in a shelter on the farm St. Fort, Clarens, could easily have been copied from the well-known painting by Toulouse-Lautrec entitled "At the Moulin Rouge, The Dance (1890)." The man in the rock painting has the same delightfully prominent nose and chin as Paul Decosse whom Toulouse-Lautrec painted as he put a new dancer through her paces. Rather remarkably there is a similar face among the few surviving paintings in Whitcher's Cave, near Coldstream, five or six hundred miles away in the Cape Province. Both are completely unlike either Bantu or Bushmen. They have more in common with European or Somali faces.

The paintings bear witness to man's continual fascination with the horns of animals and to his continued use of them for personal adornment

147.
A fearsome hunter with small tusks
to complete the effect.
Huntly Glen, Bedford.

as well as for the more utilitarian purpose of disguise in hunting which
has been dealt with in a separate chapter. The horns depicted in the paint-
ings vary from quite short ones to very large ones which could only have
been worn for short periods in the course of some dance or ceremony.
It is but a short cry from horns to tusks and in one concentrated area, on
the farm Huntly Glen, near Bedford, Eastern Cape, there are a number of
figures with prominent tusks protruding from their chins. This seems to
have been a local custom as no other examples have yet been discovered.

Many of the painted figures wear little caps, presumably made of the
skin of a small animal but a widely distributed and recurrent feature is the
distinctive cap with two tails hanging down the back, one of the finest
examples of which is at Chamisso, Maclear. The specimen at Chamisso
is rather unusually large, although there is a larger one on a remote site
in the Umtali district in Rhodesia, but the fact that there are smaller ones

148.
Lines of red pigment for facial
adornment.
St. Fort, Clarens.

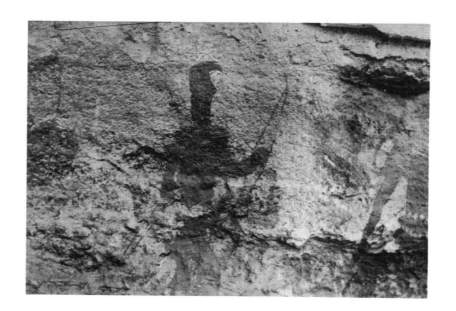

149.
Balaclava-type head-dress. Kranses
Drakensberg, Estcourt area.

in almost every part of Southern Africa draws attention to an item of dress common to very many of the people in the paintings.

Another interesting custom of widespread distribution is the painting of straight red lines across the face. This practice is mentioned by Stow in his classic work *The Native Races of South Africa* which deals primarily with the Bushmen. Apart from the numerous examples among the rock painting sites, the faces of the figures on the Coldstream Burial Stone are also painted in this way.

The possibility of the paintings being associated with initiation ceremonies has already been mentioned and it is interesting to recall that many of these ceremonies among the peoples of East and Southern Africa are accompanied by the wearing in front of the face of a little screen of vertical reeds often very artistically ornamented. There is at least one portrait which includes such a screen—at Fulton's Rock in the Natal

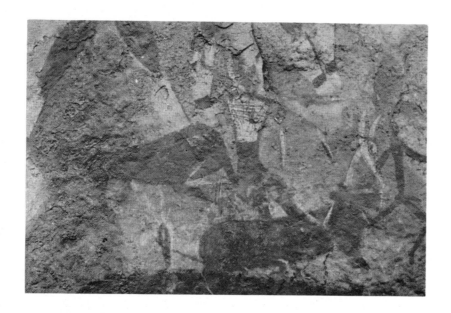

150.
Holding a buck-head on a stick which gives him the appearance of a court jester. A white-faced figure seen full face and wearing a pair of horns.
Sebaaini's Shelter, Cathedral Peak.

151.
A model of an animal surmounts
the head-dress of a hunter.
Boskranz, Wodehouse.

Drakensberg which is just the remote sort of spot that might have provided a focal point for initiates.

Although the majority of portraits are painted in profile, there are a number full-face. Specially notable examples, in red, black and cream are to be found in a tiny shelter, only big enough for one or two people to sleep in, at Qacha's Nek, Eastern Lesotho. Certain of these full-face portraits also have the red lines painted on them. A particularly fine example is at Sebaaini's shelter in the Natal Drakensberg where the figure holds a small buck head mounted on, or carved from, a stick. This buck head is reminiscent of the Ponchiello carried by a court jester in the European Middle Ages but also strongly resembles a Tsonga carved stick reproduced by Battiss in *The Art of Africa*.

The painting of faces took many forms in addition to the red lines that are so common. Another form that recurs frequently is an exaggeration of the eyes by painting semi-circles above them or circles around them. The effect is frightening and, is still common among the peoples of East Africa where it is closely connected with initiation and circumcision rites.

An interesting custom that is portrayed in paintings at one or two sites is that of a hunter wearing a small model of an animal on his head. The custom is reminiscent of the crests that surmounted the helmets of medieval knights. Rather similar is the bird between a pair of horns that surmounts the mask worn by a figure painted on a slab of rock which has been removed from the farm War Trail, Barkly East, and is now in the Africana Museum in Johannesburg.

Sophisticated examples of the art of mask-making are reflected in many

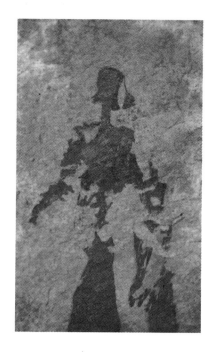

153.
Hair worn in a distinctive style or a
tasselled head-dress? A similar
style of hairdressing can still be
seen occasionally among the Bantu.
Le Bonheur, Harrismith.

152.
Wearing a pointed "pixie hat" and
an elaborate kaross.
Ncibidwane, Giant's Castle.

154.
Heavy vertical stripes or possibly a screen of reeds as used by Sotho in present-day initiation ceremonies on a hook-headed, prognathous figure.
Fulton's Rock, Estcourt.

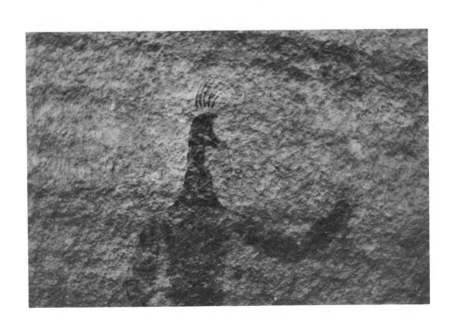

155.
Facing the group in illustration 121 with a flower dangling from his lips and wearing a head-dress of porcupine quills.

of the paintings, notably two somersaulting figures who greet a returning fisherman on the farm Leeuwkraal. They have a mouselike appearance and Bleek records in *The Mantis and His Friends* that there were tribes of Bushmen who referred to themselves as The Long Nosed Mice and The Striped Mice.

Equally sophisticated is the well-known scene at Diana's Vow, Rusape, where a reclining figure attended by dancers and surrounded by the food and drink for a feast wears a baboon-like mask, as do one or two of the dancers.

One of the most puzzling of all paintings involving head-dresses is in an obscure little shelter, Glen Rennie, near Harrismith. One might be forgiven for interpreting it as a painting of a man wearing a barred casque or visor—the effect is heightened as he appears to hold a curved sword.

Almost equally mysterious is the series of sophisticated portraits from Sijora Shelter in the Herschell district. They can be classified with the figures at Impey's Shelter near Fort Victoria and the famous White Lady of the Brandberg (which seems unlikely to be either white or a lady) as providing a continuing challenge for students of prehistoric art.

157.
The large white teeth of what may have been an early Bantu arrival in the district obviously made a deep impression on the artist.
Wide Valley, Maclear.

156.
With exaggerated eye make-up, a hunter from Uysberg, Ladybrand.

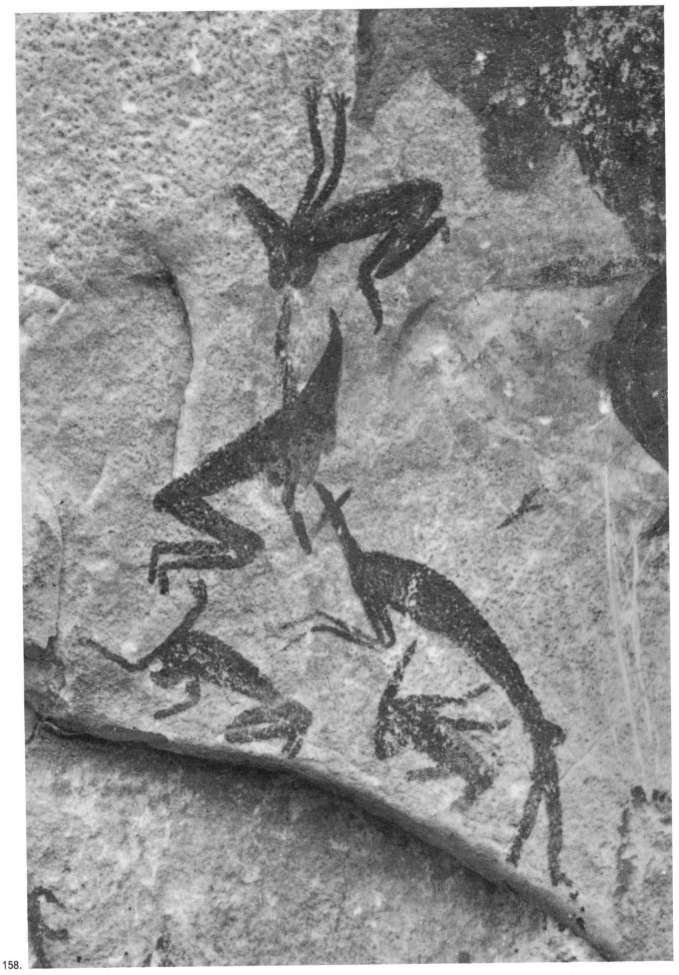

158.

CHAPTER 7

Dances and Ceremonies

D25.
The simplest way to produce music was to pluck at the string of a hunting bow.
Mountain View, Harrismith.

Along the foothills of the Drakensberg mountain range are several excellent holiday resorts. These much sought after playgrounds of today were yesterday the homes of the painters and their compatriots. The lush valleys and rolling hills were their happy hunting grounds. The overhangs eroded into the sandstone krantzes were their homes. The animals which drank from the clear mountain streams were their food and for all but a few weeks of the year when the high basalt escarpment was blanketed in snow, the climate was warm, glorious and friendly. Indeed here was an existence next door to Paradise.

Their daily chores would have consisted of hunting and gathering edible berries, tubers and other roots and plants, collecting fuel for their fires, preparing skins for clothing and generally living and catering for today. From then on, there was ample time for sleeping in the sun, for story telling and playing games and dancing. But once again we are faced with frustrating fact that there are so few written records which describe their social life in detail. Once more we must rely upon the rock paintings as our source of information about the form of their dances and accept the fact that they tell us little which we can understand about their ceremonial purpose.

In the same manner in which the tribal legends were preserved by being

158.
In ceremonial dance scenes such as this, the attitude of the top figure with its arms thrown right back is by no means uncommon. Unfortunately, we do not know what either the pose or the dance means.
Malappasdraai, Fouriesberg.

159.

Each of the men in the top row of this dance scene carry something which resembles a flowering plant —perhaps an aloe. One of the two stick-like winged creatures appears to be standing on the ground whilst the other seems to be floating in the air. Each wears a long pointed mask and there is no indication of sex in contrast to the men who are heavily infibulated. Nsangwini, Swaziland.

160.

To judge by the costume illustrated here, some dances must have had a religious or spiritual significance. Both figures have wing-like arms so they may represent a spirit form. The one on the right is shown half way through a somersault so he can best be seen by turning the book upside down.
Makuini, 2. Lesotho.

161.

Whilst on their way to gather edible roots these women seem to have been waylaid by a travelling entertainer. Dropping their skin carrying bags and digging sticks on the ground they have grouped themselves around him and are singing and clapping their outstretched hands. The dancer himself wears a Red Indian-like head gear and an essential part of his act seems to involve grasping short hooked sticks pushed into the ground.
Theodorus, Natal Drakensberg.

162.

A central figure, dressed in a long robe, is shown lying on the ground and is enclosed within a circle. People have their hands on the circle as if building a wall. It is quite possible that this may be a burial ceremony with the mourners dancing around the dead body.
Fulton's Rock. 14 ins. x 18 ins.

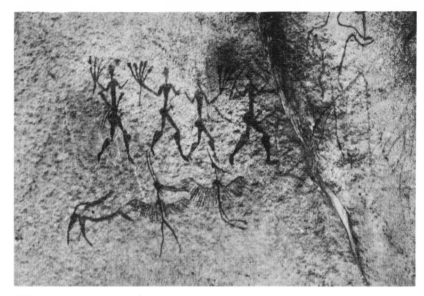

159.

passed down by word of mouth from the elders to the youngsters, so too were they preserved by being illustrated in pictorial form upon the walls of their living places. This may have been done either by an artist who was a member of the tribe or by a wandering painter whose specialist occupation it was to record events in their lives which had some special significance. Assuming the tribe to be migratory on account of their parasitic reliance upon the roving animal population, either of these explanations could account for the occurrence of paintings illustrating the same subject and done by the same artist, situated many miles apart. Examples are the identical ceremonial dance scenes at Barnes Shelter, Giant's Castle and at Mpongweni in the Underberg district some 60 miles away as the crow flies.

There are also hundreds of examples of an identically painted antelope re-occurring right along the Wilge River Valley from Warden to the foothills of the Maluti Mountains. This animal is particularly easy to recognise as

160.

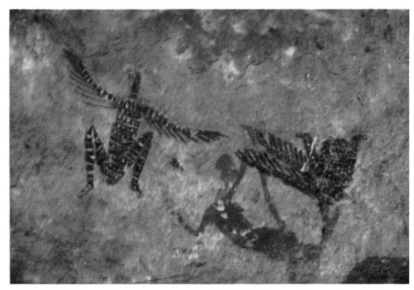

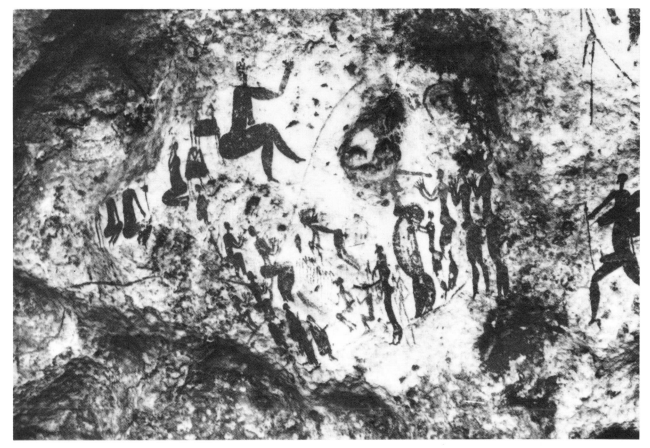

161.

162.

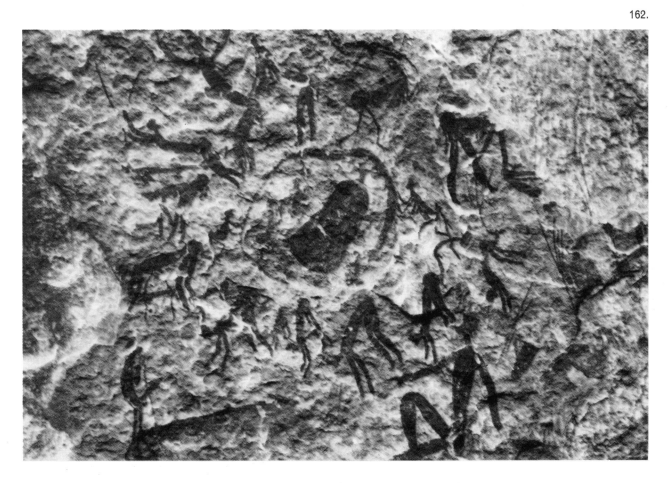

163, 164.

The creative genius of this artist must have been stretched to the limit to compose and produce a detailed scene such as this which is in fact only part of a larger frieze. It tells the story of the coming together of a large number of men for a ceremonial dance. The close-up view 164 shows the leggings worn by the dancers. In each case the smooth skin is turned to the outside and is then decorated in gay coloured patterns. In one or two cases, a ring of fur can be seen protruding below the leggings, (or are they wearing fur-lined ankle length boots?) As part of the dance routine, the skin clad legs would be brought violently together causing a loud slapping sound emphasising the tempo.
Klipkraal, Dordrecht.

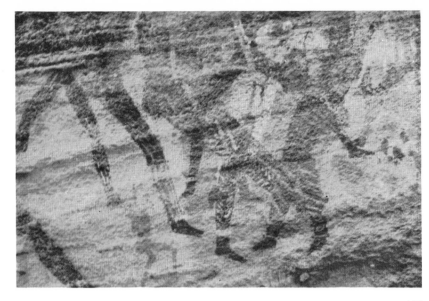

164.

163.

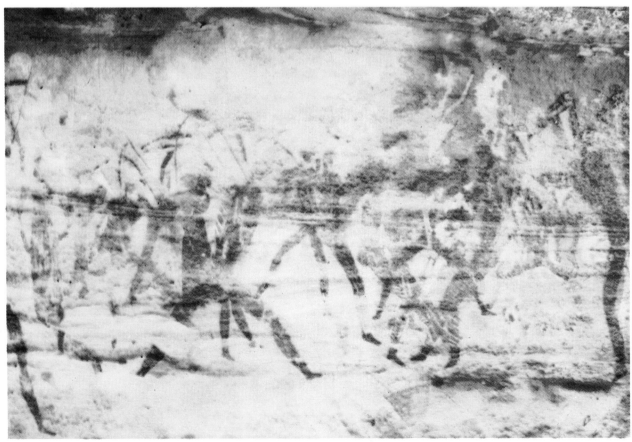

D26.
A man wearing a costume consisting of a pair of ostrich wings. It seems likely that he is about to repeat the dance of the winged creatures actually shown in some paintings.
Junction Farm, Cathcart.

it was either never completed or a fugitive second colour was used which has long since disappeared.

Returning to the "who-dunnit" aspect for a moment, bearing in mind that there are over 2,000 known sites in South Africa and that many have hundreds upon hundreds of individual paintings, it is tempting to think that as with the Australian Aborigines, most men of the tribe were able to paint and in fact were expected to take part in the business of decorating the cave walls and renewing old paintings which were beginning to fade. From the extensive researches of Dr. Schertz of South West Africa, we do know for instance that parts of the misnamed "White Lady of the Brandberg" have been touched up since they fluoresce differently when exposed to ultra violet radiation.

Paintings of dances often show large numbers of people some actually taking part in the ceremony, others standing apart as an admiring audience. This may be taken as an indication of the size of the tribal unit or on the other hand it may indicate that at certain times of the year, for special occasions, there was a gathering of neighbouring tribes for communal celebration. Having so much leisure time a dance could take place at the slightest provocation—to celebrate a successful hunt, the coming of the first rains, the first signs of spring, the appearance of the new moon. Each such occasion would be of symbolic importance to a society influenced by superstition, fears and beliefs.

It was natural then for many ceremonies to assume a religious, magical significance requiring grotesque masks and elaborate costumes to illustrate creatures of spiritual fantasy. It is difficult to say of course, to what extent such paintings are distorted and exaggerated by the artists' own vivid imagination. However, many dances required either no costume at all or at best a simple head-dress, bead veil or face mask.

An essential part of any such gathering was rhythm and music. This was supplied by the audience who sang and clapped their hands in unison to provide the beat. Sometimes it was done by the dancers themselves as for instnce at Klipkraal where some wear fur leggings, the smooth skin turned to the outside and gaily patterned with straight or zig-zag lines of different colours to match their own painted bodies. By bringing the legs sharply together during the dance step, a loud slapping sound would be made. Or they may have used rattles (See 99). According to Burchell, Bleek and

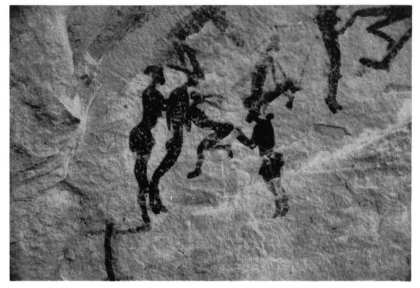

others, a few fragments of ostrich egg shell or seeds were put into pouches made from the ears of springbok and then allowed to dry. Several of these were strung together and then wound around the ankles and tied firmly into place. As the dancer stamped his feet on the ground the rattles made a pleasant swishing sound not unlike the maracas used in calypso music of today.

Although musical instruments were seldom used to accompany dances, they were used as a background for some songs. Stow describes various types of musical bows and Schapera, quoting Schultze, describes the musical bow, "kxab", used by the Naman Hottentots. "The women are the performers. They sit on the ground with the upper end of the bow resting on the left shoulder, while the lower end, propped up against a skin-covered bowl serving as a sounding board, is held there by means of the foot, inserted between the stave and the cord. The performer picks at the

166.

165.
When getting dressed for a dance it is always nice to have someone to help you do up those hard-to-get-at zippers and poppers. Note the baby on the back of the woman on the right.
Mpongweni, Underberg. Approx. 4 inches.

166.
This close-up of two figures from Barnes Shelter, Giant's Castle, gives us an idea of the wonderful head-dresses sometimes worn by the dancers. It also shows that the way-out dance steps of today are really old hat.
Approx. 3 inches high.

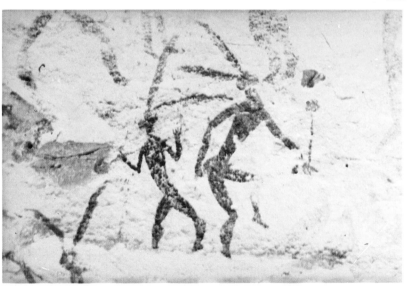

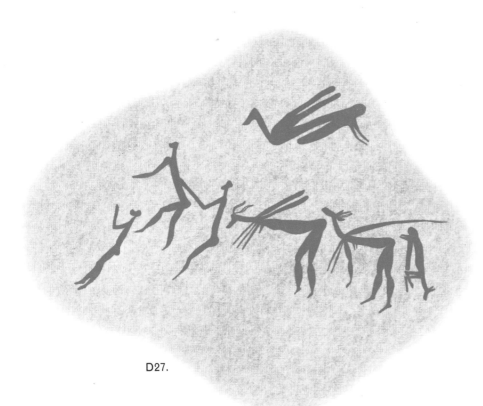

D27.

167.
It seems unlikely that this is a battle scene since there are no dead or wounded on the ground, no arrows fly through the air and all the bows are so small that they may be a type used only for ceremonial purposes. This impression is emphasised by the person seated in the top right hand corner apparently beating time on a drum. This could well be a dance re-enacting some memorable battle. The artist has used a crack in the rock to dramatise the action and the division between the two sides.
Goedgegeven, Warden. Average height 4 inches.

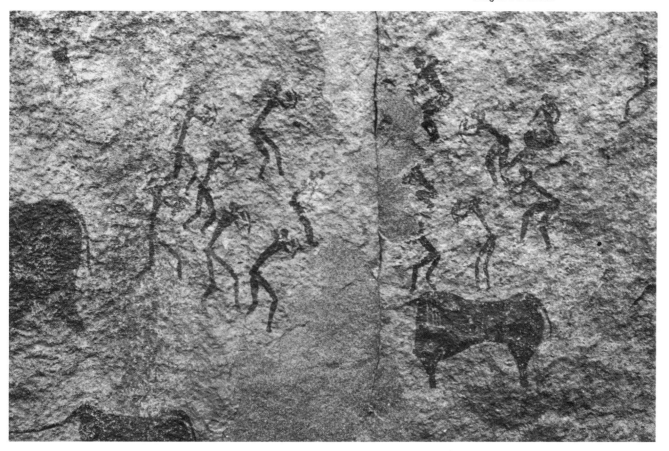

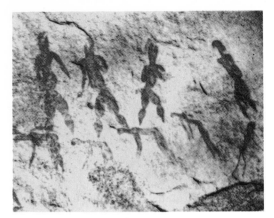

168.

cord with a small stick held in the right hand, while the left hand holds the bow like the head of a violin".

Except for the fact that our performer is a man and that he does not use one foot to hold the bow against the resonator, this is an incredibly accurate description of a painting on the farm Wide Valley in the Maclear district. Is it significant that this is so and that the shelter in which the painting occurs is fully 1,000 miles away from the territory of the Naman tribe? Naturally we have no idea of the difference in the time scale between the date of the painting and the time at which Schultze observed the construction and the use of the "kxab", but if these are paintings of the Hottentots then Wide Valley certainly provides a wonderful confirmation of the contention that many paintings do in fact illustrate people other than the Bushmen. But, if those people are Hottentots, how can we explain the "infibulated" man (page 2) who is also a member of this same frieze? Was this practice also followed by them? And so the nagging unanswered questions continue *ad nauseum*.

The second example from Rydal Mount shows a man playing in much the same manner on a smaller bow but this time without a resonator. Perhaps like the present day Xhosa women he intended to hold it between his lips so that his mouth and chest cavity may act as the amplifiers.

It is an old custom for young boys in Lesotho to make a musical instrument called a sekhangkula by attaching the stave of a bow to an old tin can. It is played by drawing back and forth a smaller bow, only about 9 ins. in length, having a horse hair string, which for maximum volume, must be kept wet with saliva. This causes frequent (and welcome) interruptions to the "melody"! The thumb is used to change the tone.

Stow, Barrow and other writers have recorded examples of drums of different types. Pictorial examples are seldom seen but the seated figure in the dance scene from Goedgegeeven (See 167) could well be playing upon a drum held between the legs whilst the painting from Oakdene (See 173) seems to illustrate a man intent upon beating the life out of a much bigger, free standing version with sticks, one held in each hand.

Examples of wind instruments in the paintings are extremely rare, in fact the only one we know of is at Bushman Point on the shores of Lake MacIlwane, a few miles north of Salisbury, Rhodesia. Here a primitive Louis Armstrong leans forward about to blow on his horn.

168, 169.
Some of the so-called "Crocodile Men" from Glen Norah who may be gods or totem symbols before whom the men of the tribe are dancing and paying homage. One of the men from another part of the same scene wears a completely different head-dress and a long tailed costume covered in hair. Glen Norah, Salisbury.

170.
Paintings of musical instruments are rare enough but to find an example such as this is without precedent. With the bottom of his bow resting on a hollow resonator, this man makes music either by drawing the stick in his right hand back and forth across the bow string or he uses it to strike the string in the manner of a percussion instrument. Whichever way he goes about it he has an admiring audience. Whilst the man in white (shown in detail in 111) has his hands up as if clapping in time to the rhythm, the upper figure sits in the relaxed attentive attitude of a true music lover.
Wide Valley, Maclear. 4 inches high.

169.

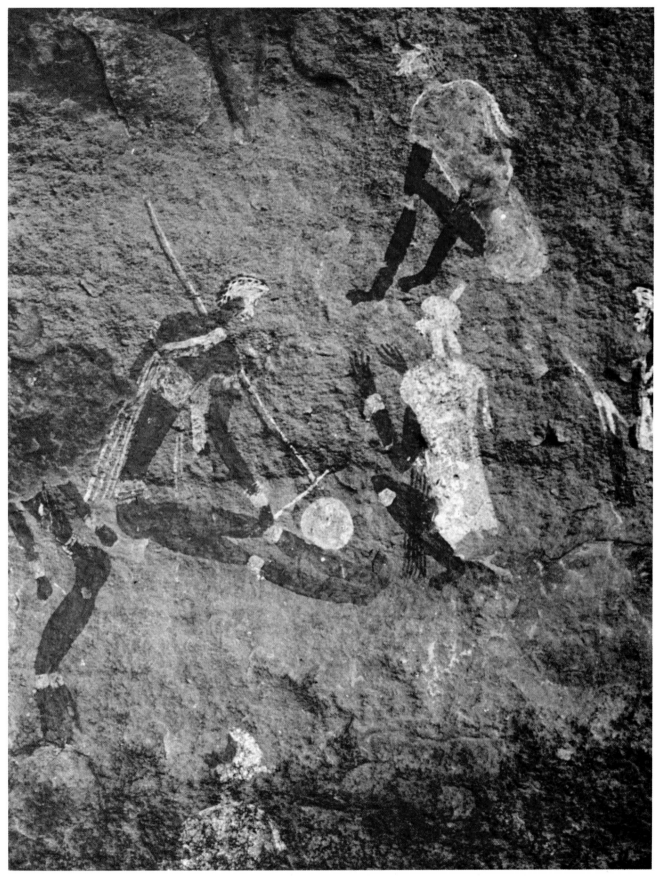

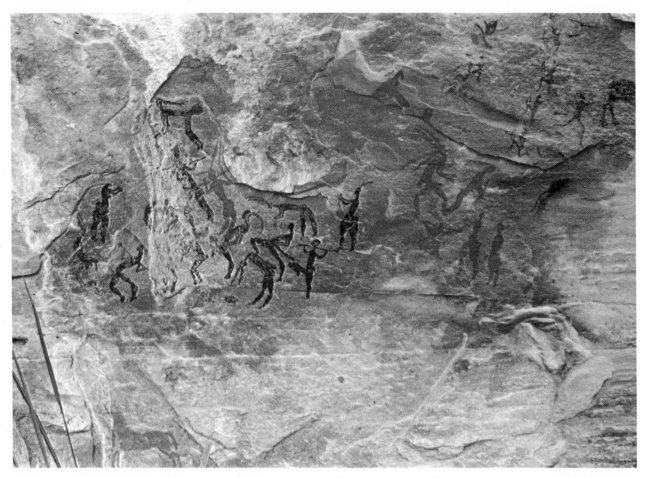

171.

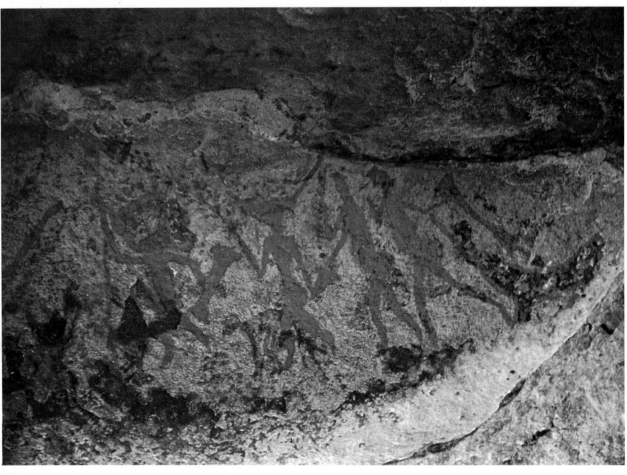

172.

173.
A man beating a drum.
Oakdene, Cathcart. 5 inches.

171.
Although published previously, this still remains one of the best dance scenes in South African rock paintings. It shows women standing in groups singing and clapping for the men who wear fanciful head-dresses and dance in contorted attitudes. It is worthwhile comparing some of the central figures with those from Barnes Shelter (166). Although the two sites are at least 60 miles apart as the crow flies, both the subject and the technique are so similar that one gets the impression both were painted by the same artist.
Mpongweni, Underberg. Average height 4 inches.

172.
The leaders of this procession of tiny figures are wearing the most incredible head-dresses and masks. One is carrying a long branch with leaves still on it. Like so many others the meaning of the ceremony and the purpose of the paraphernalia is completely lost to us.
Arrarat, Harrismith. Average height 2 inches.

174.
A jazz session at Bushman Point, Lake MacIlwaine near Salisbury, Rhodesia.

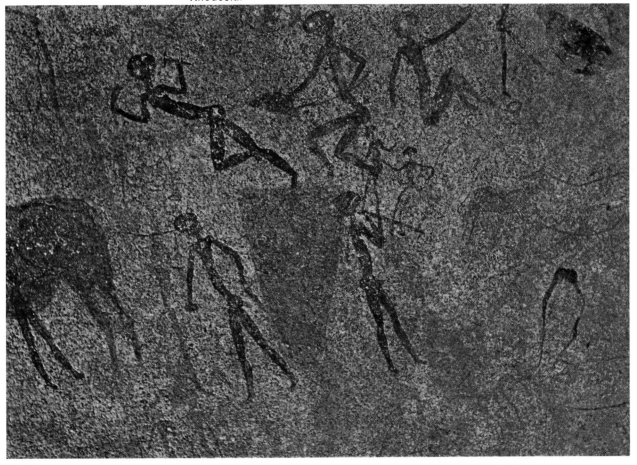

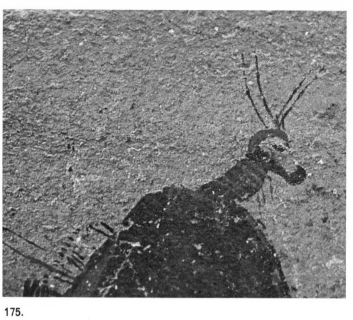

175.

176.

177.
179.

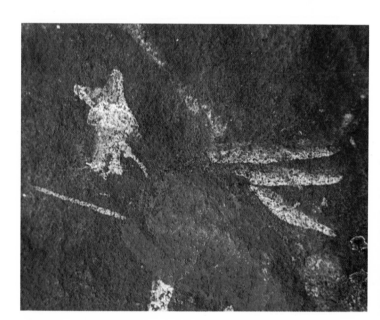

178.
180.

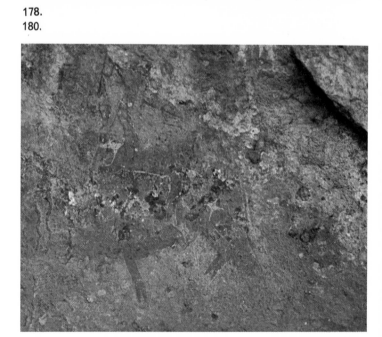

CHAPTER 8

Buck-headed figures

The use of buck-head masks for hunting disguise has already been discussed in detail and it has been suggested that in some parts of South Africa where eland were plentiful, hunting developed ceremonial features akin to bull-fighting when elaborate regalia was worn.

Animal head masks are so frequently painted in certain areas that the impression is created of a commonplace custom—as though the buck-head had become a fashionable article of clothing to be worn on many occasions in addition to hunting. In some cases, notably at the farm War Trail near Barkly East, the artist has made it quite clear that the mask is, in fact, a mask; but in other instances this is not so clear. At the national monument site at Schaaplaats, for example, the buck-heads are painted so much as a part of the human figure which they surmount that it has been argued that mythological creatures are represented. This seems highly unlikely. In view of the many obvious masks elsewhere it is much more probable that the artist was indicating the effectiveness of the disguise.

175.
Snow Hill, Underberg.

176.
Blue Bend, Barkly East.

177.
An unusual buck-headed figure poised on one toe.
Rooihoogte, Champagne Castle.

178.
Perhaps a feline rather than a buck mask.
Fern Grove, Maclear.

179.
Apparently successful use of disguise to approach two eland.
Qomoqomong, Lesotho.

180.
The three buck-headed figures first traced by Orpen in the early 1870s.
Melikane, Lesotho.

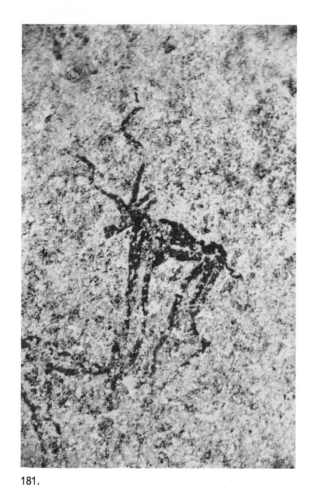

181.

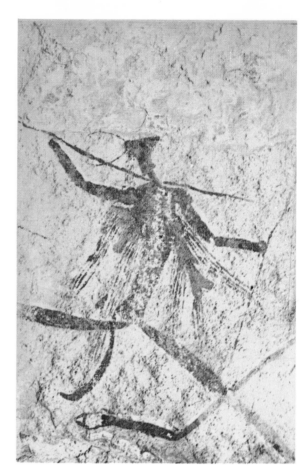

182.

183.

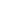

184.

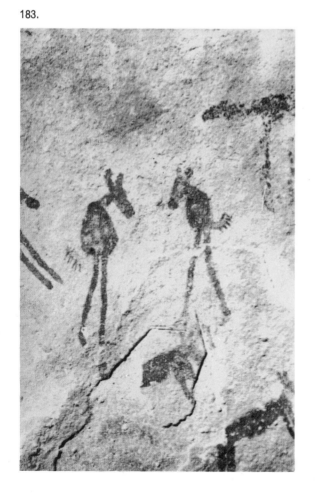

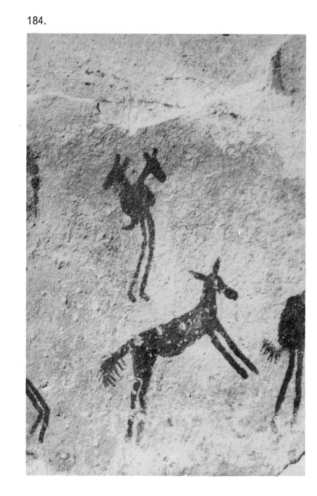

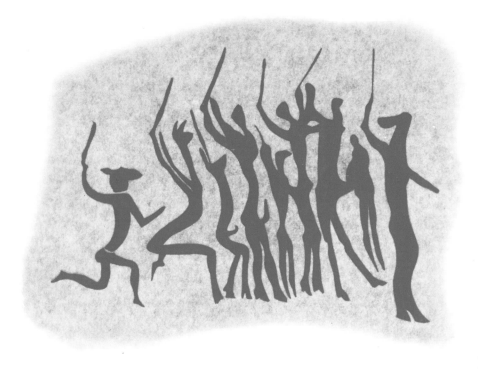

D28.
An energetic group of dancers urged on by a man wearing a buck-head mask.
Snyman's Hoek, Bethlehem.

181.
Wearing kudu horns.
Chisewe, Mtoko.

182.
It is clear from this painting that the mask is detachable.
War Trail, Barkly East (Africana Museum, Johannesburg).

183.
Buck-head masks together with the skins of the animals were most frequently used as hunting disguises. Two appropriately attired figures at Bestervlei, Fouriesburg. 3 inches tall.

184.
Apparently wearing two heads but probably carrying a slaughtered buck.
Bestervlei, Fouriesburg, 3 inches tall.

On the other hand, however, there are many paintings in which the figures also have hooves instead of, or over, their feet. There is an imposing line of such figures at Main Cave, Giant's Castle. The "witchdoctor" figure at Wide Valley (frontispiece) also has hooves but does not wear a buck-head mask.

Groups of figures wearing buck-heads are especially plentiful in the valley of the Caledon River where they are painted in great detail. In the valleys of the Drakensberg from Cathedral Peak to Giant's Castle the buck-heads are painted in a less detailed fashion and the impression is given that they had become limper, more comfortable and less formal. In many cases the "face" of the buck has virtually disappeared but the ears are still prominent.

In some groups, particularly paintings of dancers, only one figure, the leader, wears a buck-head mask; but in others the whole group have them. A pair of horns is still quite a common feature of the regalia of witch doctors in East and Southern Africa so where a single figure in a painted group is horned this may indicate that he was the witchdoctor. A famous painting in the depths of a French cave Les Trois Frères shows a human-being wearing antlers. It is usually referred to as the sorcerer. Rather similar are three

185.

The painter's fusion of mask and figure at the National Monument site. Schaapplaats, Clarens.

186.

The mask pushed by a hunter to the top of his head.
Huntly Glen, Bedford.

187.

Fetcani Glen, Barkly East, 6 inches high.

185.

186.

187.

116

buck-headed figures of special interest painted in the shelter of Melikane, Lesotho. This remote shelter was first visited by J. M. Orpen in the early 1870's. He traced the figures and they were beautifully, if a little inaccurately, reproduced in colour in the Cape Monthly Magazine of July 1874. When Dr. Bleek, in the course of his researches, showed these reproductions to a Bushman he received the opinion that they represented sorcerers wearing gemsbok horns and belonging to "the ancient Bushman or to the race preceding the present Bushman".

It is not clear what the figures are doing, they are certainly not hunting, and they might well be "sorcerers" but they might equally well be three ordinary men who choose to wear buck-head masks to "keep in fashion"! Horns seem to have a primitive fascination for human-beings—as the great collections of the big game hunters bear witness, and there is at least one young man in Johannesburg who has fastened a pair of springbok horns to the crash-helmet which he wears when riding his motorscooter!

To return to the buck-head masks, we do not know exactly how they were made, whether parts of an actual skull were used or whether the skin and horns were mounted on a framework of wood or strong reeds. The former seems unlikely in view of the weight but it is interesting to note that in 1954 Dr. Revil Mason excavated a human skeleton associated with a great deal of red ochre and buried with the skull of a reedbuck at Driekopseiland near Kimberley. Mason suggested that the skull of the reedbuck represented a food offering but it may have been the remains of the man's buck-head mask. The reedbuck would have provided a head suitable for mask-making as would the rather similar but straight-horned mountain rhebok. Gemsbok and eland heads being larger might have been more appropriate to ceremonial than to everyday wear.

188.
The painter's fusion of mask and figure at the National Monument site. Schaapplaats, Clarens.

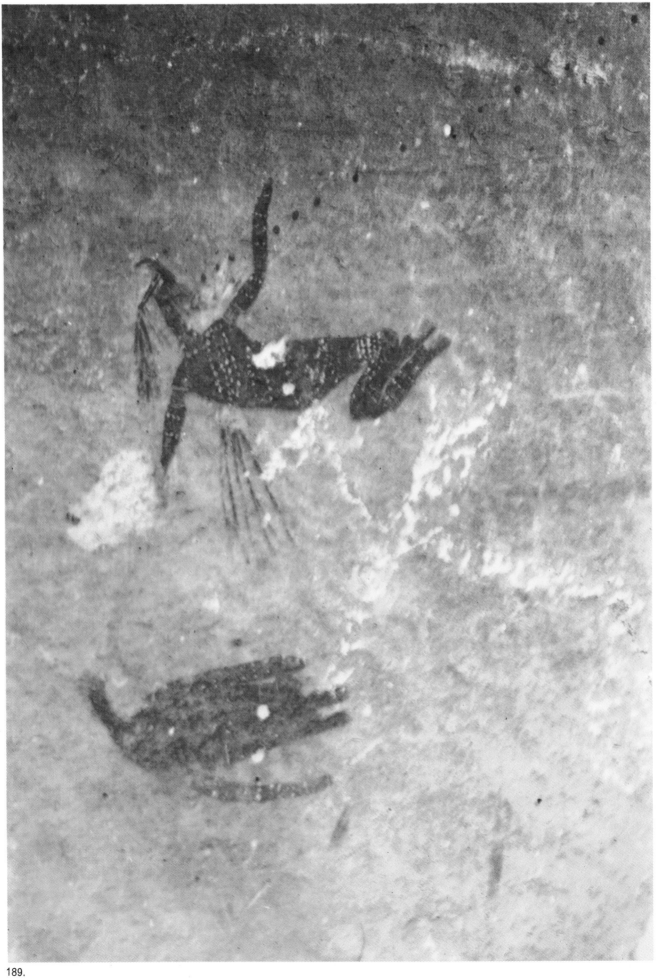

189.

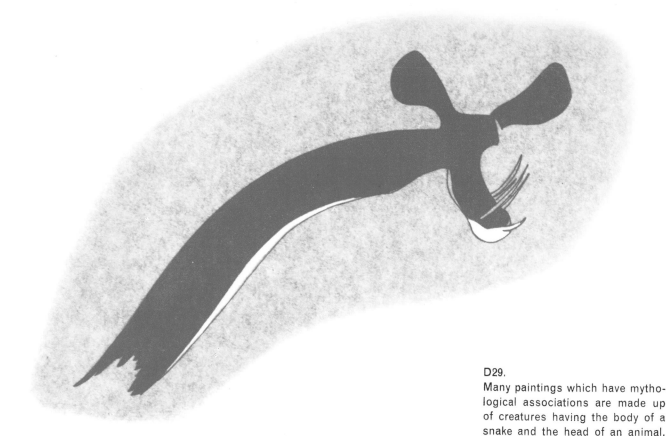

D29.
Many paintings which have mytho-
logical associations are made up
of creatures having the body of a
snake and the head of an animal.
In this case tusks have been added
for good measure.
Junction Farm, Cathcart.

CHAPTER 9

Mythology

189.
Myths, superstitions, legends—call
them what you may, they all had a
very real place in the mind and
philosophy of every Bushman.
Living close to nature they sought
reasons for all things and in so
doing they discovered a means of
explaining and understanding the
common occurrences which in-
fluenced their everyday life. A man
dies and his body decays leaving
only bones. This is easily under-
stood and is illustrated here by the
skull held in the right hand of the
wounded and dying man. But what
of the spirit which lives in the body
and departs at the moment of
death? What form does it take?
Here realism gives way to fantasy
which in turn develops into mytho-
logy. According to this artist the
spirit leaves the body and passes
on in the form of a flying buck.
(See also illus. 201, 202). The
white "drawing" is an imitation of
the man scratched onto the rock
face by a herd boy.
War Trail, Barkly East.

Much of what has been written about Bushman mythology has been
based upon the work of such pioneers as Dr. W. H. I. Bleek, his sister-in-law,
Lucy C. Lloyd, and G. W. Stow. The efforts of these three were so closely
interwoven that, upon the death of Dr. Bleek in 1875, Miss Lloyd carried
on with his work of collecting material from the Bushman prisoners
working on the breakwater in Cape Town harbour. On the death of Stow
in 1882, she purchased from his widow the unfinished manuscript of his
book "*Native Races of South Africa*" and his collection of copies of Bushman
paintings—some 200 in number. In 1904 the manuscript was passed to
Dr. George McCall Theal who had it published in 1905. She never suc-
ceeded in publishing the paintings however, and on her death in 1914,
they passed to Dr. Bleek's daughter, Dorothea. Miss Bleek not only con-
tinued the work of both her father and aunt, but she searched out and
revisited most of the sites discovered by Stow. In 1930 she published the

190, 191, 192.
Anyone who has lived in South
Africa knows that water is a pre-
cious thing. Especially so the Bush-
man who relied entirely upon water
stored on or very near the surface
of the ground. So too did the
animals upon which he depended
for most of his food and clothing.
Small wonder then, that there were
rain gods such as these large
bodied hippopotamus-like animals
with their short stubby legs and
long wandering trunks. As in two
of our examples, fish are invariably
associated with these animals and
are usually situated near the end of
the trunk.

190, 191.
St. Michael's Mission Location—
Herschel District.

192.
Limburg. Zastron. 12 inches long.

190.

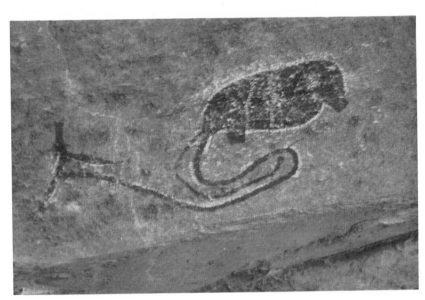

191.

192.

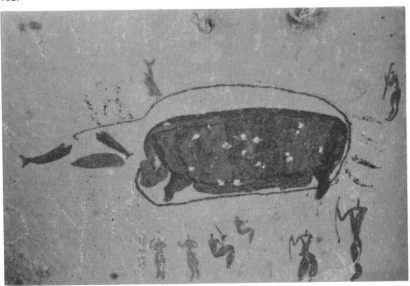

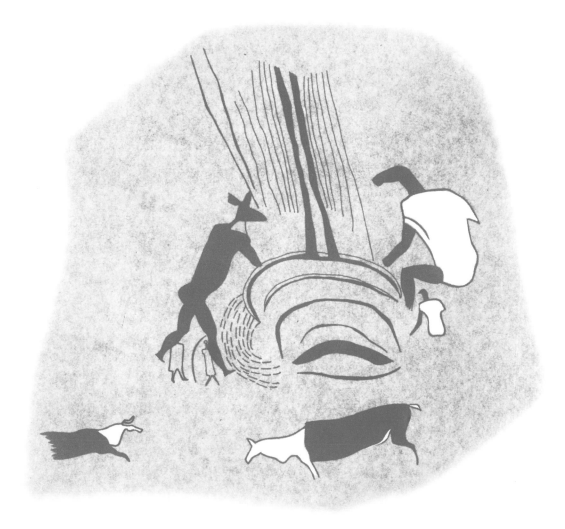

D30.
Here is another example of a painting with a rain making theme. Two mythical creatures, half animal —half man, stand beside a cloud conjuring up a storm which causes rain to spill over the edge and fall to the ground below. Klipkraal, Dordrecht. 25 inches.

book "*Rock Paintings in South Africa*", which contains seventy four of Stow's copies, many of which are accompanied by explanations given to Dr. Bleek and Miss Lloyd by Bushmen to whom the originals had been shown in 1874. Then in 1953 Eric Rosenthal issued his little book "*Cave Artists of South Africa*" in which appeared a further 48 previously unpublished examples of Stow's pictures.

As is so often the case, the work of pioneers and their devotion to their task is seldom recognised until long after their deaths. Twenty-three years were to pass before the publication of Stow's "*Native Races of South Africa*", yet it ran to three impressions within the next five years, indicating an awakening in public interest which has continued to grow ever since. Volumes have been written since that time on the subject of Bushmen

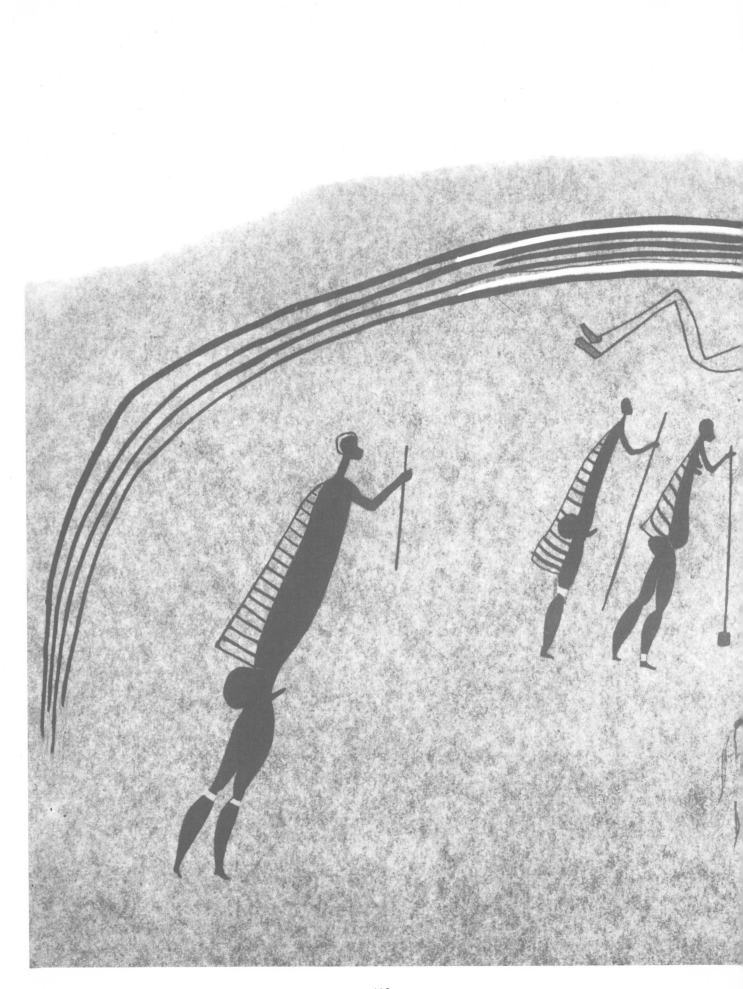

This tracing shows a massive rainbow beneath which stand both men and women all of whom wear the same type of cloak and all with the same hair style. The spotted animal is a rain-bull which again links this scene to a rain making ceremony. The supernatural element may be represented by the crudely drawn outline person lying on his back immediately below the rainbow.
Rietfontein Location, Herschel.

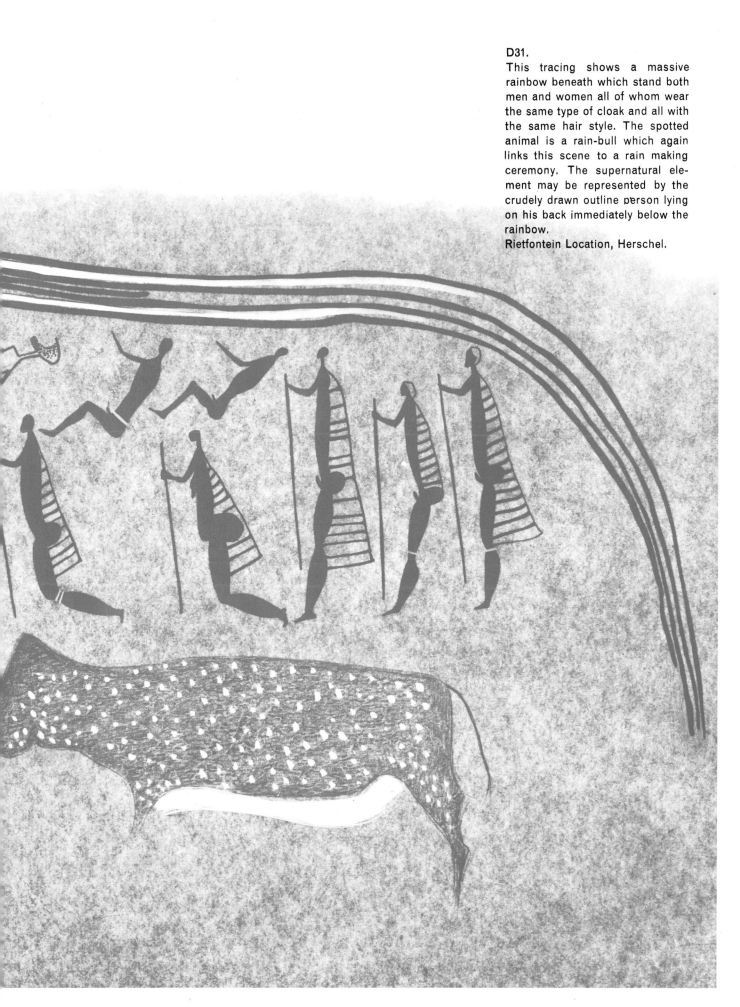

When no explanation can be found for a painting, it is a great temptation to toss it into the pigeon hole of mythology. This is precisely what we have done with these "animals".

193.
An incredible mythical animal which is almost all head. The dots were probably dabbed on with a finger.
Wide Valley, Maclear. 11 inches high.

and their mythology and it is certainly not our intention to attempt to add to them since we have little which is new to contribute. All we wish to do is introduce some examples of paintings which seem to us to be connected with their legends.

The people interviewed by Bleek and Lloyd were all "Colonial Bushmen", so called because they came from what was at that time the Cape Colony. More specifically they had lived in the sparsely vegetated Karoo regions of Great Bushmanland toward the north-west of the territory. Consequently the stories so painstakingly collected by them (after they had learned to speak the language), all stemmed from this one section of a vast country. Apart from J. M. Orpen, who was at the same time collecting material from the people of Lesotho, we have few other records of tales from the ancestral Bushmen who once roamed the whole of southern Africa. Nevertheless, enough material is available to indicate striking similarities between the fables collected by Bleek and Lloyd on the one hand and by Orpen on the other. They confirm that over the whole territory the common characteristics of Bushman mythology was the existence of animal spirits. As an example, the stories of their favourite spirit, the Mantis, vary only slightly from each other. /kaggen of the Cape Bushmen and Cagn of Lesotho and the Orange Free State were both supernatural beings who made all things—the animals, the stars, the moon. Both loved to play tricks on people and children, and they could change themselves into different forms. They were often killed (and eaten) but always came back to life again. Each was married to a Dassie (Hyrax capensis) and each had two sons who were often involved in their fathers' escapades. Cogaz, the son of Cagn, was killed by baboons and restored to life again—exactly the same thing happened to the son of /kaggen (who had a completely unpronounceable name). Cagn gave all animals their special marks—/kaggen gave them their colour.

Although Mantis may have been the favourite hero of Bushman folklore,

194.
This is the only figure in this group of illustrations which is part of a larger scene. It is a close-up detail from Diana's Vow (See pages 78 and 79). The significance of the long straight-haired mane and the long curved tusks on this dog-like creature is quite unknown to us.

he is seldom seen in their paintings, unless of course he is shown in one of his many disguises. The best examples known to us are the dance scenes from the famous Orange Springs and Delila sites; both of which occur in the north. In each case the paintings illustrate men miming the stance of the little insect.

Because of the Bushman's dependence on water, rain was something to be respected since it was essential both for his own well-being and that of the animals which provided his food. In addition, it was something to be feared since it often came as a flash storm with lashing torrential rain, wind, thunder and lightning. Small wonder then that it was considered by the Bushmen of both the Cape and Lesotho, to be a supernatural being.

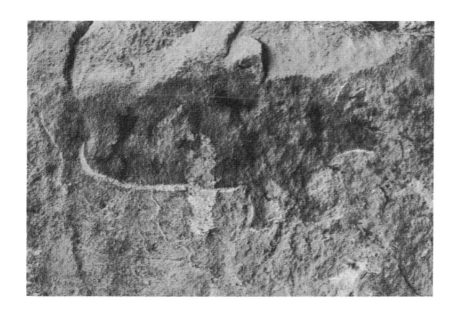

195.
This could be a hippopotamus— it could also be a rain-bull. Andover 3, Dordrecht.

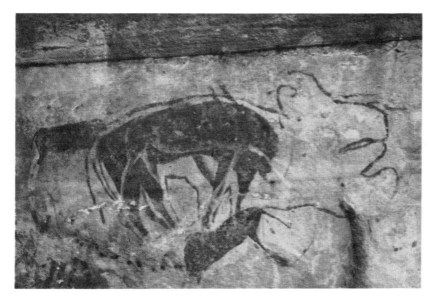

196.
This double chinned monster has either been superimposed in out- line around an earlier monochrome animal or it is intended to be part of its body. Over that part again can just be seen the faint beautifully shaded white outline of a buck. Klipkraal 2, Dordrecht. 13 inches wide.

Here in fact is another case where their mythology overlaps, but this time we have a number of pictures which illustrate the illusionary creatures who played such an essential role in their superstitions, beliefs and legends. Rain was a bull, sometimes shown as a solitary animal with a long, winding trunk and with a body covered in short hairs. Sometimes it was shown standing under a semi-circle made up of a number of lines clearly indicating a rainbow. Or it could be shown as a spotted animal.

The narrator of the fable "The Woman and the Rain Bull", explains how the Bull lives in a water hole (pit) and when it leaves it the rain dries up. He explains how when the Rain is present it becomes misty and that the Rain's scent is fragrant. These all add up to a shrewd understanding of the effects of different weather conditions. The continuous heat of the sun, so common in arid Bushmanland, would make water evaporate and cause the holes to dry up; falling rain does, under some conditions, cause mist and poor visibility, ("The Rain's breath was want to shut in the place") and after a drought there is no more fragrant smell than that caused by the first shower which settles the dust and washes the dirt from the leaves of the grass and shrubs.

197.
A typical example of the double ended, double headed snake which is so often associated with superstitious beliefs and legends. This painting is 7 feet 6 inches across so the actual overall length of the snake must be quite enormous.
Ndanda School, Birchenough Bridge, Rhodesia.

The same legend tells how Rain left the spring in which it lived and went courting a young woman. She climbed on to his back and, fearing that he intended taking her to his water hole, where she would be turned into a frog, she persuaded him to stop under a large tree. There she rubbed his neck with buchu (the sweet scented shrub Diosma) soothing him to sleep so that she could creep silently away and escape back to her hut. One is reminded here of the equally amorous Zeus who, after turning himself into a snow-white bull, lay down at the feet of Europa. The moment she climbed on to his back, he got up, entered the water and swam out to sea to the island of Crete. Unlike the Rain Bull, Zeus was successful in achieving his purpose, though little good it did him or the unfortunate Europa.

Mythology provides man with models or patterns on which he must base his conduct, and in line with this principle, many of the Bushman stories were intended to instil a sense of discipline into children by telling them of the dire consequences of disobedience. One example is the fable "The Thunderstorm" in which a young girl ignores her mother's warning that she should not play her musical instrument whilst a storm is near as this would anger /Kunn, the rain sorcerer. She took no notice, with the

D32.
This time the "snake" has an animal head, a hairy body and the suggestion of wings.
Makuini, Lesotho.

198.

It is quite possible that this form has no mythological meaning at all. We have included it as a classical example of the egnimatic paintings which are to be found scattered here and there throughout the cave art sites of Southern Africa. There is nothing about its shape or make-up which gives us any clue to its purpose.

Eland Cave—Cathedral Peak.

Page 130.

Two illustrations of a belief in a spirit world.

201.

Some distance to the right, and out of this picture is another figure more human in appearance with legs drawn up to the breast in just the position used for Bushman burials. The second and third figures shown here may illustrate the progressive transformation from the human to the spirit form, interpreted as a flying buck.

Longholme. Rhodes, Right-hand figure 4 inches.

202.

A ferocious looking lion is shown chasing a number of men. Immediately above them are the same type of flying buck but in this case they are joined to the men by a series of lines. Perhaps in this case the men are not dead but are calling desperately upon their spirit guides to aid them in their flight.

Balloch, Barkly East. 61 inches long.
Page 131

203.

Two rain bulls each standing below a rainbow. There is a great deal of stylisation in the painting, especially the cloud with the rain pouring from it which can be seen immediately below the animal on the right.

La Rochelle, Bethlehem.

204.

Artist's licence, a humorous cartoon or another mythical mystery? One guess is as good as another.
Flauwkraal, Dordrecht.

198.

result that it rained so hard it seemed as if it would tear off her mother's skin. "I had acted thus", she said, "When Mamma told me to leave off playing the goura—like /kunn—I would not listen; I was the one who saw that the rain had intended to kill us, on account of my doings". A chastened child it seems!

Rain seems to have had some special significance to the people who lived in the long shallow shelter on the farm Klipkraal, since not only is there an incredibly accurate painting of a thunderstorm, but another which could represent a sorcerer and his assistant conjuring up rain which spills out over the rim of their cloud.

Naturalistic paintings of snakes are seldom seen yet there are many examples of composite creatures with snake-like bodies which have giraffe, buck or horned heads. In some cases the head is even more grotesque with large ears, a gaping mouth and long curved fangs, on occasions with smoke issuing from the mouth in the best dragon-like tradition. It seems clear that these are illustrations of ancient folk-lore connected with both the Bush and Bantu tribes. The enormous 15 ft. buck-headed snake painted in the Gulubahwe Cave in the Matopo Hills of Rhodesia, has both animals

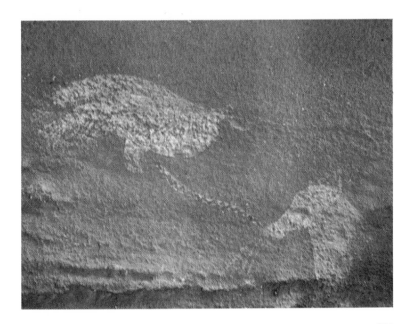

199, 200.

This photograph was kindly loaned to us by our good friend and fellow researcher Murray Schoonrad. It shows a beautifully drawn group of eland in various attitudes with a white bird in the top left-hand corner. From it, there stretches a white line with a red zig-zag pattern which connects it to some of the eland. In his monograph, "Bird-Lore of the Eastern Cape Province" Rev. Robert Godfrey tells of the lightning bird (Mpundulu) which is much feared by the Xhosa people. "This bird preys on people, sucking their blood till they die." As this painting is in a part of the country populated by the Xhosa, it could well illustrate this same superstitious belief.

Buttermead, Rhodes.

200.

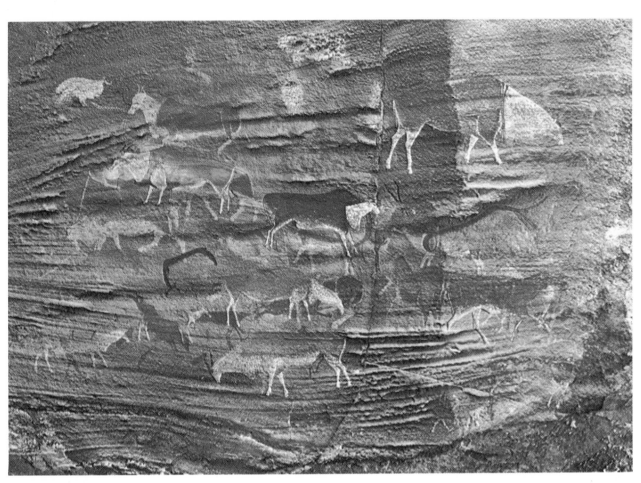

199.

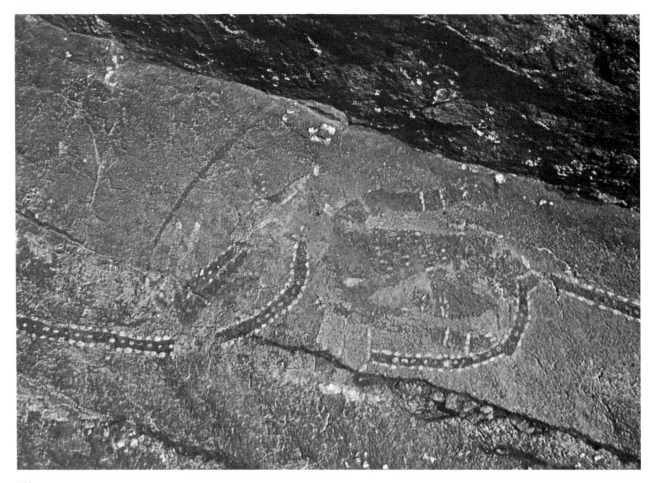

201.
202.

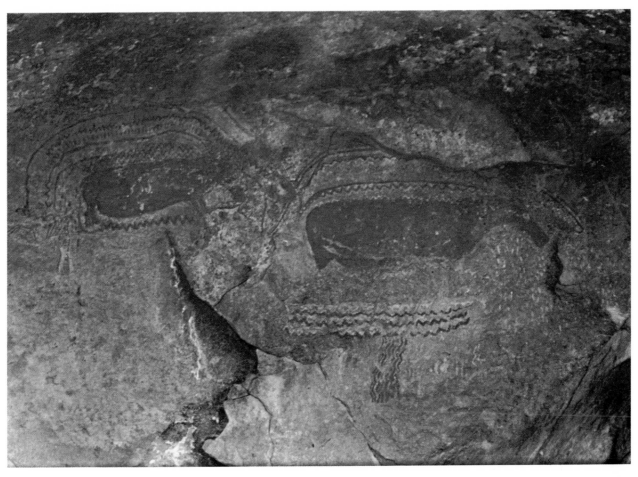

203.
204.

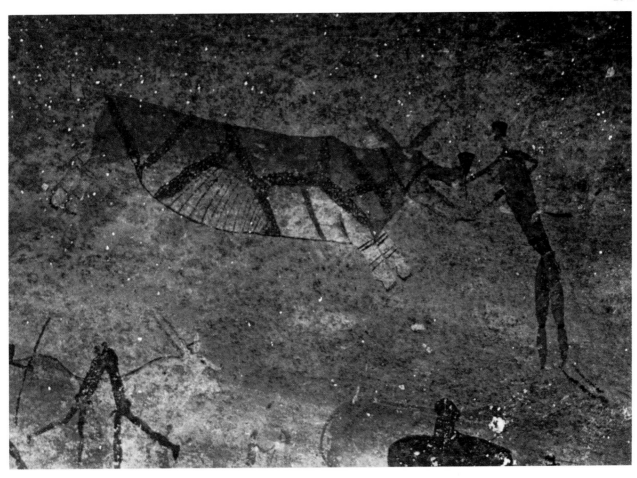

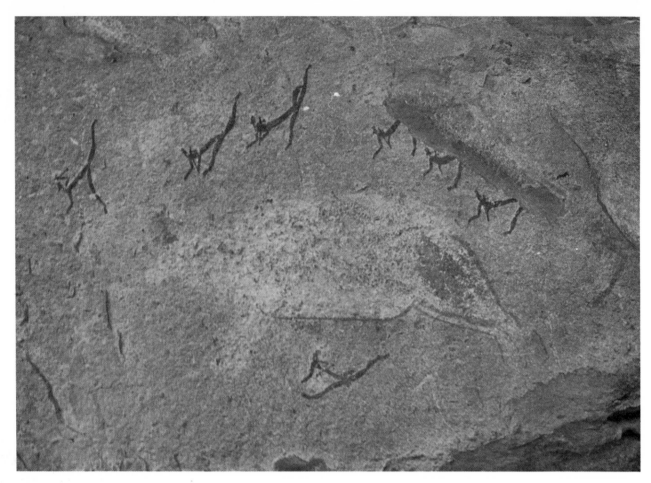

205.
206.

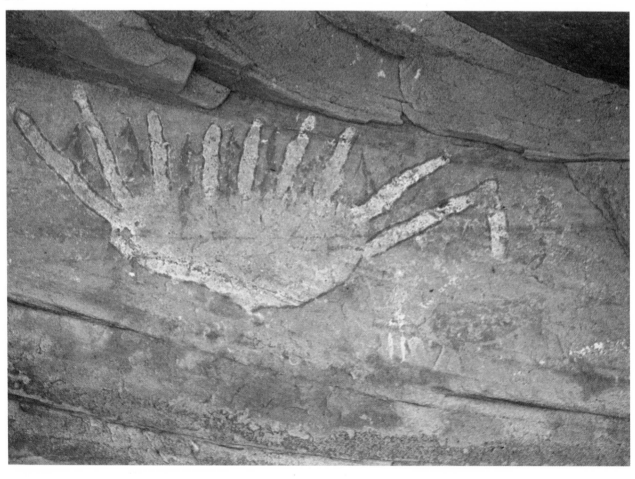

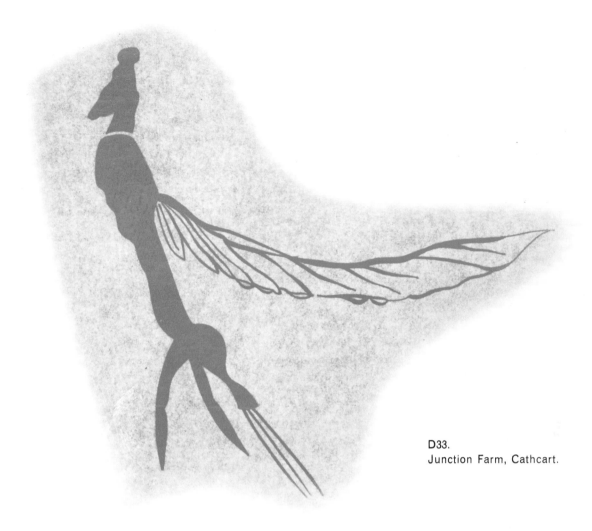

D33.
Junction Farm, Cathcart.

and people standing between the humps of its back. This has been linked with the folk story of the enormous snake longer than the rivers and taller than the mountains which has animal, people and houses on its back. Although of Bush origin, the snake exists as a very real being in the legends of the present African inhabitants of Rhodesia. Stow tells the story of an old Bush woman who described a horned-serpent in the Koesberg that was 20 to 30 feet long and lived in the water. He explains too how some Bantu held serpents in superstitious dread, believing them to be animated by the spirit of some great chief. To kill one meant death. That should have been quite enough to put anyone off snake cutlets bonne femme!

Apart from these few examples of paintings which can be linked quite accurately to recorded fables, there are many others where there is no known interpretation but which must surely have had some association with folklore and superstitious beliefs. As we have seen, the purpose of a myth is to provide an acceptable explanation for occurrences which would otherwise be completely unintelligible. They answer a fundamental need of primitive societies to be able to understand the occurrences which influence their everyday life. The story-tellers spoke of a place to which

205.
Six men jump over and another runs under a mythical animal. The implements carried by some of the men are remarkably like toma-hawks.
Makuini, Lesotho.

206.
The explanation suggested by Mr. Hepburn who took us to this painting was that it shows people standing between the rays of the rising sun. This seems as good an interpretation as any.
Ishinidini Location, Bamboospruit, Herschel.

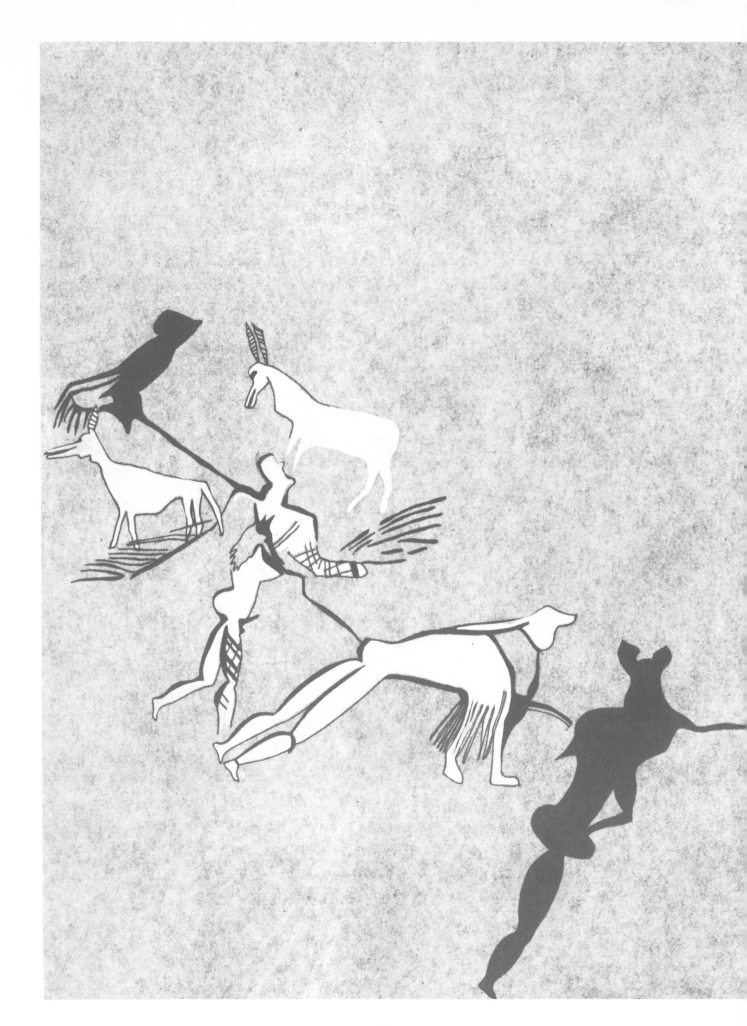

Bushmen went after death and of girls who were killed by lightning being converted into stars, whilst those who were killed by rain became beautiful water flowers. Some people make clouds when they die. These impressions all give an indication of a belief in a life after death and a series of paintings discovered by us confirm this, but in a completely different way.

One of the paintings on the farm War Trail shows a wounded man who, leaving a trail of blood behind him, has sunk exhausted to his knees, bleeding from the mouth and chest. In his right hand he holds a skull-like object whilst immediately below him is a strange figure with an antelope head, with human legs tucked under its body and outstretched arms resembling rudimentary wings. Only about five miles away on the wall

D34.
This remarkable painting occurs only a few inches above the ground on the wall of a large boulder shelter. The line connecting the figures together and the gradual change from the human to the animal form may again illustrate a primitive belief in a life after death. Klipkraal 2, Dordrecht. Length approximately 34 inches.

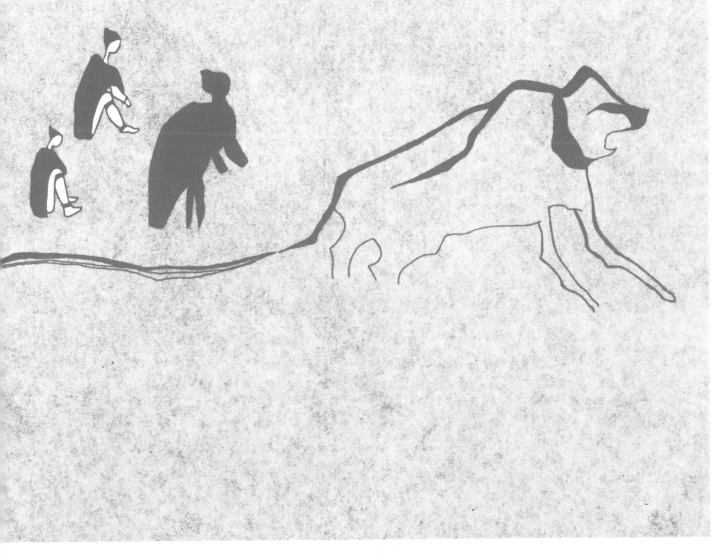

207.
This could be a man dressed in a winged costume to represent a mythical creature. The lower part of his body has been obliterated by a superimposed eland. Whoever he is, he looks down from a height of about 15 feet. How the artist got him there is a mystery in itself as there are no signs that the floor has been washed away, in fact paintings continue to a height of only 3 to 4 feet above the ground.
Makuini, Lesotho.

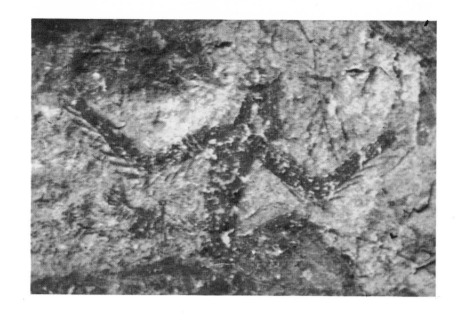

D35.
A "snake" with an animal head, horns and smoke coming from its mouth.
Frognall Drift.

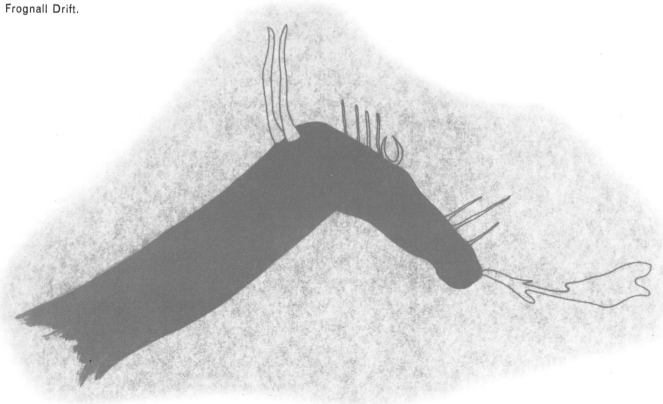

of a small boulder shelter on the farm Balloch, there is a painting showing a number of men fleeing in panic from a pursuing lion. From their heads lines stretch upwards and are connected to a series of animal-headed figures almost identical to the one at War Trail.

Then we discovered another example on the farm Longholme near the village of Rhodes in the North Eastern Cape. This time three forms are grouped along a horizontal line. The one on the far right illustrates a man with knees drawn up against his breast in just the posture in which he would be buried after death. The middle figure shows the same crouching position of the body and legs but now the arms have become more wing-like and it has an animal head. Finally on the left we see the ultimate transformation into a winged animal spirit. Who knows, perhaps these examples of the same theme illustrate a religious belief that when death occurs the spirit leaves the body and assumes the form of a winged buck. If this is the case it may also explain the significance of the ritual dance scence from Naudeslust.

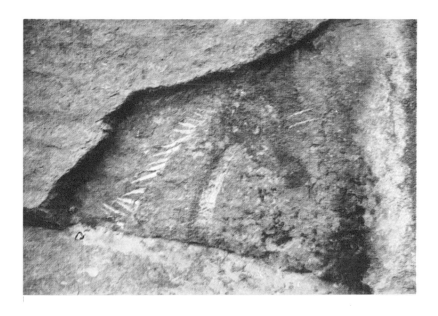

208.
A painting with an almost identical theme to D35. The spiked body continues for close on 5 feet.
Ross Trevor, Barkly East.

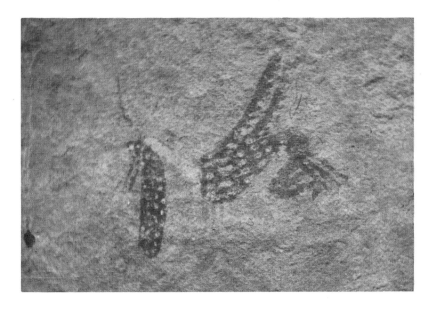

209.
A strange winged creature with horns and the legs of a human.
Elandsklip, Normandene. 2 inches.

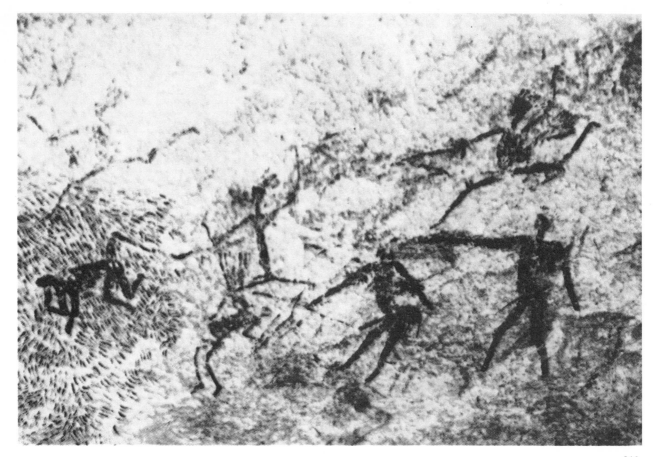

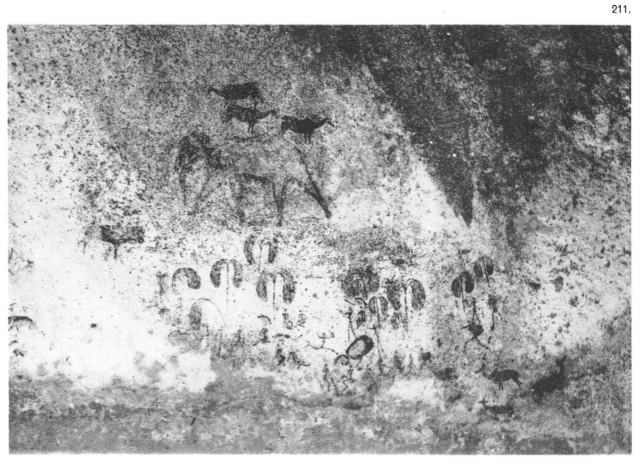

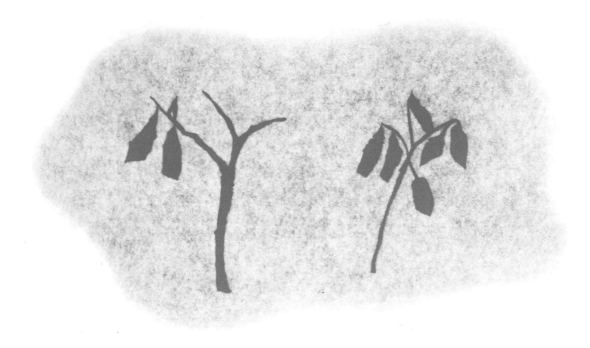

CHAPTER 10
The Surroundings

Landscape painting is not a common feature of the prehistoric art of Southern Africa, in fact it is rare—but not completely absent, particularly in Rhodesia. Mrs. Goodall has drawn attention to this in the book *Prehistoric Rock Art of Central Africa* and has made tracings of what are probably rivers and marshes. At Mrewa men armed with battle axes appear to be pursuing a fugitive into a marshy area. Lines of dots in South African paintings may conceivably represent boulder-strewn river banks, particularly at Zonneving near Cathcart. Lines of dashes at other sites also give the impression of rivers or waterfalls.

Of special interest is the suggestion that some of the amorphous shapes in the Rhodesian paintings—designated by the German ethnologist Frobenius as "formlings" for want of a better name,—may represent the huge natural monoliths and piles of boulders, the remains of granite domes, that are such a distinctive feature of the Rhodesian landscape. This seems as reasonable an explanation as has yet been made for these enigmatic scenes.

There are a large number of trees among the paintings North of the

D36.
Mrewa, Mashonaland.

210.
Pursuing a fugitive into a marshy area. The fugitive falls under a blow from a battle-axe wielded by the closest pursuer.
Mrewa, Mashonaland.

211.
A Bushveld landscape painted on a large scale, about 10 feet wide, Mavara, Fort Victoria.

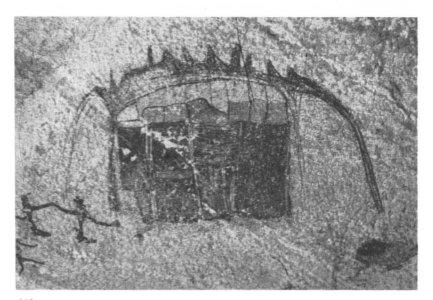

212.

212.
The entrance to a rock shelter hung with skins? A raid on a bee-hive? This painting from Amadzimba, Matopos, has yet to receive a satisfactory explanation.
Approximately 5 feet wide.

213.
A pool, a patch of marshy ground or a fish-trap full of fish?
Amadzimba, Matopos:

214.
A landscape painting? The white areas may represent the granite hills which are such a prominent feature of the Rhodesian landscape —particularly in the Matopos where this painting is to be found—and the coloured areas between them may possibly represent early cultivation patches made by the incoming iron-age people and observed with interest by the stone-age hunters. Several human heads may be observed peeping over the rounded white "hills".
Majenje, Matopos. Approximately 6 feet wide.

215.
Typical piles of huge granite boulders the remains of weathered domes which are a feature of the Rhodesian countryside. For comparison with the painting above.

Limpopo. Each illustrates well the typical habit of the tree concerned. Many include the roots. Some are isolated specimens, others are in groups typical of the countryside.

At Gomokurira trees and people are shown in a nicely integrated painting which includes a camp fire. South of the Limpopo scenes of this kind are rare but there are one or two which include trees.

A puzzling feature of many paintings is a meandering line of red ochre stretching for several yards across the rockface. In some instances this line could well be an indication of a path, as walking figures are associated with it. Alternatively it might be the horizon line. Against this practical explanation is the fact that in some cases similar lines finish in people's mouths or connect a group of animals, giving the impression of a line of magical force.

213.

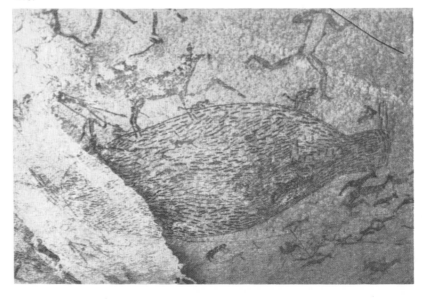

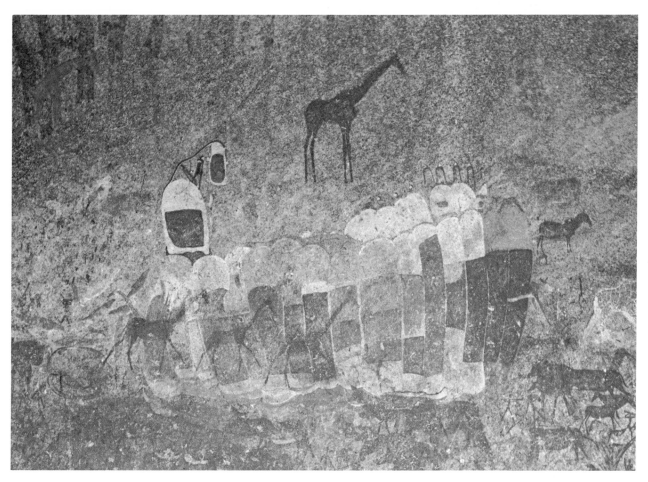

214.
215.

216.
Detail from the "landscape" scene at Majenje. Possibly two large boulders connected with a path but this guess really confesses ignorance as to the true meaning of the painting.

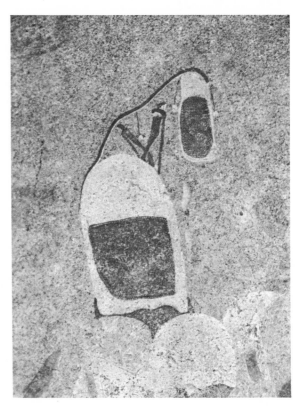

217.
An occupied rock shelter? In an attempt to domesticate the Bushmen. They were from time to time given presents of cattle. They also stole them from their Bantu neighbours. Three cows are tethered in this encampment and the typical skin carrying bags have been carefully depicted. Bamboo Mountain (now in Pietermaritzburg museum).

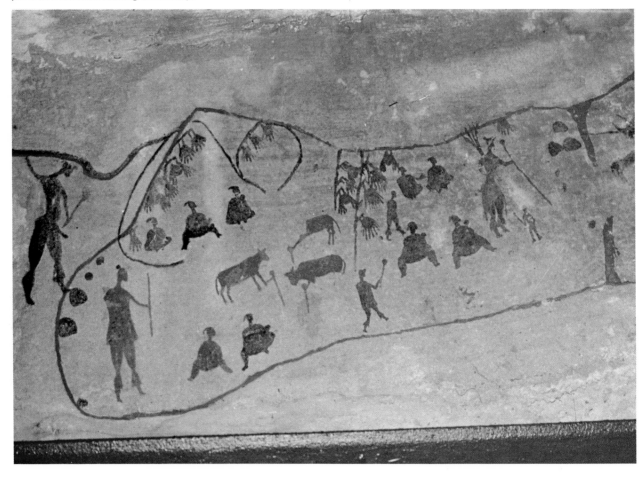

218.

219.

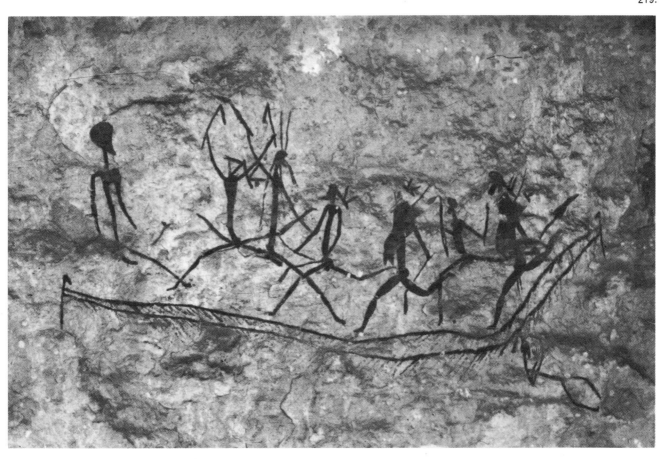

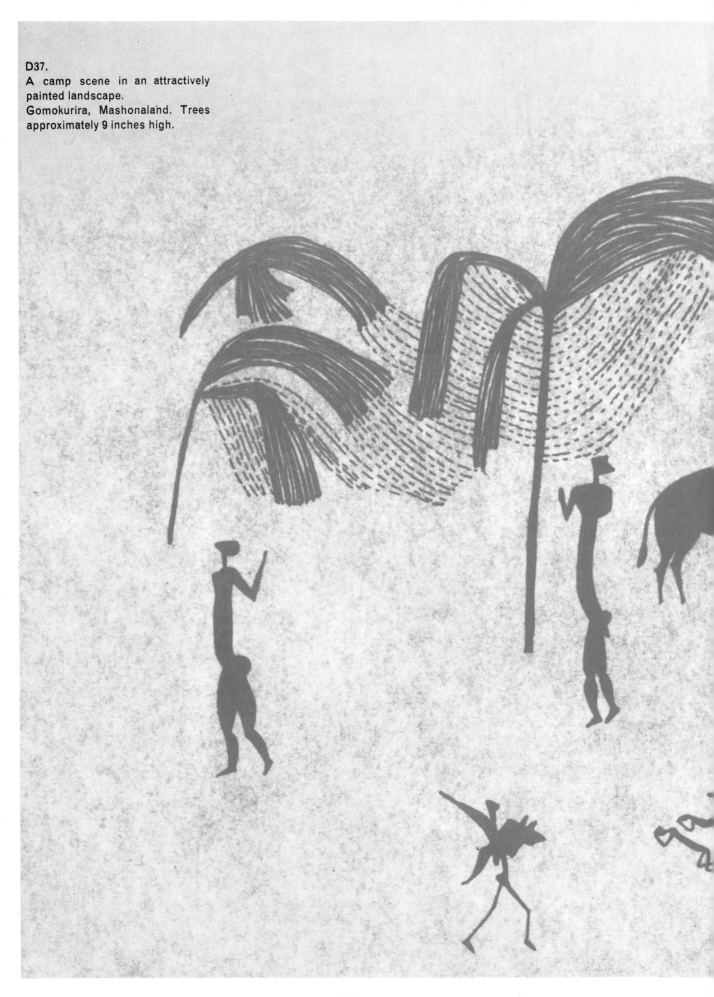

D37.
A camp scene in an attractively painted landscape.
Gomokurira, Mashonaland. Trees approximately 9 inches high.

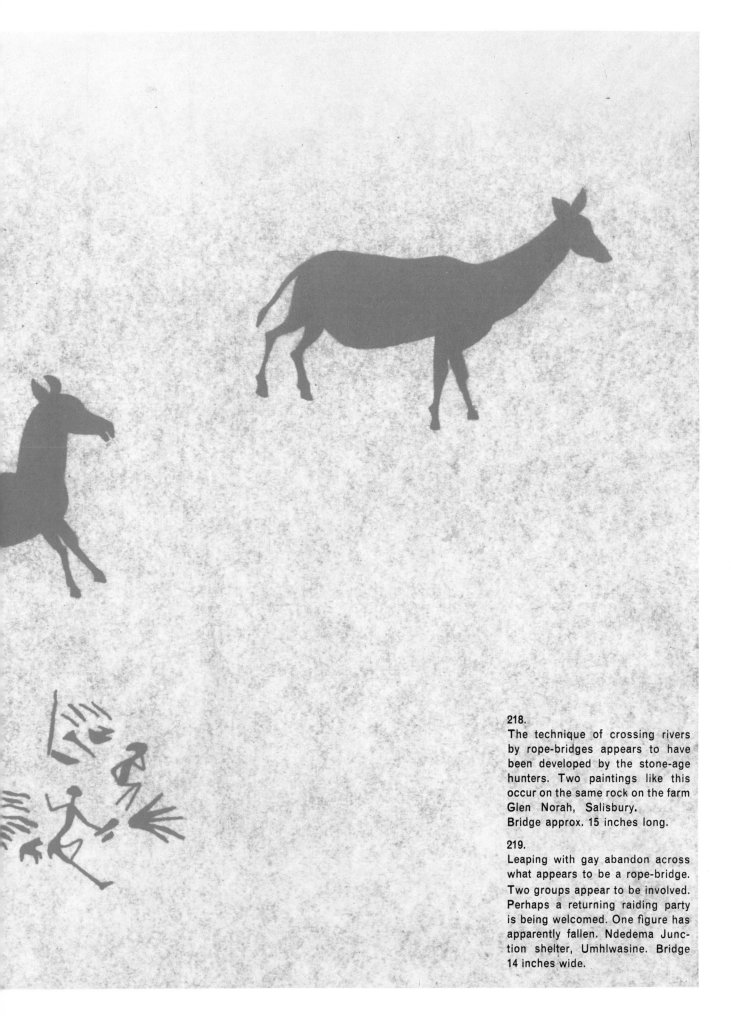

218.
The technique of crossing rivers by rope-bridges appears to have been developed by the stone-age hunters. Two paintings like this occur on the same rock on the farm Glen Norah, Salisbury.
Bridge approx. 15 inches long.

219.
Leaping with gay abandon across what appears to be a rope-bridge.
Two groups appear to be involved. Perhaps a returning raiding party is being welcomed. One figure has apparently fallen. Ndedema Junction shelter, Umhlwasine. Bridge 14 inches wide.

220.

221.

D38.

D39.

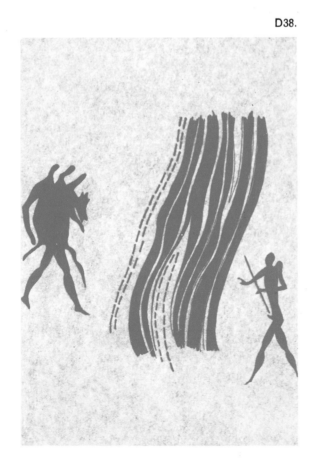

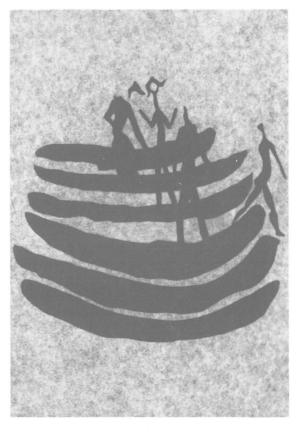

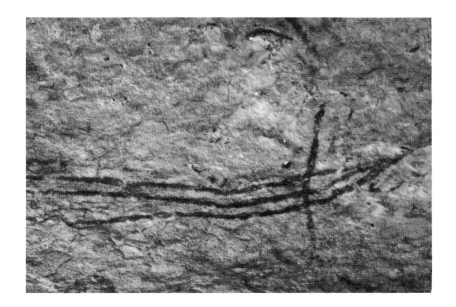

222.
Part of a set of meaningful but uninterpreted lines and rows of dots that cover close on 100 square feet of rock face in a shelter on the farm Roggefontein, Koue Bokkeveld This section is 3 feet long. The lines could possibly represent a map of the area.

There seems no doubt that other lines indicate windbreaks or rudimentary walls. They surround people engaged in various domestic activities. In certain instances they might even represent the rock shelters in which they are painted.

Natural phenomena, clouds, rain and rainbows occur occasionally. At Klipkraal in the Eastern Cape are fluffy rain clouds with streaks of rain slanting from them. On the farm Aberdeen near Harrismith are two paintings which appear to depict clouds and rain. The first is rather reminiscent of the Rhodesian "formlings" but the forms are horizontally elongated and arranged above each other so that the final result is a layer of stratocumulous clouds. The second is a veritable sheet of rain which is typical of the isolated thunder-showers common in this district of summer convection storms.

Rainbows must have been phenomena of special significance to prehistoric people. Paintings of them are rare and only occur South of the Limpopo. The largest is under a fallen rock on a farm near Oudtshoorn, but a more important one has been dealt with in the chapter on mythology.

220.
A waterfall or river? De Hoek, Oudtshoorn.

221.
Fluffy cumulous clouds and slanting rain. Klipkraal, Dordrecht.

D38.
A layer of strato-cumulous clouds? Aberdeen, Harrismith. 8 inches wide, figures 5 inches high.

D39.
A sheet of heavy rain from an isolated thunder shower? Aberdeen, Harrismith, 9 inches high.

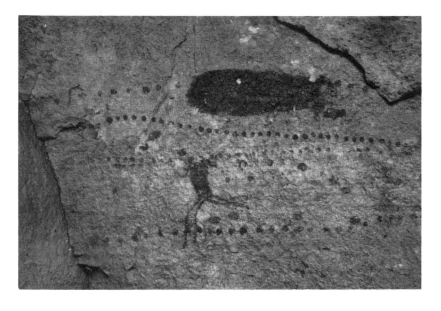

223.
The boulder-strewn banks of the nearby river?
Zonneving, Cathcart. 7 feet 7 inches long.

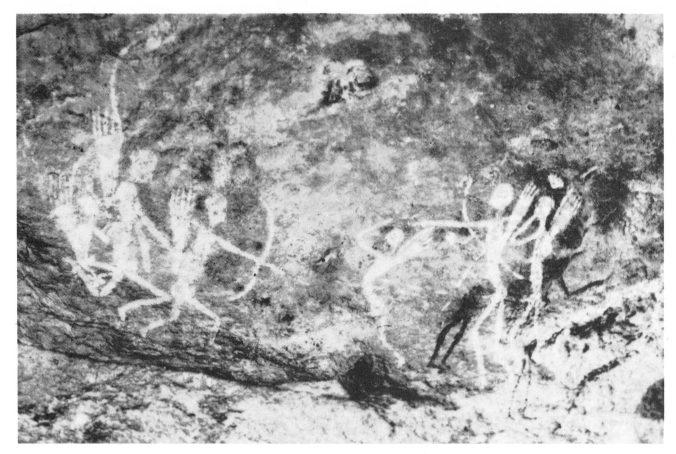

224.

225.

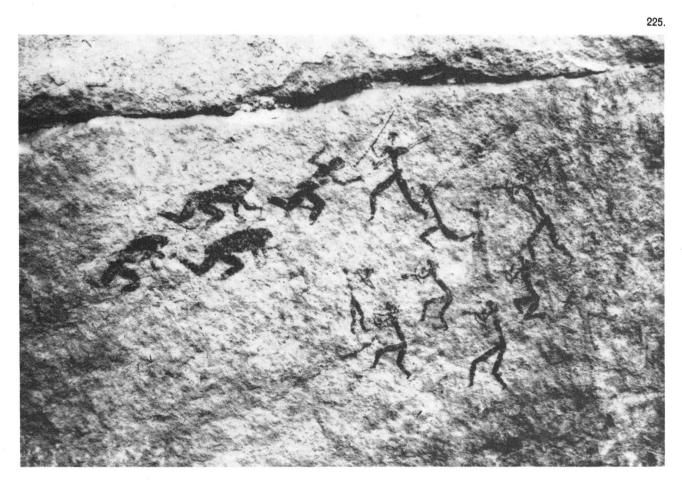

CHAPTER 11

226.

End of a Way

of Life

Throughout the centuries, even the millenia of the Late Stone Age, life in Southern Africa must have followed a peaceful pattern that changed little from year to year—a pattern dependent upon nature, the rain, the grazing and the movements of the eland herds. Occasionally there may have been clashes over territory between one group of hunters and another but in general there was plenty of room for everyone.

It is interesting to ponder the question of whether these hunting peoples were all of the same physical type or whether there remained pockets of a different stock. The question is raised by a painting at Goedgegeven where a clash of two groups is recorded. The men on the left are heavily built, crouching and have no bows or spears. One carries a short thick pointed object which could be stone or a stone implement. The members of the other group, by contrast, are lightly, rather elegantly, built people, upright and armed with bows and assegais. In this painting the difference between

224.
A clash between rival groups of hunter/gatherers over territory? Lopenderivier, Oudtshoorn.
27 inches wide.

225.
A fight between groups of completely different physical type. The lightly built, rather elegant men on the right are armed with bows and their leader has assegais while those on the left are apparently without sophisticated weapons of any sort.
17 inches wide. Goedgegeven.

226.
Times of stress produced the usual result—violence. Death made doubly sure.
Sebaaini's Shelter, Cathedral Peak.

227.
An ox at Danebury carrying a hut framework on its back in the manner of the Hottentots. Wodehouse District.

228.
The domestic animals of the Hottentots and Bantu were popular subjects among the Bushmen rock painters who saw them arrive without realising that they spelt the beginning of the end of the hunter/gatherer way of life. The bone in the nose of the upper ox indicates its probable use as a riding animal. This device was still in use among the Hottentots in recent times. Abbot's Ann, Clanville. Ox 8 inches wide.

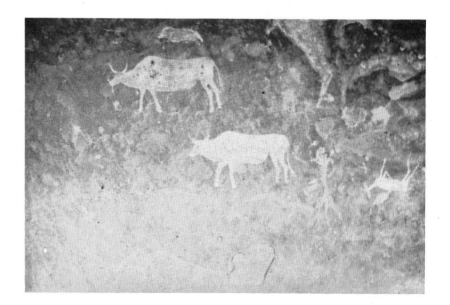

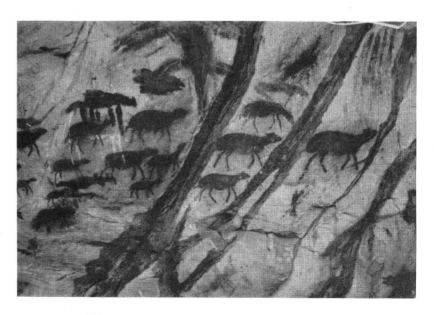

229.
Fat-tailed sheep. Boschkloof, Koue Bokkeveld.

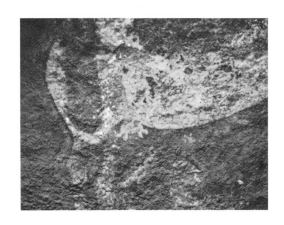

230.
The udder of a cow received detailed attention from a painter.
Andover, Clanville.

physical types is quite marked. In others, and there are many, there is not such a difference.

Although inter-tribal clashes probably took place between Stone Age groups it is even more probable that they became more frequent with the arrival of people with a different way of life—the Iron Age people. First came the Hottentots with their cattle, sheep and goats, then the Bantu with similar livestock plus a primitive knowledge of agriculture. These arrivals increased the pressure on water and grazing and hunted the wild animals for meat. Their cattle were a form of wealth only to be eaten on special occasions. At some date still to be definitely established but probably well over 1,000 years ago a knowledge of iron smelting reached South Africa—together with the corollary of more efficient weapons and more rapid diminution of the eland herds. This spelt the beginning of the end of the hunting and gathering economy of the Stone Age.

Early mining which was extensive, particularly in Rhodesia made virtually no impression on the rock painters—with one exception. At Mrewa is a clear picture of a man using a hammer—probably a stone hammer. Two thongs hang from a ring or band on his upper arm. This raises the question of whether he was a slave who was secured by these thongs at night. It is known that first the Arabs and subsequently the Portuguese had a good deal of trading contact with the kingdom of Monomotapa and that slaves were used to mine metals for trade—but we await a positive dating technique to throw more light on this enigmatic painting.

Unlike mining, the domestic animals of the Iron Age arrivals became a popular subject for the prehistoric artists. The probable migration route of the Hottentots through Rhodesia has been followed by C. K. Cooke by plotting the sites which include paintings of sheep. There are very many more such sites in the Transvaal and both the Eastern and Western Cape Province. The same applies to cattle. Animals that remained with human beings must have seemed very strange and therefore been a great source of inspiration to the Bushman artists. The Hottentot custom of carrying a hut framework on an ox is faithfully recorded as is the insertion of a bone through the nostrils of the animal to steer it by when riding. There is a painting of the use of an ox as a pack animal. The udders of both cows and sheep have been painted in detail.

151

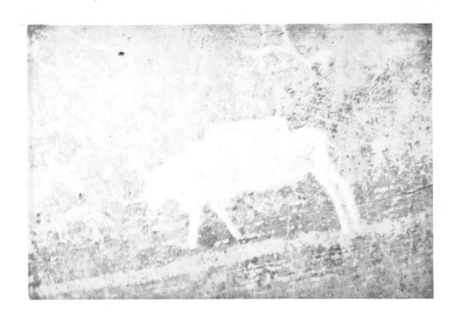

231.
An ox used as a pack animal.
Willcocks Bridge, Warden.

While it is obvious that the Hottentots and Bantu walked into South Africa with their flocks and herds, it has sometimes been suggested that other people, possibly the Phoenicians, arrived by sea. There is very little to support this suggestion but there are a few paintings of ship-like shapes that have not yet been satisfactorily explained. It is just possible that they may represent the early visitors to the coasts of South Africa mentioned by Herodotus.

Much more definite are the paintings of waggons or carriages drawn by mules and accompanied by men on horseback on remote farms in the Cold Bokkeveld. The carriages contain European women, distinguishable by their long, full-skirted dresses, and even children—one of whom is

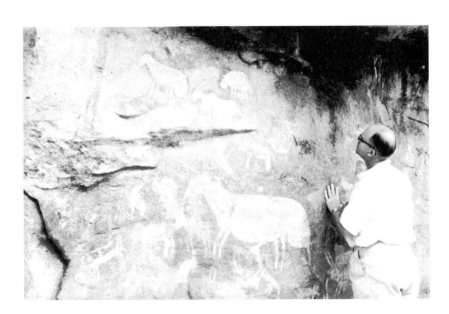

232.
Unusually large paintings of fat-tailed sheep.
Dwaalhoek, Waterberg. Largest 32 inches long.

gaily hanging on the tail board of a waggon with one hand. The style of the women's dress and the type of guns carried by the men indicate a date of late eighteenth century. Paintings of ships of unmistakeably European design also occur in this area. The technique of at least one is so similar to that of the carriages that it might easily have been painted by the same artist although authoritative opinion places it in the first half of the eighteenth century.

A man and a woman in the European dress of the early nineteenth century are painted on a rock which has been removed from the farm Klipfontein, Rouxville, to the Africana Museum in Johannesburg.

The settlement of Europeans in South Africa hastened the process of extermination of the hunter/gatherers that had been commenced by the clash with the Iron Age people. There was further pressure on the natural resources, particularly the herds of game and the Bushmen became cattle thieves with consequent persecution by both Bantu and Europeans. The reprisals consequent upon cattle raids are graphically depicted in the paintings particularly at Ventershoek and at Beersheba. At the former site a line of Bushmen painted in red are fighting a rearguard action against pursuing Bantu painted in black while other Bushmen are busy driving off the Bantu cattle. At Beersheba a mounted commando of Europeans and Griquas has caught up with the Bushmen cattle rustlers. Flashes from the rifles of the commando streak across the rockface and many of the Bushmen are painted in contorted attitudes as bullets find their marks. Cattle stand forlornly by—probably illustrating the retaliatory measure of hamstringing so often employed by the Bushmen when they were

233.
One of the mysterious ship-like objects, the nature of which has not yet been satisfactorily explained. They occur infrequently over an area from Salisbury to the Cape. Arrarat, Harrismith, O.F.S. 6 inches wide.

234.
South of the Limpopo there are no paintings of early mining activities but this figure at Mrewa, Mashonaland is using a stone hammer, either for mining or as a smith.

235, 236.
Part of the wave of Iron Age people who brought a new technology to Stone Age South Africa.
Melikane, Lesotho, Swallewkranz.
Tarkastad. 7 and 4 inches tall respectively.

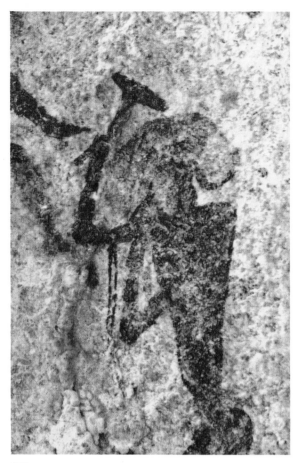

234.

235.

236.

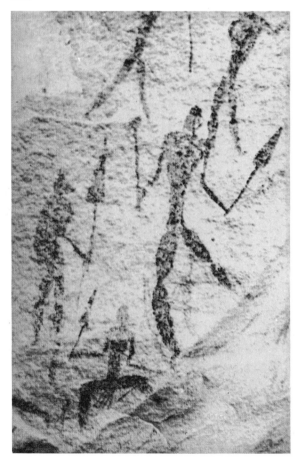

caught. The horses date these pictures to some time after 1830 and there is no doubt that a good deal of painting was still going on about this time.

The Bushmen themselves were quick to learn the use of the horse—just like their "cousins" the Red Indians of North America. They became fearless horsemen and there are a good number of paintings depicting the gay abandon with which they rode—one particularly interesting one from Bamboo Mountain in Natal clearly shows the handsome leopard-skin cloak of the rider streaming out behind him.

During the 1820s Southern Africa was subjected to the rampages of the all-powerful military machine developed by Chaka. The Zulu impis armed with the new short-handled, big bladed assegai produced ripples on the human surface of the sub-continent that were felt throughout its length and breadth. The impact on one prehistoric artist is vividly recorded at the National Monument site at Modderpoort. In some cases the assegais are

237.
The short, big-bladed stabbing assegai with which Chaka equipped his impis made a deep impression on the artist who recorded this scene in the 1820s at Modderpoort on the O.F.S./Lesotho border. Figures each approx. 2 inches wide.

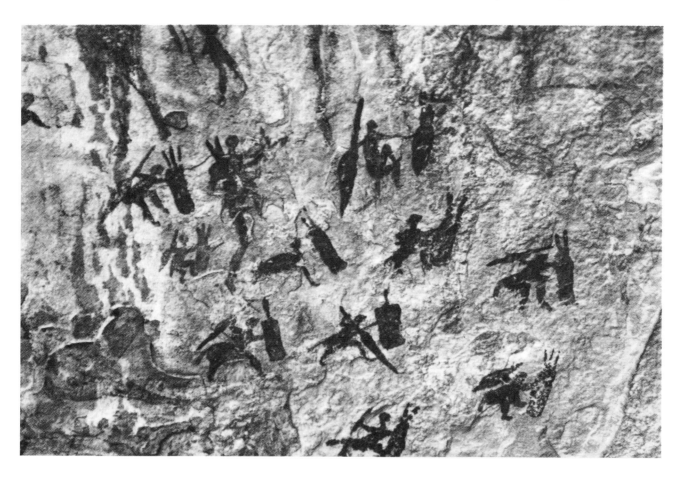

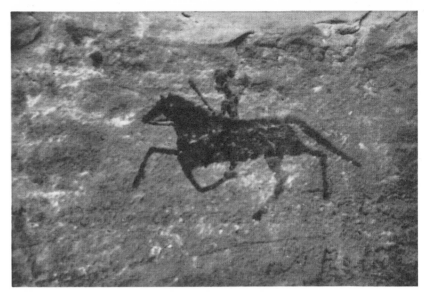

238.

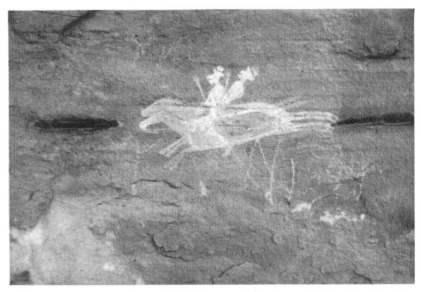

239.

240.

238, 239, 240.
The introduction of horses into South Africa provided a fascinating subject for the last of the pre-historic artists.
Mpongweni , Himeville.

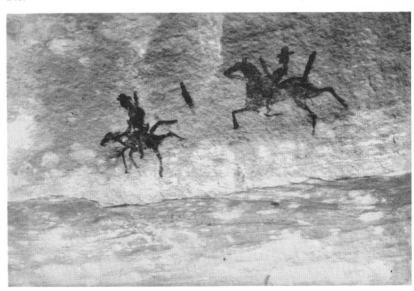

painted bigger than their owners. The dramatic effect is heightened by the use of only one colour—black. Each man carries his shield which has a number of head-like projections at the top corresponding to the number of men he has killed. Those with more than one head are designated *monyongwana*—"little wretch of the bile" from their use for catching a victim under the chin while an upward thrust of the assegai was delivered.

Many of the Bushmen perished in the Zulu holocaust together with the Sotho under whose protection they had placed themselves. By the end of the nineteenth century there were virtually no artists left. In Lesotho a good deal of intermarriage had taken place between Bush and Bantu with the result that the art of painting on the rocks lingered there after it had disappeared elsewhere. In her book *The Mountain Bushmen of Basutoland* Mrs. How illustrates paintings made by Mapote and Masitise the last men to

241.
The opening up of the interior of South Africa by the Europeans is recorded in paintings in the Cold Bokkeveld in the north-western Cape. These carriages drawn by mules, carry women in long, full-skirted dresses and sunbonnets. On one of them a child swings gaily from the tailboard.
Stompiesfontein, Cold Bokkeveld.

157

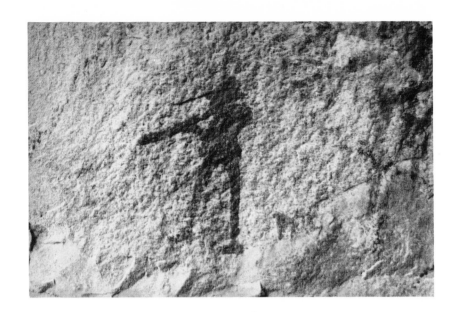

242.
Although rather crudely drawn this painting captures the typical attitude of a man firing a rifle. Stompiesfontein.

have the skill. She describes in detail how Mapote went about his task and the brushes and paints that he used.

There is little doubt that Mapote was working in the direct tradition of many generations of predecessors despite the fact that he was a Mophuthi, not a Bushman. He told Mrs. How that he and his half-Bush stepbrothers painted at one end of a rock shelter while the true Bushmen painted at the other. Mapote's brushes were feathers stuck into the ends of reeds. His red paint was a special red ochre, largely haematite but containing small quantities of mixed hydrated iron oxides e.g. limonite and goethite which he mixed with the blood of a freshly-killed ox as no eland was available. The white paint consisted of a siliceous clay mixed with the juice of a succulent plant, asclepia gibba. For black, Mapote used charcoal from burnt sticks mixed with water.

The paintings made by Mapote at Quthing, Lesotho, were the last of Southern Africa's "Art on the Rocks".

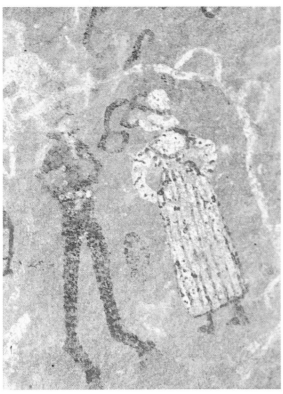

243.
A man and woman in the dress of the early nineteenth century painted at Klipfontein Rouxville (now in the Africana Museum, Johannesburg).

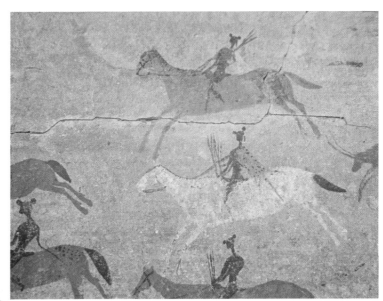

244.
The Bushmen, like the Red Indians quickly adapted to the use of horses and became fearless riders. Bamboo Mountain, Natal (now in Pietermaritzburg museum).

245.
Probably an incident in a fight between Xhosa and Bushmen. The coup de grace delivered by an iron-bladed assegai.
Delila, Jamestown. 5 inches tall.

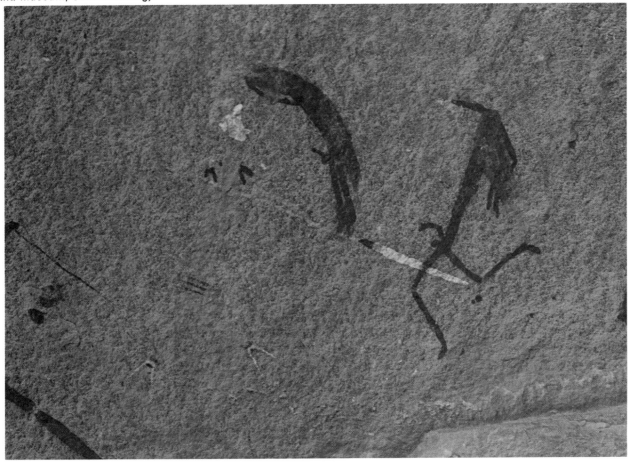

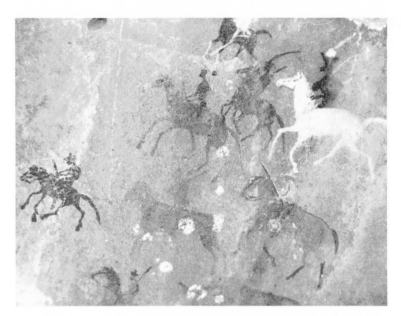

246.

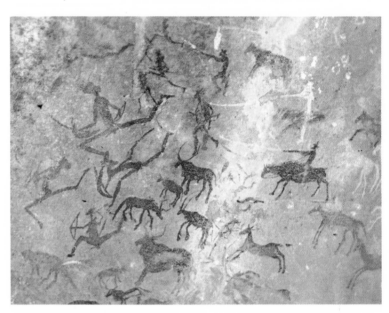

247.
248.

246, 247, 248.
The end of the story. Having very few eland left to hunt, the Bushman resorted to cattle rustling. When the cattle of Europeans were stolen, commandos were formed and the Bushmen were hunted down. Here a commando fires at fleeing Bushmen. The contorted attitudes indicate that several have been hit. Beersheba, East Griqualand.

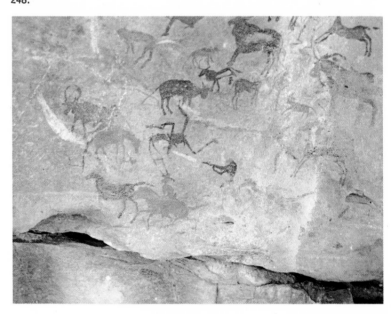

Index

Index

Index

Recommended Reading List

The following list is not a complete bibliography and does not include the periodical literature consulted by the authors. It is intended as a guide to the general reader who wishes to extend his reading on rock art in general and rock art in Southern Africa in particular.

1. Adamson, J.
 The Peoples of Kenya. Collins and Harvill Press, London, 1967.
2. Barrow, J.
 Travels into The Interior of Southern Africa, London, 1801.
3. Battiss, W.
 The Artists of the Rocks. Red Fawn Press, Pretoria.
4. Bleek, W. H. I. & Lloyd, L. C.
 Specimens of Bushman Folklore. George Allen, London, 1911.
5. Bleek, W. H. I. & Lloyd, L. C.
 The Mantis and his Friends. Maskew Miller, Cape Town, 1924.
6. Burchell, W. J.
 Travels in the Interior of Southern Africa, London, 1822.
7. Burkitt, M. C.
 South Africa's Past in Stone and Paint, Cambridge University Press, London, 1928.
8. Desroches-Noblecourt, Christiane.
 Egyptian Wall-Paintings, Fontana Unesco Art Books, 1962.
9. Goodall, E. Cooke C. K. & Clark E. J. Desmond.
 Prehistoric Rock Art of the Federation of Rhodesia and Nyasaland. National Publications Trust, 1959.
10. Harris, Capt. Sir William Cornwallis.
 Wild Sports of Southern Africa. Struik, Cape Town.
11. How, M. H.
 The Mountain Bushmen of Basutoland. Van Schaik, Pretoria, 1962.
12. Johnson R. Townley Rabinowitz, H. Sief, P.
 Rock Paintings of the South-West Cape. Cape Town, 1959.
13. Leroi-Gourhan, Andre.
 Treasures of Prehistoric Art. Harry N. Abrams, New York.
14. Lajoux, Jean-Dominique.
 The Rock Paintings of Tassili. Thames & Hudson, London, 1963.
15. Lhote, Henri.
 The Search for the Tassili Frescoes. Hutchinson, London, 1959.
16. McBurney, C. B. M.
 The Stone Age of Northern Africa. Penguin Books, 1960.
17. Mountford, Charles P.
 Aboriginal Paintings from Australia. Fontana Unesco Art Books, 1964.
18. Obermaier, H. & Kuhn, H.
 Bushman Art. Humphrey Milford, London, 1930.
19. Rosenthal, E.
 Cave Artists of South Africa. Balkema, Cape Town, 1953.
20. Schapera, I.
 The Khoisan Peoples of South Africa. Routledge & Kegan Paul, London, 1930.

Continued

21. Silberbauer, George B.
 Bushman Survey Report. Bechuanaland Government, Gaberones, 1965.
22. Sparrman, Andrew.
 A Voyage to the Cape of Good Hope, London, 1786.
23. Stow, G. W.
 The Native Races of South Africa. London, 1905.
24. Stow, G. W. & Bleek, Dorothea.
 The Rock Paintings in South Africa. Methuen, London, 1930.
25. Thompson, G.
 Travels and Adventures in Southern Africa. London, 1827.
26. Ucko and Rosenfeld.
 Palaeolithic Cave Art. World University Library, London, 1967.
27. Willcox, A. R.
 Rock Paintings of the Drakensberg. Max Parrish, London, 1956.
28. Willcox, A. R.
 The Rock Art of South Africa. Nelson, 1963.

LIST OF SITES FROM WHICH ILLUSTRATIONS HAVE BEEN TAKEN

BARKLY EAST BURLEY · WAR TRAIL · BLUE BEND · FETCANI GLEN · BALLOCH · ROSS TREVOR HALESTONE

BEDFORD HUNTLY GLEN

BERGVILLE ELAND CAVE ASCENSION · SUNDAY FALLS ROOIHOOGTE · N'DEDEMA JUNCTION · SEBAAINI'S · THEODORUS BOTHA'S SHELTER · RHEBOK PROCESSION

BETHELEHEM EENDVOGELVLEI LANGKLOOF · SNYMAN'S HOEK LA ROCHELLE · SKAAPLAATS

BUTHA BUTHE MAKUINI

CATHCART ZONNEVING JUNCTION FARM · OAKDENE

DORDRECHT KLIPKRAAL LEEUWKRAAL · DANEBURY ANDOVER · ABBOT'S ANN BOSKRANS · FLAUWKRAAL

DOMBASHAWA GOMOKURIRA MAKUMBE'S

DUNDEE HELPMEKAAR

ESTCOURT KRANSES · FULTON'S ROCK · BARNES · CASCADES GAME PASS · MAIN CAVE— GIANT'S CASTLE · CLEOPATRA NCIBIDWANE · KRAAL ROCK

FOURIESBERG COERLAND CALEDON'S POORT · ST. FORT BESTERSVLEI · MALOPASDRAAI

FORT VICTORIA MAVORA NDANGA

GWANDA MUCHEZI

HARRISMITH MOUNTAIN VIEW REENEN'S HOOP · CRAIGIELEA LE BONHEUR · ABERDEEN ARARAT · FULLERTON · GROOT- VLEI

HOFMEYER KAREE KLOOF [2]

HUMANSDORP COLDSTREAM [3]

HERSCHEL PELENDABA · ST. MICHAEL'S MISSION · ISHINIDINI LOCATION · SIJORA RIVER RIETFONTEIN LOCATION TYNINDINI

JAMESTOWN DELILA